Taking Care of Mom & Dad

The Money, Politics and Emotions that Come with Supporting Your Parents

Mike Rust

SILVER LAKE PUBLISHING
LOS ANGELES, CALIFORNIA

Taking Care of Mom and Dad
Handling the Money, Politics and Emotions that Come with Supporting
Your Parents in Their Times of Need

First edition, 2003
Copyright © 2003 by Silver Lake Publishing

Silver Lake Publishing
2025 Hyperion Avenue
Los Angeles, CA 90027

For a list of other publications or for more information, please call
1.888.638.3091. Outside the United States and in Alaska and Hawaii,
please call 1.323.663.3082. Find our Web site at **www.silverlakepub.com**.

This book includes case studies and sample forms to illustrate various
eldercare issues. However, nothing in this book should be interpreted as
legal advice. If you are involved in a dispute involving legal or financial
matters, consult with a regulatory agency or an attorney familiar with the
law in your state or region before taking any action.

Library of Congress Catalogue Number: Pending

Rust, Mike
Taking Care of Mom and Dad
Handling the Money, Politics and Emotions that Come with Supporting
Your Parents in Their Times of Need
Includes index.
Pages: 328

ISBN: 1-56343-740-6
Printed in the United States of America.

Acknowledgments

This book is written for Baby Boomers and their parents as a guide to help understand all the issues associated with advanced aging. However, anyone can benefit from understanding the dynamics of planning for their old age.

I've borrowed the concept of "critical mass" from Bob Brinker's weekend radio *MoneyTalk* program to describe the state when your parents' retirement is fully funded—meaning they have full retirement security

Expanding on your parents' funded position, is the concept of being overfunded or underfunded. If your parents have more than enough resources to maintain critical mass, their overfunded position needs to be productively managed. If their resources are below those needed for critical mass, there are steps your parents can take to manage their underfunded position. This book will give you the tools to take a realistic look at your parents' financial profile and take the steps necessary to secure their future.

This securing may mean making lifestyle changes, obtaining a reverse mortgage or relocating assets to increase returns.

You'll also learn how to eliminate windfalls through smart spending, gift-giving, setting up college savings plans or charitable trusts. Whether your parents are overfunded or underfunded, the goal remains the same: to secure the future of your parents and yourself without losing your mind or piggy bank. Managing assets to insure continued financial security is key.

Dedication
To Mr. Norbert O'Connor—who, many years ago, generously shared with me his knowledge and confidence.

November 2002
Mike Rust

Contents

Part II: Your Parents' Situation

Your Mom and Dad Need Your Help...Now What?

The theory of **unintended consequences** holds that the manner in which a good thing is achieved can sometimes lead to a bad outcome...or several bad outcomes.

If you ever needed proof that unintended consequences are real, look no further than your parents. If you are an average American, they are still living—and will probably be with you for many years to come. That's good. And you should appreciate that good in all of your interactions with your parents.

What is the unintended consequence? The happy fact your mom and dad are still alive is threatening the solvency of America's main social welfare programs.

In 1900, the average life expectancy was 47 years; in 2000, it was 77 years. That's the fastest and largest increase in the world's history. It's dramatically **changing the demographics** of the United States. You've probably heard about the rising political clout of groups like the American Association of Retired Persons (although *that* group has dropped "Retired" from its name and goes with the simpler acronym AARP).

But the effects are more than political. And the statistics are, frankly, staggering:

- In 2002, more than 77 million Americans were over the age of 50; **35 million were over 65**; and 4 million were

over 85. Many of these people will be living into their 80s and 90s, often with chronic illnesses.

- The average life expectancy for an American woman turning 65 in 2002 is age 84; for a man, age 81.

- Some 44 percent of American adults are caring for both elderly parents and minor children. Almost half of those said they should be doing more for their parents.

- There is virtually no government assistance for those who prefer to keep their elderly relatives at home. According to a 2001 AARP study, 27 percent of caregivers between 45 and 55 help pay expenses for older family members.

- As many as one in four American households now is involved in caring for an older adult, with the average caregiver devoting 18 hours a week to patient care, according to the National Alliance for Caregiving (NAC).

- Caregiving costs the givers upward of $659,000 over a lifetime in lost wages, Social Security and pension contributions, according to a MetLife study.

- Of the caregivers studied by MetLife, 84 percent made adjustments to their work schedules by taking sick leave or vacation time, decreasing work hours, switching from full- to part-time employment, resigning or retiring.

- A survey by the Family Caregiver Alliance (FCA), a California nonprofit that helps family members navigate the elder-care system, found that 18 percent of people helping to care for an elderly relative had quit their job to provide care, and 42 percent had reduced their work hours.

- According to the FCA, of the $127 billion spent on elder care in 1998, $78 billion came from private pockets—versus $34 billion from federal and state coffers.

- The Centers for Disease Control reported that 82 percent of seniors admitted to nursing homes each year do not come from a family member's home. In other words, families are relying on institutional care as a default solution.

- A nationwide study released by the Alzheimer's Association estimated that 64 percent of those providing care to people with Alzheimer's disease are in the work force.

- According to a study sponsored by the National Alliance for Caregiving and AARP, 54 million Americans—three-quarters of them women—are involved in caring for a parent, a spouse, a sibling or a disabled child.

- According to a study by the U.S. House of Representatives, the average woman spends 17 years caring for a child and 18 years caring for her elderly parents.

- A survey of about 500 U.S. employers found that 21 percent offered elder care referral services in 2002 versus 15 percent in 1998.

- All of these statistics will grow dramatically some time around 2010, when the first wave of the huge baby boom generation hits age 65.

You're reading this book because these statistics have hit home for you. The aging population isn't about demographics anymore; **it's about your mom or dad needing your help**...now. And you're not sure about what to do.

What you'll find in the 13 chapters that follow is a detailed discussion of what you can do to help your parents most effectively. I've organized the discussion in two parts: the first deals with **how you can get the most for your parents** out of private insurance, pensions and retirement accounts, government programs and other benefits; the second focuses on the **physical, emotional and family-political issues** that affect your parents directly.

Another unintended consequence—this one related to America's social welfare programs—is that the very rich and the very poor have either private or government benefits that will assure their elderly parents a reliable level and type of care.

The uncertainty and difficult decisions about elder care fall to caregivers helping middle-income elderly people—those who make too much to qualify for state or federal programs, but not enough to write a check for the best assisted-living center or in-home care.

Elder care consultants urge advanced planning as the only way to avoid financial havoc brought on by an aging parent with expensive needs and no assets; but they also admit **most older people are not well prepared**. These older people usually assume—wrongly—that they can count on government programs to provide long-term care.

If you're like most Americans, part of the reason that your parents' cries for help come as such a shock is that you don't spend a lot of time around old people who need assistance.

The **segregation of old people** into planned retirement communities or institutional care facilities has left many Americans with no idea about what it means—in a financial, emotional or physical context—to *be* old.

You're going to need to know more about these matters. Caring for your older parents may be too expensive to contract out and is surely too complicated to delegate. Regardless of whether your parents live on their own, are in a supervised environment, stay in a critical-care facility…or even have a "grandma flat" that you build over the garage…you are going to make a lot of decisions you may not have expected.

Not every person is able or willing to have an older parent move in with them; but older family members living in three- or four-generation households are sure to become more common in the 2000s and 2010s. And even this doesn't resolve everything about elder care. You're still going to need to know the mechanics of how your parents' retirement money and medical coverage works.

This books covers all of that.

Longer lives mean more costs and new financial issues. The real estate industry has recognized that opportunity by inventing tools like reverse mortgages. The insurance industry has recognized it by creating flexible long-term care policies that allow benefits to be used for home care as well as nursing homes. However, insurance companies leave the details of these flexible plans up to you to discover.

This book covers all of that.

If you bought this book because you just had a scary conversation in which your father admitted he can't balance his checkbook anymore...and he needs you to take over, you've come to the right place. Calm down. You can honor your father by making sure he's going to be okay—and as comfortable as circumstances allow. Tell him you'll do that.

Then use the tools and tactics we discuss here to straighten out his accounts, clean up his finances, get his insurance working right and do your best to keep his spirits up.

And keep the book. Someone else you know is going to need it.

1 Health Care and Medical Coverage

My dad had always been independent, even after my mother died. When he had the stroke, my brother and I were shocked to find out that he hadn't applied for Medicare. He'd had health insurance as part of his retirement package...but the company where he'd worked for 30 years had eliminated that in '96. Since then, he'd been going without. No doctor visits...no nothing. We had to file the Medicare paperwork while he was in the hospital. Luckily, the hospital had a benefits person on staff who helped us out; she'd been through this before and had all the government stuff on file.

Health care is the place to start when you're taking care of your aging parents. It's as important—if not more important—than money issues. People who are in their retirement years will sometimes take or stay in jobs because of the medical benefits they provide. Health coverage is *that* important.

Older people live in a more regulated world. In the United States, the federal government's Medicare system provides health insurance for most older people...and influences the coverage that everyone over 65 has.

In this chapter, we'll consider the various kinds of medical coverage that are available to older people. Then, we'll help you determine the level of your parents' existing medical coverage to see whether there's a shortfall or a windfall…and how to make up the difference if what they have isn't enough.

> **The number of North Americans living into their 80s and 90s is exploding. This trend translates into huge actuarial increases in the cost of retirement and retirement benefits plans. We'll see this same issue again and again in this book; but, in this chapter, we'll focus on what it means for medical coverage and health care.**

According to the CPI-E index, a Bureau of Labor Statistics measure, **inflation for the elderly rises faster than for the rest of the population**. This is primarily due to **higher medical costs**. Retirees are paying higher deductibles and other payments for prescription drugs than ever before…and this will only get worse.

Health expenditure experts forecast 7 to 9 percent annual cost growth in health insurance premiums through the 2000s and 2010s. This is especially troubling to private-sector employers, who are reacting to these increases by reducing or eliminating the medical benefits they provide to their retired employees.

Private Retiree Health Plans

Traditionally, private-sector medical insurance provided by the company or firm where a retiree used to work was the highest-quality health coverage available to older Americans. But retiree benefits are among the first things to go when cash-strapped companies look to cut costs. Through the 1990s and 2000s, reductions in the retirement benefits companies offer have forced many people to rely on government programs and personal savings to pay for their medical care.

Still, if your parents worked for a large employer for a good part of their career—and retired from that large employer—they may have medical coverage provided by that company. Benefits from this coverage can be substantial, especially the prescription drug coverage that is not covered by government plans. Unfortunately, few companies want to deal with the rising costs of health coverage for older people. Plus, the government has never offered tax-advanatged funding vehicles (as it does for pensions) which could help pay for retiree medical benefits.

This hard truth, combined with an early 1990s accounting rule that forces companies to write off future medical obligations against current profits, means private-sector medical benefits are often reduced from what they used to be.

> **Some companies are getting downright ruthless, questioning the wisdom of providing benefits to former employees who no longer contribute to the bottom line.**

Courts have generally sided with companies in suits brought by angry retirees who've lost their benefits. In 1998, a federal Court of Appeals in Ohio ruled that General Motors had the right to change health benefits for 50,000 former workers—even though they'd taken early retirement based on company promises of free lifetime health insurance. While some documents given to workers made the promises, the court said, others mentioned GM's right to change benefits at any time in the future.

Bottom line: You can't count on an employer to provide your parents with the benefits they'll need in retirement. In many companies, retirees are forced to pick up a portion of the bill and absorb all rising health care costs. A growing number of companies require retirees to pay the full amount of their medical benefits premiums.

In most cases, companies modify the benefits they offer retirees to so-called **Medigap coverage**. This means that the retiree has to

use government insurance (Medicare) and the company pays for (or makes available at a discounted price) additional insurance that covers the things that the government plans don't.

These Medigap plans highlight one major issue for retirees: They can pit people under age 65 against those over age 65. In most situations, government health coverage is only available to people who are either seriously disabled or over age 65; so, private-sector companies may end up offering different benefits to retirees on the different sides of 65.

> **Depending on the specific collective-bargaining rules and benefits laws that apply to a given company or employee group, these different levels of health coverage can be legal. Even so, they can be unpopular. Older retirees often complain that younger, healthier retirees get health insurance that's like what active employees get—while everyone over 65 gets lower-cost Medicare-plus-Medigap coverage.**

The government has encouraged this change by mandating that Medicare is a **secondary payor** of benefits if the employer offers any other form of health coverage. This means that Medicare only covers medical costs not covered by other insurance offered by the employer. So, most employers offer no other insurance.

But even this issue is fast becoming moot, as companies move away from paying for even Medigap coverage. According to the Employee Benefit Institute, only about 10 percent of retirees have employer-paid Medigap protection. The reason: Due to the increases in cost, **employers aren't paying for *any* retiree medical benefits**.

In most cases, by the time you need to step in to help your parents manage their affairs, they will have already reached 65—whether they have employer-paid benefits or not. So, the questions you need to ask are relatively simple:

- What kind of medical insurance your parents have?

- Is more or better coverage available to them?

- Would you know if your parents suddenly lost employer-provided supplemental coverage and don't have the means to pay for it themselves?

If you and your parents don't know the answer to that last question, it's probably worth investigating. Contact the benefits administrators at the company (or companies) where your parents worked and find out what coverage is available.

> While two-thirds of all companies with 200 or more employees provided retiree health benefits in 1988, fewer than half were providing it in 1993. By the early 2000s, fewer than one-third provided retiree health benefits to people under 65, according to Mercer Human Resource Consulting.

In many cases, companies rely on the lack of information they provide their retirees to obscure what coverage is available and—more specifically—what coverage may be taken away. They won't actively mislead people about what's available (benefits laws forbid that); but they'll count on people simply not understanding what's available and not asking. **So ask.**

Imagine that your 70-year-old dad loses his company-paid Medigap insurance and turns to you for help. He's taking expensive medications to lower his blood pressure. Medicare won't pay for these things. He swallows his pride and asks you for financial help. You agree and look into getting him Medigap coverage.

The company where he used to work used to provide Medigap coverage to retirees. It doesn't anymore; but it does allow retirees to buy their own Medigap at a lower, group rate. You don't know this…and your dad never read the brochure explaining it. A call to the company to find out exactly what's available could save you thousands of dollars.

So, ask some background questions:

- Do your parents currently have employer-paid retiree medical benefits? If so, what do they cover and how long will they last?

- Does their current coverage sufficiently cover both of your parents and all of their needs?

- If your dad has the employer-paid benefits, does it cover your mom as well? Sufficiently?

- If your parents haven't reached 65, do they have enough coverage to sustain them until they qualify for Medicare?

- Can you get a written promise from the employer that their coverage won't be subject to change?

The worst that could happen is they lose coverage before they qualify for Medicare...or they can no longer get group coverage—even if they pay for it themselves.

Don't be afraid to ask your mom and dad these critical questions—and then call the companies where they worked and talk to the benefits or human resources departments—before making decisions, buying expensive policies or forgetting to renew old policies.

There is a lot of redundant or repetitive health insurance sold to people as they transition from work to retirement.

These questions may seem awkward or uncomfortable at first; but they're necessary. As we'll see throughout this book, it's essential to maintain an **open conversation between you and your parents**. It's important for you to have a clear sense of where your parents are with regard to their health benefits and options.

Convincing your parents to share this information may require patience. You might **start by asking** your parents if *they* know what kinds of coverage they have. The point is that *someone* has to take an inventory. Not only can medical benefits change, but the medical needs of your parents will most definitely change as they get older.

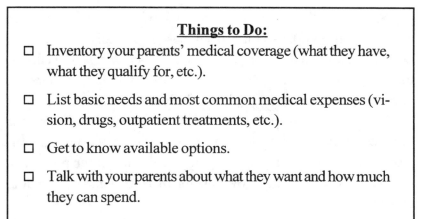

Things to Do:

☐ Inventory your parents' medical coverage (what they have, what they qualify for, etc.).

☐ List basic needs and most common medical expenses (vision, drugs, outpatient treatments, etc.).

☐ Get to know available options.

☐ Talk with your parents about what they want and how much they can spend.

When Your Parents Have to Pay

Any sort of arrangement in which a private-sector employer sponsors retiree health coverage—regardless of how much of that coverage the employer pays for—is referred to as an **employer-sponsored benefits plan**. The employer retains the duty to administer the plan; it has to determine the benefits provided and how much participating retirees have to pay. But it's up to the retiree to decide whether to participate…and how to get the best out of the plan.

> Being in an employer-sponsored group health plan, is always the cheapest way to go. Paying for health coverage on your own, as an individual consumer, can get very pricey…if it's available at all.

The amount that your parents have to pay in an employer-sponsored plan can depend on many things: their age, length of service with the employer, the package of benefits they select and how much the employer will kick in.

What would your parents pay if they don't have access to an employer-sponsored plan? A 55-year-old woman in good health might

pay $250 a month for coverage under a standard preferred provider organization (PPO), in which beneficiaries generally see specified doctors but can go out of the network at higher cost. A 63-year-old male smoker could face premiums of $600. A retiree with diabetes, arthritis or heart disease might find it difficult to get coverage at all.

For worst-case scenarios, federal law requires that full insurance be made available to those applying within 63 days of leaving an employer-sponsored plan. When coverage under the group plan ends, your parents may continue coverage for 18 to 36 months, depending on why the coverage ended.

The federal law that controls these matters is called the Consolidated Omnibus Budget Reconciliation Act (COBRA). Therefore, these benefits are typically called "COBRA coverage."

If your parents have retired without medical insurance, they can usually pay for COBRA coverage for 18 months. If one of your parents stops being eligible for COBRA coverage because he or she qualifies for Medicare, the other parent can continue COBRA coverage for up to 36 months. If your parents continue coverage, they usually have to pay 102 percent of the employer's cost (the extra 2 percent helps cover the employer's administrative costs) **each month**.

The actual form of COBRA coverage can be anything—traditional indemnity insurance, an HMO or something in between. It is simply the same insurance that the employer provides to other employees or retirees; the only difference is that your parents are paying for their coverage themselves.

Knowing how the system works and being experienced in shopping around can make a difference. This is especially true for people who are under 65; whether through a group plan or otherwise, they will have to find some form of private insurance. In most cases, COBRA coverage from a former employer will be **the best option**.

Research indicates that consumers often don't know what type of health plan they currently have. In general, they don't know how managed care plans work and are not knowledgeable about the intricacies of health benefits. Many are also unaware of, or indifferent to, the potential for financial disruption in their lives following a sudden illness or injury.

It's important to understand the differences in coverage, enrollment options and the possible financial consequences of failing to plan adequately for health care. This is why you need to know what kind of coverage your parents have. They may not even know—and may come to rely on you for guiding them down the right path.

Age, health and habits all affect the cost of insurance. But, more important these days, is the amount an employer (or former employer) is willing to contribute. According to Mercer Human Resource Consulting, 77 percent of U.S. companies employing more than 500 workers **offer no health benefits in retirement** to employees who retire at age 65 or older. And of those that do offer coverage:

- 22 percent of employers pay all costs;

- 47 percent offer plans where the worker shares the costs; and

- 31 percent offer plans in which the retiree pays all the costs.

The portion of retiree medical benefits that even the most established companies provide is a changing thing. Consider the example of retailing giant Sears, Roebuck and Co. In the 1990s, Sears began to reduce the amount it would pay for medical benefits to retirees. It started by freezing the dollar amount it contributed to prescription drug costs and catastrophic medical expenses. The company then capped its plans in 1996 for pre-1996 retirees as well as the amount for post-1995 retirees. For those who retired after 1995, Sears cut the amount it paid for retirees' spouses from 100 to 50 percent of the amount it contributed to the retiree's medical coverage. Finally, Sears

stopped subsidizing health care coverage after age 65 for employees who retired after December 31, 1999—which meant these people had to pay 100 percent of the cost of their medical benefits.

> The steady rise in the cost of prescription drugs and health insurance has crippled retiree benefits programs. And, without significant structural changes, there's little chance of a cure in the near future.

As we've seen before, the laws regarding companies' obligations to their retirees do not favor workers. The Sears retirees formed the National Association of Retired Sears Employees and fought their former employer over the cutbacks. But a judge ruled in March 2002 that Sears's benefit plan enabled it to make cuts at any time.

Meeting the challenges of today's struggling health care market when it comes to taking care of mom and dad is tricky. They may have already lost some of their coverage, such as an employer-paid plan, making it more work for you to ensure their health care safety. And, if they've never had any employer-paid plan, they have to turn to other options.

Medicare Basics

In most situations, your parent's primary source of medical coverage is a government program (Medicare if they are aged or disabled; Medicaid or state-level programs if they're poor or otherwise uninsurable).

Aged means 65 years old or older (though Congress has considered raising the qualifying age to 67); *disabled* means physically impaired as determined by the Social Security Administration or having a major kidney problem that requires dialysis. **Medicare enrollment** can be either automatic or optional.

If your parents are over 65 and getting Social Security pension benefits, they automatically qualify for Medicare. They also qualify if they've been collecting disability benefits for two years. Everyone else must file an application.

Technically, Medicare is administered by the Health Care Financing Administration—an agency of the Department of Health and Human Services. The program is **federally funded**, which means participants pay very little for the coverage they receive. The coverage applies to hospitalization as well as basic medical expenses.

Medicare pays only for services **determined to be medically necessary** by federal health care experts. Even then, services are covered only to the extent that Medicare **deems them to be reasonable**. The basic medical care covered by Medicare includes:

- necessary day-to-day outpatient medical care;

- occasional hospitalization for care of chronic or acute ailments or accidents; and,

- in some cases, skilled nursing care in a nursing home.

Medicare benefits aren't great—most **private sector health insurance covers more**...more completely. But Medicare does offer the functional level of health coverage that most older people in the United States use.

Medicare benefits come in two parts. **Part A (hospital insurance)** is paid for by a Medicare payroll tax on people still working. Part A helps pay for inpatient hospital care, skilled nursing care and other services. **Part B (medical expenses)** is paid for by monthly premiums of those who are enrolled and from general revenues. It helps pay for such items as doctors' fees, outpatient hospital visits and other medical services and supplies.

In short, Medicare will pay for some health care expenses; it by no means pays for them all. There are limits on covered services—

and the program includes both **deductibles** and **coinsurance provisions**. We'll consider each of these in turn.

Medicare Part A

Medicare Part A covers **inpatient care** in a hospital and skilled nursing facility care after a hospital stay. It covers **home health care** and **hospice care**. It pays for whole blood or units of packed cells, after the first three pints during a covered stay in a hospital or nursing facility. In addition, it pays 80 percent of **durable medical equipment**—such as wheelchairs and walkers—when approved.

In its current form, just about every working person will be eligible for Medicare coverage at age 65. Ordinarily, your parents' Medicare cards will be mailed to them three months before they reach their 65th birthdays and coverage begins on the first day of the month in which they each turn 65.

If one or both of your parents is disabled and receiving benefits for 24 months, their cards will be automatically mailed as well. However, if they're not receiving retirement benefits, they must apply directly to the Social Security Administration (which may direct them to other agencies, depending on their work histories). They're also eligible for benefits if they are:

- a disabled person who has been receiving Social Security disability benefits for at least 24 months;

- a person who is diagnosed as having permanent kidney failure that requires dialysis or a kidney transplant;

- an individual born prior to 1909 who has no quarters of coverage under Social Security; or

- a retired railroad worker.

Be sure you—and your parents—know the vital dates for getting Medicare coverage in place. They should apply for the benefits at least **three months before they reach 65**, to avoid any delays in

coverage. They only have seven months to enroll, beginning three months prior to their 65th birthdays; otherwise, they'll have to wait until the following January 1 to enroll. And, in that case, their benefits won't kick in until July 1.

If your parents don't qualify for Medicare hospital insurance (they never worked or had a spouse who worked, etc.), they can buy coverage for a monthly premium. If they take this route, they must also enroll in Part B Medicare, live in the United States and be either a citizen or a lawfully admitted alien.

How Much Does It Cost?

If either of your parents worked for at least 10 years in a Medicare covered job (meaning one or both of them had deductions withheld from their paycheck for the Medicare payroll tax) and they are a citizen or permanent resident of the United States and eligible for Medicare, there is no charge for Part A (hospital insurance).

Disabled individuals, kidney dialysis and certain transplant patients are not charged, either.

If none of these qualifications fit your parents' circumstances, they may purchase Medicare Part A if they are at least 65 years of age and meet other requirements. The per-month cost in 2002 ranged between $175 and $340.

Finally, when you're thinking about what Medicare Part A costs, it's worth keeping in mind the things that it doesn't cover—and that you and your parents will likely have to pay for out-of-pocket.

Hospital insurance under Medicare Part A does not cover any of the following:

- private duty nursing;

- charges for a private room, unless medically necessary;

- conveniences, such as a telephone or television in the room;

- the first three pints of blood received during a calendar year (unless replaced by a blood plan).

Medicare pays about half of beneficiaries' health care expenses, on average. The remainder is paid by private supplemental coverage, Medicaid and other public sources, or by the beneficiaries themselves.

> According to one study, Medicare beneficiaries age 65 and older paid about $2,149, or 19 percent of their income, out-of-pocket for health care in 1997. This included Medicare cost-sharing payments, Medicare Part B and private insurance premiums, balance billing by physicians and payments for goods and services not covered by Medicare. It did not include the cost of home health care services or nursing home care.

Medicare Part B

Medicare Part B is medical expense insurance covering costs associated with doctors' services, outpatient care, laboratory tests, x-rays, mammograms and pap smears and medical supplies. Your parents will have to pay the first $100, which is the **annual deductible**, then Medicare will pay 80 percent of all approved charges for any eligible medical expense. The approved charge may or may not be close to the actual fee charged by your parents' provider. This means they are responsible for the difference…as well as the additional 20 percent of the approved charge.

Fortunately, when doctors accept a **Medicare assignment**, they agree to charge no more than Medicare's approved charge.

Here's what Part B covers:

- doctors services provided on an inpatient or outpatient basis, no matter where received in the United States, including surgical services, diagnostic tests and x-rays, medical supplies furnished in a doctor's office and services of the office nurse;

- services of clinical psychologists, chiropractors, podiatrists and optometrists;

- outpatient diagnostic services and lab fees, such as care in an emergency room or outpatient clinic of a hospital;

- outpatient physical and speech therapy;

- dental work that is required due to accident or disease;

- the use of outpatient medical equipment such as iron lungs, braces, colostomy bags and prosthetic devices such as artificial heart valves;

- ambulance service, if the patient's condition requires it;

- outpatient psychiatric care (there is a 50 percent copayment instead of 20 percent);

- the cost of certain vaccines and antigens (only medicines that are administered at the hospital or at a doctor's office are covered by Medicare. Drugs that can be self-administered—taken at home—are not covered, even if prescribed by a doctor);

- an unlimited number of home health care visits, if all required conditions are met and your parents do not have Medicare hospital (Part A) coverage;

- preventive health care expenses such as pap smears and mammography (however, mammograms are covered only when performed in a Medicare-approved facility); and

- one pair of eyeglasses following cataract surgery.

Blood is a covered expense under Part B (also Part A). In essence, there is a "three-pint deductible" for blood, which means that Medicare is responsible for either paying for the first three pints of blood or replacing the blood. The blood deductible for Part B can be used to satisfy the blood deductible for Part A. Thus, only one three-

pint deductible is required. However, any blood provided under Part B is still subject to the 20 percent copayment.

Under Part B, there are a number of services that do not require a deductible or a copayment, including:

- the cost of a second opinion required by Medicare for surgery;

- home health services (except the 20 percent copayment applies to the use of certain medical equipment);

- pneumococcal vaccine (flu shots);

- outpatient clinical diagnostic lab tests conducted by Medicare-certified facilities or doctors who accept assignments.

There is a fee for Part B (Medical Expenses). In 2002, the monthly premium was $54 and automatically deducted from Social Security payments. Enrollment is automatic—unless your parents state that they don't want it—when they are eligible for premium-free Part A.

If your parents don't qualify for premium-free Part A, but are 65 or older, they can still buy Part B.

Still Working?

If your parents continue to work after the age of 65, they will still be covered by Medicare. However, such coverage will—in most cases—be secondary to medical insurance offered by their employer.

Example: If a company has at least 20 employees, employees over 65 must be offered the same health benefits as younger employees. Medicare becomes a secondary payor of benefits for the employees over 65. The company's health plan is primary.

Accordingly, any health claim made by an age 65 or older employee will first be paid by their employer's group health plan. If any

part of the claim is not satisfied by the group health plan, that portion of the claim would then be submitted to Medicare.

Some employers try to talk older employees into choosing Medicare as their primary health coverage. If your parents are still working, they may reject their employer's plan and elect Medicare as the primary payor...but their employer may not—in any way—encourage them to do so.

Common tactics employers use to encourage older workers to choose Medicare as their primary plan include: offering to pay for Part B coverage on your parents' behalf and offering to purchase a Medicare supplement policy for them.

Doctors and Medicare

The main reason that your parents should keep private-sector health coverage as long as possible is that using Medicare effectively requires a lot of paperwork and attention to bureaucratic detail.

About half of the doctors in the United States will accept the amounts paid by Medicare as payment in full. This is referred to as **accepting the Medicare assignment**.

If a pathologist or radiologist who performs services on an inpatient basis accepts a Medicare assignment, Medicare will pay 100 percent of reasonable charges. It will also pay the cost of a required second opinion for surgery with no 20 percent copayment. And it will pay for services of other specialists on the standard 80 percent of reasonable charges basis.

That's the easy scenario; others are more complicated.

Doctors who do not accept Medicare assignments are prohibited by law from charging more than 140 percent of the Medicare prevailing charge for office and hospital visits.

Some doctors try to circumvent the limits on what they can charge by making patients sign a **contract to pay full charges**. The Health Care Financing Administration has cautioned that these contracts are not valid. **Don't let your parents sign them.**

Doctors and other providers must submit claims for covered Part B services directly to Medicare. Some doctors ask patients to **waive the right** to have doctors submit Medicare claims and obligate the patient to pay privately for Medicare-covered services. These waivers are also invalid. **Don't let your parents sign them.**

If your parents' doctor doesn't accept their Medicare assignment, he'll send the bill for Part A services directly to them. In this case, they fill out a Medicare claim form and attach any itemized bills from the doctor—including date and place of treatment, description of treatment, doctor's name, etc. The documents are then sent to a Medicare administrator in their area. Upon receiving the claim, the administrator will send an **Explanation of Medicare Benefits**, showing which services are covered and the amounts approved for each.

Medicare claims are sometimes paid on a **indemnity basis**, meaning directly to your parents—usually after they've already paid the doctor. However, if the doctor or hospital has agreed to accept the amount reimbursed by Medicare as payment in full, benefit payments may also be made **directly to the provider**.

In the direct payment or reimbursement model, your parents pay a deductible for each benefit period, beginning with the first day of admission to a hospital and continuing for 60 days. If they are released or hospitalized for more than 60 days, a new benefit period begins and a new deductible applies. That's the bad news. The good news: There's no limit on the number of benefit periods they can have.

If a Medicare claim is denied, your parents can **appeal** the claim. Within six months of receiving the Explanation of Medicare Benefits notice, they must file a **written request for review**. The admin-

istrator will check for miscalculations or other errors. If the administrator declines to make a change, an appeal can be made to the Social Security office (but only if the amount disputed is $100 or more).

Your parents must **appear in person** to attend a hearing and present evidence, such as a doctor's letter, to support their point. A written notice of the decision will be sent to them after the hearing.

Medicaid

The other main federal health care program is **Medicaid**. This coverage has many limitations—it doesn't pay for many diagnostic tests and treatments that most doctors and hospitals consider ordinary. For this reason, many doctors and some hospitals will not treat patients whose only insurance is Medicaid.

> Qualification for benefits under Medicaid is based on financial need. You have to be extremely poor to qualify; if your parents are under 65 and own their home or have any private-sector retirement benefits, they probably won't qualify.

In some states, local programs administered at the state level take the place of Medicaid. The terms and conditions of these state programs may differ slightly from the federal program but, speaking broadly, the coverage is pretty much the same.

It's not great coverage.

These programs should be used as a last resort, because they typically offer only limited benefits, are expensive and usually include a waiting period before coverage kicks in. But at least they're there, if your parents need them. They can find out about these plans by calling their state insurance department.

Medicaid provides medical assistance to low-income families and individuals of all ages. The program works well for seniors who have run through most of their assets. In fact, the Health Care Financing

Administration reports that about half of all Medicaid spending goes to people who had financial resources when they entered a nursing home, but reached the poverty level while they were there.

> **A third of the $55-billion-a-year budget for Medicaid goes to those over age 65, primarily to support them in nursing homes.**

Medicaid offers a minimum set of services including hospital, physician and nursing home services. State agencies have the option of covering an additional 31 services including prescription drugs, hospice care and personal care services. A result, **Medicaid is the largest insurer of long-term care** (LTC) in the U.S.—covering the bulk of retirees in nursing homes. It covers 68 percent of nursing home residents and over 50 percent of nursing home costs.

Using up a lifetime of assets is a frightening scenario for an older person on his or her own. But what if one of your parents must move into a nursing home? Will your parents have to sell the house to cover the nursing home costs? Where will your other parent live?

At one time, Medicaid rules required people to liquidate virtually all assets—including cash, investments (such as stocks and bonds), bank accounts, real estate and even some forms of cash-value life insurance—to qualify for coverage. Fortunately, the federal government modified the requirements in 1993 to allow surviving spouses and disabled children to retain more of the family's assets.

Now, if a person is married and enters a nursing home while the other spouse remains at home, the at-home spouse is permitted to keep the following:

- one home;

- one car;

- one-half of the couple's assets or $75,740; and

- up to $1,919 in monthly income.

These amounts are indexed annually for inflation and are significantly lower for unmarried seniors. However, once neither spouse is living in or likely to return to the home and the house is sold, Medicaid may demand reimbursement for expenses associated with prior nursing home services.

An entire "**Medicaid planning**" specialty has emerged in the estate planning field to help people avoid running through their life savings before qualifying for Medicaid. Some people are even tempted to give away assets so that they can qualify for Medicaid and still pass something along to their heirs. However, the government frowns on this: Federal provisions enacted in 1996 set criminal penalties for transferring assets for the sole purpose of qualifying for Medicaid. The penalties include fines of up to $25,000.

Medigap Insurance

Medicare won't pick up the tab for all health care needs. Even with Part A and B coverage, financial risks related to deductibles and copayments can be overwhelming if your parents are living on a fixed income. This is particularly true if one or both of them develop a major chronic illness and they turn to you for the tens of thousands of dollars for treatment. Furthermore, since Medicare won't pay for most outpatient prescription drugs, long-term care, hearing aids, eyeglasses and some preventive medicine, **it's important to consider the gaps**.

Because Medicare covers less than half of all health care bills, your parents will probably need to get supplemental coverage—commonly called **Medigap insurance**.

Simply said, Medigap pays for medical expenses that are not covered by Medicare—such as prescription drugs, long term care and hospital deductibles.

Medigap policies also pay some or all of Medicare's deductibles and copayments. Thirteen million Medicare beneficiaries don't have drug benefits and need some other form of coverage to help pay for

these costs. Prescription drugs are the fastest growing health care expenditure in the U.S. and are expected to be 10 percent of all such expenditures by 2010.

> A typical senior without prescription drug coverage pays 34 percent of his or her after-tax income on health care. Prescription drug spending is the single largest component of out-of-pocket spending on health care (other than premiums and copayments).

According to the AARP, 80 percent of retirees use a prescription drug every day. And, older Americans account for one-third of prescription drug spending, though they represent only 12 percent of the population. Because of the extra—vital—coverage offered by supplemental policies, many older people opt for this coverage.

Medigap policies are sold by insurance companies under standardized formats mandated by the government. This standardization makes it easy to compare policies from different companies.

> There are some caveats. Chief among these: Medigap insurers have the right to reject retirees who don't sign up within 63 days of losing a company's supplemental policy. If your parents are forgetful or difficult, they can cause themselves serious insurance problems that will last for years.

Be Careful of How Medigap Is Sold

Insurance companies and retiree associations deluge the senior population with ads for Medicare supplement policies. It's a booming business. One hundred forty-six companies sold roughly 11 million Medigap policies to Americans in 2002. As with most other health insurance policies, Medigap policies are sold on both an individual and group basis. Medigap policies are neither sold nor serviced by the state or federal government. Insurance agents and companies may

not claim that they represent the Medicare program or any government agency, or that the policy they are selling is guaranteed, approved...or otherwise backed up by the government.

However, agents selling Medicare supplements don't always practice the professionalism and ethical conduct they should. Often, the combination of these factors results in poor decision-making with regard to supplemental coverage—buying too much coverage, the wrong kind or none at all.

> **One common scenario: An impressionable older person ends up buying six or seven supplemental policies—when one is all he or she needs. As a result, Medicare supplemental policies are heavily regulated by the government...and consumers have been assured by law of certain important legal rights.**

Keep in mind that, even though agents are by law required to exercise great care in recommending and selling Medicare supplement policies, they are *paid* by commissions on the policies they sell. This is why knowing what kind of insurance your parents currently have—and from where it came—is important. If they've purchased a supplemental policy, you need to know if they picked the right one at the right price. And that they haven't paid for three or four.

> **Your parents only need one medigap policy, because only one policy will pay benefits.**

Although it is unethical and illegal to duplicate existing coverage for the sake of generating a commission, agents have been known to do so. There are serious penalties for agents who duplicate or "pile on" supplemental coverage, including the loss of their license to sell insurance, jail terms of up to two years and fines of up to $10,000.

Insurance is regulated at the state level, so **state insurance departments** impose regulations on Medigap companies. State depart-

ments approve the policies sold by insurance companies, but only to the extent that the company and policy meet the requirements of state law. State departments also oversee the licensing of agents who sell Medicare supplements. Some states require additional instruction in ethics for agents who serve the senior market.

OBRA 1990

The Omnibus Budget Reconciliation Act of 1990 (OBRA 1990) enhanced the protections for Medicare supplement buyers. Under the law, Medicare supplement insurance **may not be denied** on the basis of an applicant's health status, claims experience or medical condition during the first six months a Medicare beneficiary age 65 or older first enrolls in Medicare. This is known as the **open enrollment requirement**.

OBRA also protects consumers in other ways:

- It prohibits the sale of Medicare supplement insurance to anyone who already has another health insurance policy that provides coverage for the same benefits. Insurance companies must ask applicants about their existing coverage when taking applications.

- It requires insurance companies to suspend insurance benefits upon request of a policyholder during any period of time he or she is entitled to benefits under Medicaid.

- It requires all Medigap policies to cover pre-existing conditions after the coverage has been in force for six months.

- It holds that, if a Medicare supplement policy replaces another which has been in effect for at least six months, the new policy must waive any time periods applicable to pre-existing conditions, waiting periods, elimination periods and probationary periods.

Perhaps most importantly, OBRA required that Medicare supplement policies be standardized. This was done because the staggering number of different Medicare supplement policies available from different insurance companies in different states was beyond confusing. Congress concluded that standardizing the policies would be the best way to improve consumer protection.

The National Association of Insurance Commissioners (NAIC) developed 10 standard Medicare supplement policies, one of which is a core benefit or no frills policy with basic benefits that must be included in all Medicare supplement policies. No more than these 10 standard Medicare supplement policies may be offered for sale.

The 10 Medicare supplement policies developed by the NAIC are identified by letters **A** through **J**. Insurance companies may not change the letter designations assigned to the 10 policy forms, but they may add other names or titles.

Plan A is the **basic policy** offering core benefits. The other nine policy forms (Plans B through J) contain the core benefits plus various additional benefits. A state may limit the number of available plans to fewer than 10, but Plan A must be one of them. Insurers aren't required to offer all 10 plans but each must offer Plan A.

The Basic Medigap Package

The benefits that make up Plan A and form the basis for all the other plans cover:

- the Medicare Part A coinsurance amount for days 61 through 90 of hospitalization in each benefit period;

- the Part A coinsurance amount for each of the lifetime reserve days;

- 100 percent of Part A eligible hospital expenses, limited to a maximum of 365 days, after all Medicare Hospital benefits have been exhausted;

- the reasonable cost of the first 3 pints of blood;

- the 20 percent copayments for Medicare Part B services.

Medicare supplement policies **may not use waivers** to exclude, limit or reduce coverage or benefits for specifically named or described pre-existing diseases or physical conditions. The policies must be adjusted each year to reflect changes to Medicare deductibles or copayments. Most Medicare supplements pay nothing for services Medicare finds unnecessary, such as cosmetic surgery.

If your parents have health coverage before they become eligible for Medicare, their insurer must send them a notice of the availability of a Medicare supplement. If they have coverage under a group Medicare supplement policy, and the policy is terminated and not replaced, the insurance company must offer them an individual policy and a choice between a policy that continues the same benefits provided by the group policy or one that provides only the benefits required to satisfy the minimum standards required by their state.

A Closer Look at the Standard Plans

Buying Medicare supplement coverage is like buying a car: The core benefits represent the basic sticker price of the vehicle; you can add optional benefits to the core package in much the same way that you can add options to a car. The optional benefits included depend on the needs and wants of the individual.

As we've mentioned, basic benefits (**Plan A**) supplement Medicare benefits by providing coverage for hospitalization coinsurance payments from day 61 to 90 and 91 to 150. This means that the daily copayment required under Medicare will be paid for by the supplement. If benefits end during a period of hospitalization, the supplement pays for an additional 365 days at 100 percent.

In addition, the 20 and 50 percent coinsurance payment due under Medicare Part B is covered after your parents pay the required

deductible. The first three pints of blood or packed red blood cells are covered as well under both Medicare Parts A and B.

Plan B includes the basic benefits from Plan A and adds on coverage for the Medicare Part A deductible per benefit period. Therefore, if your parents had Plan B, they would have their deductible met and all coinsurance payments.

Plan C includes everything in Plan A and B and adds the coinsurance amount per day for skilled nursing care your parents would be required to pay under Medicare Part A for days 21-100. It pays the deductible under Medicare Part B and 80 percent of emergency care while in a foreign country after a certain deductible. If your parents travel out of the country a lot, they may want to consider this.

Plan D includes everything in the plans that precede it except the Medicare Part B deductible and adds on coverage for custodial care (dressing, laundry, shopping, etc.). Medicare Part A home health care coverage doesn't pay for custodial care and many older people need assistance with daily life functions, especially after recovering from a serious illness or injury.

Plan E does not cover the Medicare Part B deductible or at-home recovery services but does include preventive care. The benefit amount is a dollar amount per year for physical exams, screening procedures and patient education.

Plan F does not include preventive care or at-home recovery but does add on excess charges for Medicare Part B expenses. This means if your parents go to a doctor who doesn't accept Medicare assignments, they would be obligated to pay the entire bill. This benefit pays the amount they'll be billed for at either 100 or 80 percent. (Under the 80 percent plan, they have to pay the balance.)

Plan G excludes the Medicare Part B deductible and preventive care and pays the excess charges at a level of 80 percent, rather than 100 percent as in Plan F.

Plan H includes coverage for prescription drugs at 50 percent with an annual limit after a deductible is met. An extended benefit is

available in Plan J that increases the annual amount to a higher limit. This is the least expensive plan that includes drug coverage.

Plan I excludes Medicare Part B deductible and preventive care but includes prescription drugs at an annual basic level.

Plan J is the most comprehensive and includes coverage for all benefits previously listed at the maximum levels.

Which one of these plans should your parents buy? Plan A is the least expensive and should be priced most competitively because all health insurance companies are required to offer it. Plan A works well as catastrophic coverage—it will keep your parents from being wiped out is one gets sick. But it will leave them on the hook for routine health care expenses, including the ever-increasing cost of prescription drugs.

Which plan is the most popular? Data from the federal government shows that Plan F is most often selected. Why? Because it allows the greatest choice among doctors and hospitals.

Since supplement plans are the same—Plan C is Plan C, no matter which company is offering it—when you shop for coverage for your parents, you'll be looking at **price, service and reliability**. Prices vary from state to state and company to company. That's because states have different medical costs and insurance companies have different claims experience.

It's also vital to find an insurance company you feel comfortable with—and one that is reputable and in good shape financially. Or, said another way, it's important to avoid companies that have histories of financial problems and bad customer service. Your state insurance department can alert you to problem companies.

Of the various provisions found in Medicare supplement policies, there are a number which are of special importance to the policy-

holder. These include: premium payment and **renewability**; treatment of **pre-existing conditions**; benefit provisions; the claims process; **exclusions and limitations**.

Most insurers band premiums by age. That is, all applicants ages 65 to 70 pay the same premium, ages 71 to 75 pay the same premium, etc. Most insurers do not make any distinction regarding male or female rates. So, the premium is the same for both sexes.

Medicare supplement policies must be issued as **guaranteed renewable**, which means the insurer guarantees to renew (and cannot cancel the policy) but does not guarantee the premium. The premium is often increased at certain ages or on the policy's anniversary.

A caveat: Always find out whether or not a premium is guaranteed, and ask to see a schedule or scale of the increasing premium payments.

Because these policies are guaranteed renewable, they can't be canceled solely because a person's **health has deteriorated** or because of **age**. And termination of a policy cannot reduce the benefits for any continuous loss or claim that began before the termination.

The death of one of your parents will not terminate coverage for the other if they are covered under the same policy, as long as the surviving parent pays his or her portion of the premium.

Pre-existing Conditions

Many older people are being treated for some medical problems by the time they become eligible for Medicare. Your parents may already have serious medical conditions (high blood pressure, heart disease, etc.) or minor ones (such as allergies). For health insurance purposes these problems are defined as **pre-existing conditions**.

In any health insurance policy, you should investigate the coverage limitations for pre-existing conditions. The fastest way to do this:

Read through the definition of a pre-existing condition in the policy. Most Medicare supplement contracts will define a pre-existing condition as *any condition for which the policyholder sought treatment or advice* in the six months prior to the start of the policy.

Treatment generally consists of actual medical treatment provided by a doctor, nurse, hospital, etc.; **advice** consists of consultations, but could include a conversation about the medical condition.

Most Medicare supplements exclude benefits for pre-existing conditions until the policy has been in force for six months. In other words, there is a **six-month waiting period** for coverage of these conditions. (A few companies require no waiting period, some require a 90-day period…but none can require more than six months.)

Benefit Provisions

The **benefit provisions** of a Medigap policy include the details of how the deductibles and copayments under Medicare Parts A and B are reimbursed, how the policy treats allowable Medicare charges and excess charges and how important it is for your parents to use participating providers. Optional benefits—such as private hospital rooms, coverage for blood and coverage of outpatient prescription medication—are also described here.

It's essential that your parents understand the claims process under both Medicare and the Medicare supplement policy. The mandatory provisions in their policy will define the steps for filing a claim.

Generally, Medicare supplements exclude the same services that Parts A and B do; but some supplements offer coverage for certain Medicare exclusions. These additional benefits (available for an additional premium) might include a benefit for private hospital rooms or prescription drugs. In addition, the Medicare supplement normally excludes conditions common to most health insurance policies. These would include losses from war or act of war and self-inflicted injuries.

Most Medigap policies (Plans A to G) exclude coverage for prescription drugs. While your parents may never need inpatient hospitalization, they'll probably need prescriptions filled at some point. So, unless your parents are very healthy, very wealthy—or both—**it's worth the extra premium** for them to have this coverage.

Outline of Coverage

In most situations, a Medigap insurance company must provide an outline of coverage at the time of application, and obtain written acknowledgment that the insured person has received it. Outlines of coverage describe whether the insurance covers private duty nursing, skilled nursing home care (beyond what is covered by Medicare), custodial home care, intermediate nursing home care, home health care (above the number of visits covered by Medicare), physician charges, drugs, care received outside of the United States, dental care, cosmetic surgery and the cost of eyeglasses and hearing aids.

The outline of coverage must also describe the policy provisions that exclude, eliminate, resist, reduce, limit, delay or in any other way qualify the payment of benefits. This chart, however, only briefly describes the benefits. It will usually contain a disclaimer suggesting that the Health Care Financing Administration or its Medicare publications should be consulted for further details.

Policy provisions that restrict renewability or continuation of coverage, especially if the insurer has reserved its right to change your premium, must be explained. The amount of the policy premium to be charged must also be given.

A Medicare supplement policy, which provides for the payment of benefits based on standards described as "usual and customary" "reasonable and customary" or similar words, must define and explain those terms in the outline of coverage.

Many of the most important policy features such as renewability and exclusions or limitations must appear on the first page of the policy, and not be buried in the fine print at the end of the policy booklet. Policy forms that do not meet these requirements usually will not be approved for sale.

Free Look Language

Medicare supplement policies and certificates must have a notice prominently printed on the first page, or attached to the first page, informing every applicant of his or her **right to return the policy** or certificate within 30 days of delivery and have the premium refunded if he or she is not satisfied for any reason.

Any refund must be paid directly to the applicant in a timely manner—which often means 30 days.

Marketing Rules

As we've said before, Medigap insurance is often sold aggressively by brokers or agents paid by commission. **Abuses sometimes occur**. Insurance regulators watch Medigap companies closely—but they don't always know about every sleazy seller. No one will watch out for your parents as carefully as you do.

The terms **Medicare supplement, Medicare wrap-around**, etc., may not be used in marketing a policy unless the coverage and forms are approved by the state insurance department. Many states bar use of the term **Medigap** because it implies that *all* health care costs not covered by Medicare are covered by the supplement.

Marketing materials sometimes emphasize benefits that have little real value. An example: A brochure from Union Fidelity Life Insurance, a unit of Illinois-based Combined International Corp., warned that "Medicare pays nothing" after 150 days of hospitalization. The Union Fidelity plan supplemented hospital charges for up to 365 days.

Senior citizen groups pointed out that few people need such a benefit, since the average Medicare hospital stay is 7.5 days.

States usually require insurers marketing Medicare supplement insurance coverage to establish marketing procedures to assure that any comparisons of policies done by its agents are fair and accurate. Also, insurers must have written, established procedures to assure that excessive insurance is not sold or issued.

Advertisements that produce leads by using a coupon or response card must disclose that an agent may contact the applicant. Ads may not imply connection to a government agency, charitable institution or senior organization to imply the policy is endorsed by governmental agencies. And, in most cases, ads used by agents or brokers must have prior written approval of the relevant insurance company before being used.

Most states prohibit agents and insurance companies from engaging in any of the following practices in the sale and marketing of Medicare supplement policies:

- **Twisting**. Knowingly making any misleading representation or incomplete or fraudulent comparison of insurance policies or insurers in order to induce a person to lapse, forfeit, surrender, terminate, retain, pledge, assign, borrow on, or convert any existing insurance policy or to take out a new policy.

- **High pressure tactics**. Employing any method of marketing having the effect of or tending to induce the purchase of insurance through force, fright, threat (explicit or implied), or undue pressure.

- **Cold lead advertising**. Using any method of marketing that fails to disclose conspicuously that the purpose of the marketing effort is to solicit insurance, and that the prospect will be contacted by an insurance agent or insurer.

Replacing Supplemental Policies

One of the most common forms of abuse that occurs in the marketing of Medigap coverage is convincing a policyholder to replace an existing—and perfectly good—policy with another, more expensive one. For this reason, there are strict government regulations for replacing Medicare supplement policies.

If your parents already have a policy and want better benefits, they can replace their policy with a new one. But they should proceed carefully—and make sure that the old policy doesn't expire before the new policy takes effect.

Application forms must include questions as to **whether the insurance will replace existing Medicare supplement insurance** and whether the policy or contract being applied for is intended to replace any other policy or contract currently in force.

Your parents may be asked to respond to the following questions:

- Do you have another Medicare supplement insurance policy, subscriber contract or certificate in force (including health maintenance organization contract)?

- Did you have another Medicare supplement insurance policy, subscriber contract or certificate in force during the last 12 months? If so, with which company? If the policy lapsed, when did it lapse?

- Are you covered by Medicaid?

- Do you intend to replace any of your medical or health insurance coverage with this policy, subscriber contract or certificate?

These questions are designed to protect your parents by drawing attention to question of whether they need a new policy. Some states require agents to list any other health insurance policies or contracts they have sold to your parents, including those that are still in force and those sold during the last five years that are no longer in force.

> The main risk of replacing a Medigap policy: That the new policy will have exclusions for pre-existing conditions or other coverage limits that may end up temporarily reducing the amount of insurance your parents have.

If your parents replace Medicare supplement insurance, the insurer or its agent must give them a **Notice Regarding Replacement**. The notice informs them that their pre-existing conditions may not be covered by the new policy—which could result in delay or denial of a claim for benefits.

The notice must also inform them that failure to include all material medical information on the application may result in denial of claims. Your parents must receive a copy of the notice before the policy is issued or delivered, and a copy signed by both them and agent is retained by the insurer.

Insurance companies must show that they have established procedures for determining whether a replacement policy contains **clearly and substantially greater benefits** to the policyholder than the replaced coverage in order to trigger first-year commissions for the agent.

Protecting Your Parents from Scammers

There are agents and companies selling Medicare supplement policies whose lack of professionalism and ethics harm consumers. But there are also ways for your parents to protect themselves. There are definite **warning signs** to watch out for when shopping for a Medicare supplement insurance policy.

Insurance agents and companies can't claim that they represent the Medicare program, the Social Security Administration, the Health Care Financing Administration or any government agency. They can't imply that the policy they're selling is guaranteed, approved, or otherwise backed up by the government. If someone calls your parents **claiming to have been authorized by the government** to contact

them in order to review, modify or discuss their existing insurance, tell your parents to hang up.

Remind your parents to beware of anyone who tells them that he or she is a "counselor" or "adviser" for any association of senior citizens. This person may in fact just be an insurance agent trying to sell them a Medicare supplement insurance policy. Your parents should ask for credentials, the licenses they hold, and what kinds of products they are authorized to sell. **A business card is not a license.**

Your parents should not let an agent talk them into signing any form, application or document in blank. When they are buying a policy, they should never pay a premium in cash or make out a check to an agent's personal account. The agent should make it clear that they have the option of paying their premiums directly to the insurer.

Be careful of any description of benefits that sounds too good to be true. It probably is. Agents have been known to give inaccurate, exaggerated and misleading descriptions of the benefits provided by both Medicare and Medicare supplement policies in order to convince an unsuspecting consumer to purchase a policy from them.

Any agent who tries to sell your parents a number of identical policies is ripping them off.

Similarly, agents may try to get your parents to surrender insurance they already own and replace it with a policy they are selling by:

- misrepresenting the policy they are selling,

- making an incomplete comparison of the policies, or

- claiming that your parents' current insurer is in financial trouble.

As with all insurance policies, it pays to compare the costs of similar policies available from different insurers. The 10 standardized plans make it easier: Plan A is always a company's lowest priced

Medicare supplement policy and is identical in coverage to the Plan As offered by other companies.

A study by the Missouri Department of Insurance found annual premiums for Plan A ranged between $347 to $785 (for the same coverage!) while premiums for Plan F ranged from $732 to $1,436.

> The best strategy is to shop aggressively when your parents first buy a policy; after that, they should change insurers or policies only when they want to make substantial changes to the coverage. If your parents cancel one policy to purchase another, there is generally no refund of premium and they may be subject to new policy limitations and restrictions.

Medicare HMOs

Due to the increasing costs of Medicare supplement policies, many seniors are switching to **managed care plans**. In 1998, the federal government estimated that some 70,000 Medicare recipients a month were switching to some form of managed care. At that point, of the 38 million seniors and disabled eligible for Medicare, almost 6 million were enrolled in a Medicare HMO.

> Medicare HMOs combine the benefits of Medicare and Medigap policies all in one. However, some people who've used these HMOs complain about the bureaucracy and non-responsiveness that seems typical of managed care programs.

Even though there are some complaints, **Medicare HMOs can be a cost-effective alternative**. The federal government funds most of the revenue for the plans, which makes the cost to your parents about the same as the premium they'd normally pay for Medicare Part B ($54 a month in 2002)—depending on membership, geographic location and other factors that influence the HMO's cost structure.

Items such as eyeglasses and prescription drugs are covered under most HMOs. As long as your parents have Medicare Part B, continue to make the payments and live in a service plan's area, they're usually eligible for enrollment without health screening.

Your parents can find the names of HMO plans in their area by calling their state's insurance office. Once they enroll in a Medicare HMO, they can **switch back** to Medicare anytime; however, they may not switch back to a Medicare supplement policy they previously had without the insurance company's permission. And, they can be sure the company will review their health record if they do.

Problems with switching back are the reasons that some smart seniors hang on to their Medigap coverage while enrolled in an HMO. Doing so assures continuous coverage under the supplement if they go back to traditional Medicare service.

The other managed care option your parents have is through a program called **Medicare Select**. Basically, this is another form of Medigap insurance sponsored by the federal government. Congress proposed Medicare Select in 1990 as a pilot program for those seniors who wanted some level of choice in where and with whom they could secure health services. Service delivery is in the form of a **Preferred Provider Organization (PPO)** and provides standard Medicare supplement benefits.

If your parents buy a Medicare Select policy, they are buying one of the standard Medicare supplement policies. They can purchase a policy through an insurance company or HMO—but be sure to inquire which policy they are buying. When they enroll in a Medicare Select policy, your parents choose a physician or medical provider from a list provided by the insurance company of "preferred providers." To receive full benefits, they must go to this provider.

If your parents choose to go elsewhere, Medicare Select policies are not required to pay any benefits for non-emergency services.

The Essential Points

When it comes to reviewing your parents' medical coverage, it's easy to be intimidated. The mechanics of Medicare, Medicaid and Medigap coverages can seem impossibly complex. But **focusing on a few essential points** may help make sense of the system:

- If your parents are under 65, the best health care option is usually to keep whatever **group medical insurance** they have at work...or had at the last place they worked. Depending on their health, it may be cheaper to pay for COBRA coverage instead of buying an individual policy.

- If your parents are over 65 and still working, the group policy from work may still be the best coverage. If they aren't working or they can't get coverage at work, **Medicare** (combined with some form of supplemental coverage) will probably be the best health care.

- If your parents are over 65 and haven't applied for Medicare, get them signed up as soon as possible. Depending on how old they are and when they last had health insurance, they may not have coverage for six months.

- If your parents purchase Medigap insurance other than at the time of open enrollment, they will be subject to **medical underwriting**, **physical examinations** and pre-existing condition or other **restrictions**.

- One of the key questions to ask when helping your parents make health insurance decisions is: Will a plan pay for **prescription drugs**? Many plans do not, leaving members to pay one of the biggest expenses out of pocket.

- When your parents are covered by Medicare, it becomes important to know whether their health care provider will accept payment from Medicare as **payment in full**.

- Your parents need to know how to submit medical insurance claims and how to appeal a claim denial.

- The 10 standardized Medicare supplement plans have helped cut through the confusion and provide a clear basis for comparison when you are shopping for the best Medicare supplement policy.

- You should be concerned if your parents are thinking about **replacing existing Medicare supplement coverage** with a new and different policy. It is rarely a good idea. Ask them why they're doing it. And make sure the new policy doesn't have exceptions or exclusions that are worse than the existing policy's.

- The state insurance department or state office on aging can provide you and your parents with information and counseling regarding their decision to purchase or not purchase Medicare supplement insurance.

For more detailed information on Medicare, as well as a variety of other health-related materials, visit the federal government's Medicare Web site at **www.medicare.gov** or call **1.800.633.4227**. This is a helpline that can provide answers to questions about the Medicare plan, managed care plans and private fee-for-service plans. You can also get information about the quality of care and member satisfaction in Medicare managed care plans, such as Medicare HMOs.

Finally, helping your parents with their health coverage means asking them questions and getting to **understand their needs**. Among the questions you should ask:

- What kind of medical conditions do they have that may influence the kind of health plan they need?

- How much *can* they pay for their health care?

- Will they have to pay a lot of out-of-pocket expenses for out-of-network doctors or specialists?

- How will your parents handle these extra costs?

- Are your parents giving up retiree coverage? Is this a mistake?

- Do your parents travel a lot and need to be concerned about out-of-area coverage when they're away from home?

- Do they need a plan for prescription drugs?

- Are they aware of the limits of their coverage and how these might come into play in the future? Are you?

- If they change their existing Medicare plan, will they lose any Medigap or supplemental coverage they might have?

Conclusion

Helping your parents get good health care and medical coverage isn't like shopping for your own health insurance. The main reason: Medicare influences the way that Americans over 65 get medical services (even if they don't use Medicare directly).

In order to help your parents, you need to know the basics about government insurance.

Another reason is that there's more abuse among agents and brokers selling health insurance to older people than among those who sell to the rest of the world. So, you'll need to help your parents be wary of scammers without becoming paranoid of being scammed.

Maintaining the best possible health is the most important aspect of life at any age. Poor health can make an older person's last years miserable. So, medical care is likely to be the place that you start helping your parents...and the place that emotional issues of **privacy, independence and control** first come into play.

In some cases, these issues come to hard point—your parents have serious health or competency problems and someone needs to step into to help clean up the mess.

But, more often, the process is gradual. You're not sure how your parents are doing...and you're not sure it's appropriate to ask. One strategy for handling this situation: Educate yourself on the mechanics. Ask general questions about your parents' health coverage. Offer informed advice for what decisions they might make...and let them ask for more advice or help, as they feel they need it.

2 Long-Term Care, Assisted Living and Nursing Homes

My mom is in great shape, physically. But her mind is gone. She has Alzheimer's—and it's not even in its latest stages yet. But she can't take care of herself anymore. She forgets to eat or bathe. She doesn't recognize us. She'll fall asleep anywhere. And she can get physical if you try to make her go somewhere or do something she doesn't want to. Like I said, she's in really good physical shape. So, we had to move her into a place...a nursing home...where professionals can keep her on a regular schedule. She didn't seem to mind moving, though I'm not sure she even knows where she is. The hardest thing to deal with is that her heart and lungs are strong. She may be in there for 20 years. I'm not sure how we're going to pay for it.

❧

Improvements in medical care mean your parents can expect to be living well into their 80s and 90s. But longer life expectancy has a downside; many older individuals have serious health problems that prevent them from living on their own or completely caring for themselves. If your parents make it into their 80s, **the odds are about 50 percent** that they will suffer from a cognitive impairment or have illnesses requiring long-term care services.

Aging issues are even **harder on women** than men. Since women live four years longer on average than men do, they're more likely to reach the point where they require health care services at home or in a nursing facility. Married women have an additional worry. They often use up their financial resources taking care of a sick husband, leaving them little left in reserve to take care of *themselves* later. This puts them financially at risk when it comes to long-term care.

Other figures bear this out. Women make up 75 percent of all nursing-home residents, 67 percent of elderly home health-care recipients and 73 percent of family caregivers.

The fear of running out of money in old age and becoming a burden to their family is an incentive for your parents to have **long-term care (LTC) insurance**…also sometimes called **nursing home insurance**. That fear is also an incentive insurance agents use to sell their LTC products. But don't let fear *control* your parents' decisions; the fact is that relatively few people spend more than a year in a nursing home or convalescent facility.

Long-term care facilities can be expensive. Insurance industry experts estimate that nursing home costs bankrupt 70 percent of all single people within three months and 50 percent of all couples **within six months** of one spouse being admitted.

Statistically, the likelihood of a person requiring confinement in a nursing home after age 65 is about one in three. At age 75, this likelihood is about one in two. In 2000, the average national annual cost for a person confined to a nursing home was $50,000 per year—with costs in excess of $100,000 per year in expensive areas.

Long-Term Care Insurance

LTC insurance policies pay for extended care arrangements like assisted living facilities and nursing homes. LTC is not covered by

Medicare, Medigap or supplemental insurance policies. Sometimes LTC policies are found as optional coverage in employer-provided or employer-coordinated insurance plans. A **basic LTC policy** covers the cost of a long-term stay **in a nursing home**. It pays for people with severe mental impairment, such as Alzheimer's disease or those who can't handle at least two of their essential physical needs (typically, bathing, dressing, eating, continence and moving around).

Comprehensive LTC policies include coverage **at home**, in **adult day care** and at **assisted-living communities**. They typically cover benefits in the following stages of care:

- **Skilled care**. This is medically required care from certified medical professionals (nurses, therapists, etc.) working under a physician's supervision. This care is provided so that a person can get back to a prior state of health. It can take place in a nursing facility (usually) or in your parents' home (less often).

- **Intermediate care**. This is skilled care supervised by a physician, but isn't required continuously—only intermediately over a set period of time. This can take place in a nursing facility but is more likely to in your parents home.

- **Custodial care**. This is standard nursing home care that many elderly people require towards the end of their lives. It includes help with bathing, dressing and eating.

- **Home health care**. Also known as assisted living, this care is a step down from custodial care—and takes place in your parents' home. It can include assistance with the activities of daily living—housekeeping and routine chores.

Paying in Advance

Unlike Medicare and Medigap, in which premiums are paid for once a person reaches a certain age, long-term care insurance is a

"pay in advance" insurance plan. Usually, people start paying for long-term care insurance **prior to retirement**. This way, your parents may be able to pre-fund some of the cost of long-term care. Because of the high cost of long term care coverage, the sooner your parents start paying premiums, the more cost-effective the insurance will be.

> Depending on your parents' ages, the cost of care in their region, and the features they select—such as a daily benefit that adjusts for inflation—premiums may run from $500 a year if they're in their 40s to $3,000 if they're over 70.

Long-term care policies vary in both **cost and in the benefits they cover**. The following are some of the coverage items and policy features that you will find when pricing long-term care insurance:

- definition of **assisted living facility care**;
- definition of **nursing home care**;
- definition of **hospice care**;
- definition of **in-home care** (such as a visiting nurse);
- maximum coverage **time periods** for each of the above;
- exclusions for **pre-existing conditions**;
- **deductibles**; and
- cost-average adjustments and **indexing for inflation**.

Next, I'll discuss each of these issues—and what they mean to your parents—in detail.

The Myths that Color Many Decisions

Half-truths and myths about LTC and its financing persist. These include:

- the belief that your parents **will never need LTC** services;

- the belief that **home care costs less** than nursing home care (if your parents are really sick, it can cost more);

- the fear that **all nursing homes are terrible**;

- the myth of **no difference in quality** among nursing homes;

- the hope that retirement income, savings and real estate assets will be adequate to cover LTC costs;

- the misconception that Medicare and Medicare Supplementary (Medigap) insurance are significant LTC payers;

Few people understand that Medicare coverage covers only two percent of LTC services and, more importantly, uncovered LTC costs often exceed the costs of acute medical care.

- the hope that the government will pay for LTC, through Medicaid or creation of some new comprehensive program (it's unlikely that any new government program will be created in the near future due to the huge cost associated with any meaningful government program); and

- the myth that private LTC insurance is **not affordable** and the related assumption that, since it is so expensive, any policy with a reasonable price tag has no real value.

One thing's true: The longer your parents wait to purchase a long-term care policy, the more expensive the coverage and greater the chance that a pre-existing condition will disqualify them for coverage or reduce their potential benefits.

The primary **methods people use to cover the costs** associated with nursing home confinement include: personal income and assets; gifts and financial support from family; some local government or social service programs; Medicaid; Medicare; and long-term care insurance.

The **skilled nursing care** provided by Medicare and Medicare supplements is extremely limited. Medicare pays less than 5 percent of the annual nursing home expenses in the United States. To be eligible, a person must be admitted to a nursing home within 30 days of a hospital stay that lasted at least three days; coverage for skilled nursing care is limited to 100 days per calendar year—and there is a **copayment** per day after the first 20 days.[1]

Medicaid, the low-income medical assistance plan run by the states, pays nursing-home bills, but only after your parent has **depleted most of his or her assets**. Many times, a person is admitted to a nursing home because he or she needs custodial care, in which case Medicare pays nothing. All of the person's financial resources are drained—and nursing homes are very good at locating and liquidating assets—and then, when he or she is destitute, Medicaid coverage kicks in.

Medicaid eligibility varies by state, so check with your parents' state's requirements to learn more. You can contact the Medicare Fiscal Intermediary and the State Health Insurance Assistance Program in their state. You can search for the relevant contact information by logging onto *www.medicare.gov* and searching for places in their state.

What LTC Insurance Covers

LTC insurance pays for the kind of care needed for individuals who have a chronic illness or disability. It often covers the cost of custodial nursing care (nursing homes), but also provides coverage for **home-based care**, visiting nurses, chore services and respite care for daily caregivers who need time away from these difficult duties.

LTC insurance usually provides coverage for at least 12 consecutive months for medically necessary diagnostic, preventive, therapeutic, rehabilitative, maintenance or personal care services, provided in

[1] In 2002, that copayment was $101.50 per day for days 21 through 100 per benefit period.

a setting **other than an acute care unit** of a hospital, and includes group and individual policies.

This insurance normally provides a **daily benefit** (usually $50 to $250) following an **elimination period**. The elimination period is usually expressed as 30, 60 or 90 days, and serves as a "time deductible" during which no benefits are provided. Once the elimination period is satisfied and the daily benefits begin, they will be paid for the **benefit period** selected by the policyholder. Typical benefit periods range from one to five years.

Regulatory Uncertainty Poses Risks

LTC insurance is still in an evolutionary stage. In 1980, there were a few standard products offered. By 1990, a variety of products had emerged. There are literally hundreds of individual contracts, with none of the standardization that's part of Medicare supplement policies.

> While it might seem logical for federal regulation of LTC to follow up with Medicare supplement regulation, experts feel the move would be premature. There are two reasons for the hesitation: fewer people buy LTC insurance and the insurance industry is still experimenting with different versions. Product revisions and changes occur with such rapidity that last year's LTC policy is quickly replaced by a new version.

For example, early LTC policies **excluded Alzheimer's disease**. Now, most policies cover this ailment. In addition, early policies usually required a period of prior hospitalization before benefits were triggered. Many current policies do not have such a requirement.

In the early years, the LTC policy was a contract sold only to individuals. Now, LTC coverage is marketed on a group basis, as an employer-sponsored benefit and as a rider to life insurance policies.

Probably the most important advantage to ownership of LTC insurance is **protection of personal assets**. This is insuring against the

risk of liquidating assets and exhausting personal financial resources to pay for a nursing home stay.

Benefit Schedules

LTC policies, even though they are not standardized, contain **similar benefits and provisions**. Occasionally, some of these policies will offer newer or unique benefits or features. The following is a composite of the common benefit features and provisions found in most individual contracts.

Most LTC policies provide a daily benefit during confinement. Benefit amounts range from $50 per day up to $200 or $250 per day. Some insurers may pay all of the actual charges incurred.

> Assume your mother has a LTC policy with a 30-day elimination period, a daily benefit of $150 per day and a two-year benefit period. And, let's say that your mother is confined to a nursing home for a total of seven months.
> Her benefit calculation would be:
> 1) First 30 days: No benefit paid (elimination period)
> 2) Next six months: $150 per day (assumes 30-day month) $150 x 6 x 30 = $27,000
> If your mother's actual charges were more than $150 per day, she'd be responsible for the excess amount.

Most individual LTC policies are **guaranteed renewable**. That is, the insurance company guarantees to renew the policy but reserves the right to increase the premium. A small number of individual LTC policies are **optionally renewable**. The insurer has the option to renew, cancel or increase the premium by class. Eventually, there may be noncancellable LTC contracts where renewability and premium are guaranteed for the life of the policy.

If the premiums are increased, they will be changed on the policy anniversary and the increased premium will apply to an entire class of

policyholders, not a single individual. For example, all policyholders in a given state will have their premiums increased on their respective policy anniversaries.

LTC Preexisting Conditions

All policies will contain a preexisting condition provision of some kind. Most will contain a six-month preexisting condition provision that basically will not provide benefits for any preexisting condition during the first six months that the policy is in force. More liberal policies may state that all preexisting conditions are covered as of the effective date of the policy if the condition is stated on the application.

A *preexisting condition* is usually defined an illness or physical impairment that has required medical treatment or advice within a certain period of time prior to the start of coverage. The specified period of time is usually six months...sometimes it's a year or 18 months. But this period doesn't mean an insurance company has to limit its questions about your parents' health history; it can ask about—and base its underwriting decisions on—their complete history.

One way insurance companies limit their exposure to preexisting conditions is by **reducing the benefit amounts** they offer.

Again, let's say your mother applies for a LTC policy with a daily benefit amount of $150, following a 30-day elimination period. Benefits are payable for up to five years. Your mother indicates on the application that she has several medical problems: high blood pressure, arthritis, borderline diabetes and hardening of the arteries.

Your mother's medical history presents **underwriting problems**. The insurance company may use it to limit the daily benefit it offers your mother. It may approve the policy issue but only for $50 per day in benefits. In essence, the policy is reduced from a total benefit of $273,750 (five years x $150 per day) to $91,250.

Another underwriting approach that could be used for your mother's situation would be to **increase the elimination period** from 30 days to 90 or 100 days. The insurance company could also approve the policy with a **shorter benefit period**.

Whatever the approach, the insurance company will try to limit coverage based on any preexisting conditions your mother has—and on her entire health history.

Prior Hospitalization vs. ADLs

As I mentioned earlier, early LTC policies normally required a period of prior hospitalization before the policyholder would be eligible for benefits. Most of the newer versions of LTC policies **no longer require prior hospitalization** as a condition of benefits. Admission to the nursing home must be because of an accident or sickness and the elimination period must be satisfied.

However, some insurers may offer prior hospitalization as an optional provision to be elected or rejected by your parents. If they elect it, the cost of the LTC policy will be slightly less than a policy without the prior hospitalization provision.

Some of the newer LTC policies base eligibility for admission to a nursing home on the inability to perform some of the **activities of daily living** (ADLs) instead of a particular sickness or injury. Consequently, these contracts don't require prior hospitalization.

For example, if your father is no longer able to perform personal hygiene or is unable to walk or "get around," he would be eligible for admission to a nursing home and payment of policy benefits.

LTC insurance that's triggered by ADL problems is becoming more common every year. This kind of policy is a more liberal approach to the needs for LTC protection due to the fact that it does not require that the policyholder's admission to the nursing home be related to a sickness or injury.

The **recurring** provision found in LTC policies is similar to relapse provisions found in other forms of health insurance. Under this provision, if a parent is released from a nursing home and is readmitted within 180 days of the discharge due to the same or a related condition, the second admission (the relapse) will be considered a **continuation** of the previous nursing home stay.

If 180 days has elapsed since your parent was released from the nursing home facility, a subsequent admission for the same or a related cause will result in **new elimination and benefit periods**.

Spousal Coverage

Often, one spouse is confined to a nursing home and the other spouse remains at home. Since the income and assets of both spouses are considered when determining **eligibility for Medicaid nursing home coverage**, the process of income and asset depletion could—and often did—reduce the stay-at-home spouse to the point of poverty to pay for the confined spouse. To remedy the situation, Congress passed the **Spousal Impoverishment Act**, which protects a portion of the income and assets that a stay-at-home spouse may retain without terminating Medicaid eligibility for a confined spouse.

Before the Act, the healthy spouse would either be driven in poverty or even divorce the ill spouse so that he or she could qualify as a single person. This created a generation of so-called "nursing home widows," who had to take drastic measures to make sure their mates received decent care.

Under Spousal Impoverishment Act, the healthy spouse was allowed to keep some of the couple's joint monthly income (up to a maximum of $1,565 of joint monthly income) and joint assets (a minimum of the first $12,000 of assets, not to exceed to maximum of $60,000 of assets). These amounts are indexed for inflation and increase annually.

The federal law provides a degree of protection for a healthy spouse, but it is **not a substitute for insurance**. Without long-term care insurance, most middle- and upper-class families would still be exposed to a considerable reduction in family resources if an extended stay in a nursing home became necessary.

Assisted Living Facilities

Assisted living facilities provide basic services, including meals, help with medications, bathing and dressing. Usually, they aren't required to have trained personnel on staff, although some do.

There are three basic types of assisted living facilities—**adult family homes**, **community based residential facilities** and **residential care apartment complexes**.

In most states, background checks are conducted on licensees and direct caregivers. They include a criminal background check and a check against the state's caregiver database to ensure the person or facility has not had a finding of abuse or neglect. In addition, each facility must meet specific building code requirements, and program statements must be submitted for approval.

In most cases, the regulations don't spell out specific staffing ratios, and only require that facilities have enough staffers and services **to meet the needs** of their residents. Written care plans are usually required for each resident.

Adult Family Homes

These homes can house as many as four adults. Many times, these are private homes where owners rent out bedrooms and provide supportive services. Recently, corporations have started running these facilities. The homes are run by operators. Most states require no educational requirements for operators. A high school dropout could qualify. In some states, an operator must be at least 21. In some states

a care provider must complete some minimum training requirements, including fire safety and first aid. Additional requirements may include health and safety training.

Community-Based Residential Facilities

These facilities can house up to 200 adults. Some have **private apartments**, and others have separate **resident bedrooms with a common living area**. Residents generally can choose from a package of basic services, such as meals and activities, which is included in their rent. Additional services will require increased fees. Facilities are run by administrators who in many states are required to be at least 21 years old and a high school graduate. Often, they are required to have administrative experience or one university-level course in business management. Lastly, they need to have one year of experience with the type of clients being served, or one university-level course relating to the needs of the client group.

Residential Care Apartment Complexes

These are buildings with individual apartments. Unlike the other options, residents must be mentally competent when admitted and able to sign a **risk agreement** that spells out potential problems and a **service agreement** that specifies what services will be provided. Fees are set based on the services that are provided.

Typically, nursing oversight is required for caregivers who pass out medications. A service manager is responsible for day-to-day operations.

Underwriting LTC Insurance

LTC policies will contain some exclusions or limitations. Common exclusions include: war or act of war, intentionally self-inflicted

injuries, losses covered by workers' compensation or other government programs and losses due to personality disorders that are not subject to a physical or organic disease. Mental or personality disorders resulting from an illness or accident are covered, including Alzheimer's disease.

Long-term care underwriting is concerned with some of the same factors as health insurance underwriting—but there are some differences in the kinds of conditions that cause problems.

> **A person who has a heart condition that could require surgery might not be a good candidate for health insurance, but might be accepted for LTC insurance because the condition would probably not result in a nursing home stay.**

Your parents will be asked questions about their health when applying for coverage. Some companies use a **short form,** which only asks if the applicant has been hospitalized in the last 12 months or if he/she is confined to a wheelchair. If the answer is "no," the policy will usually be issued on the spot.

It's important that these health questions be answered truthfully. If the insurance company later finds out your parents lied about their health, it can **cancel the policy and return the premiums** paid, leaving your parents with no coverage. The insurance company can usually do this within two years after a policy is issued.

Additional or **detailed medical information** may be obtained from your parents by an additional questionnaire or from their doctor through an Attending Physician's Statement sent by the insurance company (with your parents' permission). However, applicants for LTC insurance are **rarely required to take a physical** exam.

Once the underwriting information is gathered, the underwriter will basically classify the person as a standard or substandard risk. Accordingly, if the applicant is a standard risk, he or she will pay the standard rate or premium for the policy. Substandard risks may have

to pay an extra premium for the policy, have a policy issued with a rider omitting some element of the coverage or they may be declined.

Better Information Means Better Rates

Price is often cited as a reason not to buy LTC insurance. This argument is often made politically to advocate universal LTC coverage. However, it also has to be acknowledged that LTC often costs less than private medical insurance. The amount of coverage may be geared to a person's budget and strategy. The younger a person is, the more affordable the coverage.

The pricing of LTC coverage depends on several actuarial assumptions: **mortality**; **persistency** (the length of time a policy remains in force without lapsing); investment return earned by the insurance company; expenses of marketing, regulatory compliance, and operations, **morbidity** (i.e., the length of time benefits are paid); a state required minimum loss-reserve ratio; a company's underwriting standards and experience; and finally product profitability.

During the 1980s, standard LTC premiums decreased as a result of better and more reliable risk information. Considering these actuarial factors, it is possible to understand the favorable cost benefit values and pricing of LTC. A high percentage of individuals will either die or lapse their policies.

Policy Restrictions

Many of the recent *second generation* LTC policies have been greatly improved with standard provisions, home care benefits and valuable, affordable coverage. However, enough **restrictions still apply** that many old people don't qualify or aren't able to afford more than a minimum level for Medicaid strategy purposes. If your parents are past age 79, the odds are that any available LTC policy will be so limited and restricted that it's often not cost effective.

One study—published by the United Seniors Health Cooperative—showed that 82 percent of long-term care policies contained clauses that **seriously restrict coverage**. The most important places to look for these restrictions: **Terms and conditions** of coverage for skilled, intermediate and custodial care.

Policies that require a hospitalization or require a skilled level of care **before they pay for custodial care**, for example, won't work for many people.

Group LTC Policies and Other Options

In the 1990s and 2000s, **group LTC contracts** have begun to appear—as well as LTC benefits attached to new or existing life insurance in the form of policy riders.

> Typically, group health insurance is written for employer-employee situations, professional associations and trade unions. Eligibility for participation in these group health plans is often restricted to employees and their dependents.

Many employer group LTC contracts marketed today provide the following participation eligibility: the employee and spouse; parents of both the employee and the spouse; retired employees and their spouses. Premiums can be paid through payroll reductions, just like other employee benefits.

This is a liberal benefit, in that it not only covers the employee and his spouse but reaches out to provide **coverage for an older generation**—as well as retired workers and their spouses. These older people may not be insurable on their own.

Employers can usually offer LTC coverage to their employees on a group basis with **little cost** other than adding the premium deduction to their payroll systems. The standard benefits offered under group contracts are similar to those offered as individual policies. Benefits

typically offered include skilled nursing care, intermediate care, custodial care and home health care.

Hospice care may also be provided by the group policy as a standard or optional benefit. Another optional policy benefit is adult day care that provides a functionally impaired adult with a daytime environment of social as well as certain functional activities. Adult day care usually includes transportation to the day care facility, at least one meal and certain vocational or recreational activities.

Most group contracts provide that benefits will be paid based on one or more of the following criteria: the policyholder **has been hospitalized** for a period of time (usually three days) due to an accident or illness and, as a result, it becomes necessary to put him or her in a nursing home; the policyholder has to go to a nursing home due to an accident or illness **without prior hospitalization**; the person is **unable to perform some of the activities of daily living**.

Most group contracts are on an indemnity basis as opposed to an expense-incurred basis. This means that the coverage doesn't require your parents to pay bills first and then be reimbursed. Daily benefits range from $50 to $150.

Elimination periods under group contracts range from 10 to 100 days and the benefit periods are usually three to five years in length. Typically, the group elimination period seems to fall between 30 and 90 days with at least a three-year benefit period.

LTC Applications

Applications for long-term care insurance (except guaranteed issue LTC insurance) must contain **clear, simple questions** designed to ascertain your health condition. Questions must contain only one inquiry each and require only a "yes" or "no" answer (except for names of physicians and prescribed medications).

Many states require the application to include the warning: *If your answers on this application are misstated or untrue, the insurer may have the right to deny benefits or rescind your coverage.*

If the insurance company does not complete medical underwriting and resolve all reasonable questions on the application before issuing the policy, it may only rescind the policy or deny a claim on clear evidence of fraud or material misrepresentation. The fraud must pertain to the condition for which benefits are sought, involve a chronic condition or involve dates of treatment before the date of application and be material to the acceptance for coverage.

> **The contestability period is usually two years. Some states require insurers to maintain records of all policy rescissions and annually report them to the insurance department.**

Disclosure Requirements

An **outline of coverage** must be delivered at the time your parents apply for group LTC insurance. (For direct-response solicitations, the outline of coverage must be delivered at their request—but no later than at the time of policy delivery.) The outline must include a description of the **principal benefits** and coverage provided, a statement of the **principal exclusions**, **reductions and limitations** of the policy, its **renewal provisions** and a description of your parents' rights regarding continuation, conversion and replacement.

The outline of coverage must state that it is a summary of the policy only, and the complete policy should be consulted to determine governing **contractual provisions**.

Prohibited Provisions

Many states have passed LTC regulations based on NAIC (National Association of Insurance Commissioners) model laws. These

model laws prohibit certain provisions from being included in long-term care insurance policies.

> **LTC policies may not be canceled, nonrenewed or otherwise terminated on grounds of age or deterioration of mental or physical health. Benefits policies may not provide coverage for skilled nursing care only, or provide more coverage for skilled care in a facility than for lower levels of care.**

No LTC insurance benefits may be reduced because of out-of-pocket expenditures made by your parents or by someone else on their behalf. Although the provisions differ slightly from state to state, the most common **consumer protections** are summarized below.

Special Provisions

The amount of daily/annual benefit coverage, years of coverage, amount of home care coverage, waiting period before benefit begins and inflation rider options also vary by contract.

Home care coverage is usually available at the 50 percent, 80 percent or 100 percent level of the base nursing home-care coverage. This is the most important variable area. If home care is a priority, it is important to factor the different level of home care coverage into any comparison of premiums between different company proposals. A home-care rider has an incremental cost for the extra years purchased for this purpose, which amounts to about 30 percent of the base nursing home cost.

As in health and disability insurance, LTC claims can be paid on either a **reimbursement** or an **indemnity** basis. In a reimbursement policy, an insurance company reimburses a licensed agency for custodial aid services or a nursing home up to but not more than a policy benefit limit. In an indemnity policy, the full coverage is paid directly to the policyholder.

The specific definition of **activities of daily living** varies from policy to policy, but—as I mentioned before—inability to perform two or more ADLs is the usual qualification for LTC benefits. Contracts also vary slightly on extra areas such as **respite care or day care**, reimbursement for certain **home equipment**, starting time period for a **waiver of premium payments** and **waiting time periods** after an interruption in LTC services.

Nonforfeiture Provisions

Nonforfeiture provisions return some of your parents' investment if they drop their coverage. These provisions became a big selling point for LTC insurance in the 1990s. Without them, LTC insurance provides no recovery for the policyholder who lapses the policy or— more commonly—who dies without having needed LTC benefits. If your parents cancel coverage or die suddenly after 10 or 20 years and never use any of policy benefits, their loss could be significant.

Standard nonforfeiture options in LTC insurance include:

- **Cash Surrender Value**. A guaranteed sum is paid to the policyholder upon surrender or lapsing of the policy. This sum is generally equal to some portion or percentage of the insurer's policy reserve at the time premiums cease.

- **Reduced Paid Up**. A lesser or reduced amount of daily benefit payable for the maximum length of the policy's benefit period with no further premium payments required.

- **Extended Term**. A limited extension of insurance coverage for the full amount of the policy benefits without any further premium payments, for a limited period of time only. The reduced paid up and extended term options are paid from the policy's cash value. These are fairly standard and are very similar to the nonforfeiture options found in permanent life insurance policies.

- **Return of Premium**. A lump sum cash payment equal to some percentage (60 percent, 80 percent, etc.) of the total premiums paid is paid to the policyholder upon lapsing or surrendering the policy. Normally, any claims previously paid would be deducted from the return.

Some LTC insurance companies have been accused of "predatory pricing"—keeping initial premiums low but increasing them dramatically, "squeezing out" policyholders who cannot afford the premium payments and allow the policies to lapse.

In a similar context, policies sold **without an inflation protection** provision could leave your parents with inadequate coverage years later, when they make a claim.

Some insurers argue that nonforfeiture values were not contemplated when premium rates were developed, and that adding nonforfeiture provisions to long-term care policies will **increase premiums** up to 100 percent. Others have shrugged off these claims and make nonforfeiture values a selling point.

Termination of Coverage

If LTC insurance is terminated, any benefits payable for institutionalization that began while the insurance was in force must continue **without interruption after termination**. This extension of benefits may be limited to the duration of the benefit period, if any, or to payment of a maximum benefit, and may be subject to any policy waiting period and all other applicable provisions of the policy.

As I've mentioned, applications for LTC insurance usually contain questions designed to determine your parents' health status. They may be asked whether they've had medication prescribed by a physician—and to list the medications. If the medications listed are directly related to a medical condition for which coverage would otherwise be denied, and the policy or certificate is issued, it may not be later rescinded for that condition.

Companies are generally prohibited from **post-claims underwriting**, which means investigating medical records only *after* your parents enter the nursing home.

That said, some insurance companies will attempt to deny benefits based on inconsistencies in an application. If they reject your parents' claims, your parents will get their premiums back—but by then it's usually too late to get coverage elsewhere.

The best time to clear up any information on the application is *before* your parents make a claim.

Consumer Protections

Like Medigap insurance, long-term care policies are regulated by state insurance departments. Consumer protections that have been implemented at the state level include rules for **full and fair disclosure** of LTC insurance terms and benefits, including:

- terms of renewability;

- conditions of eligibility;

- nonduplication of coverage;

- termination of coverage;

- probationary periods;

- limitations, exceptions and reductions;

- elimination periods; and

- recurrent or pre-existing conditions.

Other common rules, designed to protect LTC insurance buyers, include:

- Riders or endorsements that **reduce or eliminate benefits** usually require the signed acceptance of your parents (unless they requested the change in the first place). Riders or endorsements that increase benefits and increase the

premium must also be accepted in writing—unless the change is required by law.

- Limitations on **preexisting conditions** must be set forth in a separate paragraph on the first page of the policy and clearly labeled. Any **limitations or conditions for eligibility** must be set forth as a separate paragraph and labeled "Limitations or Conditions on Eligibility for Benefits."

- Insurers must display prominently on the policy and the outline of coverage a statement that resembles the following notice:

 This policy may not cover all of the costs associated with long-term care incurred by the buyer during the period of coverage. The buyer is advised to review carefully all policy limitations.

- Insurers must make **every reasonable effort** to discover whether an applicant already has LTC insurance, and the type and amounts of such insurance.

If your parents already have a long-term care policy and want better benefits, they might try to enhance their existing policy with **additional riders** (it might be cheaper to do this than to buy a new policy). Or, they can **replace their policy** with a new one. This might make sense if they have an older policy with requirements for prior hospitalization and if they are in good enough health to qualify.

As with Medigap insurance, there's a lot of abuse in the selling of LTC insurance. Some unnecessary replacement LTC policies are sold. If your parents are replacing theirs, be sure their application for the new policy is accepted before they cancel the old policy. When they switch policies, pre-existing condition restrictions will usually apply and they may not have coverage for a period of time.

State laws prohibit brokers and agents from persuading anyone to replace an LTC policy unnecessarily, especially when the replacement causes a decrease in benefits or an increase in premium. Some states set a standard—such as **three or more policies** sold to a person in **one 12-month period**—as being *presumed* unnecessary.

Long-term care insurance application forms must include a question about whether the proposed insurance is intended to replace any existing LTC coverage. If a sale involves a replacement, the insurance company is required to furnish the applicant with a **notice regarding replacement of long-term care insurance**.

Except when the replacement coverage is group insurance, the **replacement notice** must include a statement signed by the agent documenting that, to the best of the agent's knowledge, the replacement coverage **materially improves the policyholder's position**. The statement must also include the specific reasons the agent is making this recommendation.

If existing coverage is converted to or replaced by a new form of LTC insurance **with the same company** (except for an increase in benefits voluntarily selected by the policyholder) the insurance company may not establish any new waiting periods.

Insurance companies offering LTC coverage must establish marketing procedures to assure that **comparisons of policies are fair and accurate** and that excessive insurance is not issued.

Should Your Parents Buy LTC Insurance?

Not everyone over 65 is necessarily a candidate for LTC insurance. Insurance companies and agents have been criticized for selling LTC coverage to people who do not need it—either because they can't afford it or because they don't have enough assets to protect.

If your parents are having trouble meeting their other financial obligations—utilities, food and medicine—they probably don't need LTC insurance. If their sole source of income is a relatively small pen-

sion and they have minimal financial assets, they may already be eligible for **Medicaid reimbursement of LTC expenses**.

One rule of thumb for whether your parents need LTC insurance: If they have enough wealth that they may have to pay estate taxes—and they don't want that money going to a nursing home—they should have LTC coverage.

In 2003, estates will be taxed at the federal level if they're worth more than $1 million. So, if your parents' estate (including all cash, investments, real estate and other assets not transferred to a trust or other vehicle) is worth more than $1 million, you can argue that they need LTC insurance. If they're within 20 percent of that number, they *may* need it. **If they're way below half, they probably don't need it** because they don't have an insurable risk (meaning enough money to make the LTC insurance premiums worth paying).

There's another way to look at LTC insurance. If your parents have a lot of money—an estate worth substantially more than $1 million—they might be able to pay any nursing home costs out of their pockets without much worry. This is the "self-insurance" argument.

Self-insurance makes sense sometimes because LTC policies have strict **maximum coverage limits**. Once those limits are reached, Medicaid is supposed to take over. If your parents buy a policy, use it to its maximum and then have too much money to qualify for Medicaid, they are going to have to pay out of their pockets, anyway.

The pricing models of nursing homes are designed to eat up old people's wealth. In most cases, the homes will have various **rate schedules**. These usually include:

- a monthly rate for patients paying **cash**;

- a monthly rate for patients who have **LTC coverage**; and

- a special rate that combines some form of **lump-sum payment** with a smaller, monthly maintenance fee.

The last option is usually designed to wipe out the patient, financially and then sustain care on Medicaid's relatively small LTC allowance. Depending on the facility, that lump-sum payment (also sometimes called a *contribution, endowment* or *honorarium*) can be several hundred thousand dollars.

If your parents have some money—but aren't billionaires—LTC insurance can provide cost-effective protection. Assume that your 65-year-old mother buys an LTC policy, paying a level premium of $1,900 for 15 years. At age 80 (the average age at which LTC services are required), she will have paid $28,500 in premiums for $500,000 worth of home-care and nursing home benefits. This results in a 17.5-to-1 **value ratio**.

What other investment might your mother consider with a return of better than 15-to-1? Of course, if she reaches age 80 and hasn't used the insurance yet, the value ratio begins to go down. But it's hard to complain if she gets to 80 and is still in good health.

The high value ratio of LTC insurance takes away some of the economic argument for self-insurance. LTC policies become more cost-effective as the benefit increases. So, if your parents buy LTC coverage at all, they should buy enough to protect their entire estate.

One caveat about LTC coverage: Unlike life insurance, LTC insurance doesn't usually reward your parents for buying early.

Most insurers offer policies beginning at age 50 (a few, as low as age 40). Most policies are guaranteed renewable but the **premium is not guaranteed**; this means it can go up each time the policy is renewed. So, if your mother buys a LTC policy when she's 50, she'll get a low premium. But, when she renews at age 65, the rate will increase—and she might have trouble paying it when she's 66.

Insurance companies defend the rising premiums as actuarially necessary and point out that the 10- to 15-year terms of most LTC policies give people time to budget for the increasing expense.

Shopping for LTC Insurance

If your parents need a long-term care policy, a good way to begin is to assemble information on the types of long-term care services and facilities they might use and find out how much each costs.

Shopping for LTC insurance can be difficult because the plans have not been standardized like Medigap policies. So, there's more pressure on your parents to read policies and compare the benefits they provide, the premiums they charge, the limitations and exclusions on coverage and the types of facilities covered.

A few common sense tips to give your parents:

- Don't buy a policy on the first interview—no matter how pushy the agent is.

- If an agent can't provide a policy or, at least, an outline of coverage, find a new agent.

- Always read over a form before you sign. If the agent fills out the form for you, read it carefully before you sign.

- Don't sign a form with incorrect information on it and **never sign a blank form**.

- Take your time reading through the policy or outline of coverage and ask questions. If the agent can't answer your questions, try the insurance company's home office.

- Contact your state insurance department or state insurance counseling program if it has one.

- **Never pay an agent in cash.** Write a check payable to the insurance company, write the policy number on the check and get a receipt.

- Be sure you get the name, address and telephone number of both the agent and the insurance company.

Your parents should receive their executed policy within 30 to 60 days. When they do, advise them to put it in a safe place and tell someone they trust where it can be found when needed.

Your parents usually have 30 days after purchasing a long-term care policy to make sure it's the one they want. If they decide they don't want it, they can cancel it and get their money back. In order to do this, they will probably need to send the policy and a letter requesting a refund to the insurance company. And they should send this by certified mail, postmarked within 30 days of the purchase date.

The most restrictive LTC policies cover **only skilled care** (care ordered by a doctor and given by a registered or practical nurse). This limitation excludes the typical nursing home patient, who doesn't need constant medical attention, yet is unable to take care of himself.

More liberal policies require only that the policyholder be unable to perform certain **activities of daily living**—eating, dressing or moving around—before claims will be paid. But insurance companies can define these activities in a way that makes collecting difficult.

Make sure your parents' policy covers **cognitive as well as physical impairments**. Other tips to remember:

- Try to buy a policy that covers care at home as well as in an institution. Home care coverage may allow your parents to stay out of a nursing home altogether.

- Make sure the policy keeps up with inflation. Assume your dad is 60 and will go into a nursing home when he's 80. If costs climb at 7 percent a year, today's $50,000-a-year home will charge $195,000 a year when he needs it. A policy allowing for up to **five percent a year in benefit escalation** is typical—though it may cost more each month.

- Pay attention to the cancellation and termination language in the LTC policy. In some states, insurance companies may **cancel at any time**, thus robbing the policyholder of equity he thought he was building up with his premiums.

- If your parents' policy is guaranteed renewable, their premiums can't be raised selectively. But their insurance company can **raise rates** across the board for all policyholders—or for everyone in a single state or single age group.

- Make sure your parents fill out the application **completely and accurately**. Otherwise, the insurance company may take their money for years, then decide after they enter a nursing home that they don't qualify for coverage—because of some medical problem they failed to disclose.

Since long-term care policies haven't been around for very long, the insurance industry underwriting is being done on what amounts to speculation. Insurance companies are constantly improving on their LTC policies and, in many cases, lowering rates. **Good ones let their policyholders gain from these improvements.** When Massachusetts-based John Hancock introduced a new version of its nursing home insurance, it allowed all existing policyholders under age 80 to upgrade (with some limits), without evidence of health.

Conclusion: A Long-Term Care Checklist

Following is a checklist of questions that your parents should consider and a reputable agent should be prepared to answer.

☐ Does the policy provide benefits for the following and, if so, how long will benefits be provided?

- skilled nursing care?
- intermediate care?
- custodial care?
- home health care?

- ☐ What is the daily benefit for each level of care?

- ☐ Does the policy have a maximum benefit amount expressed in dollars or time?

- ☐ What is the maximum benefit or coverage limit?

- ☐ Does the policy contain nonforfeiture provisions?

- ☐ Does the policy contain any optional policy benefits?

- ☐ How long is the elimination period?

- ☐ Does the policy require prior hospitalization? If so, how long?

- ☐ Does the policy base benefits on the ability to perform the activities of daily living? If so, what are those activities?

- ☐ Does the policy provide purely custodial care?

- ☐ Is there a waiver of premium provision?

- ☐ What are the policy's exclusions?

- ☐ Does the policy cover Alzheimer's disease?

- ☐ Does the policy cover preexisting conditions? If so, when?

Your parents are entitled to know the answers to these questions. This, in turn, requires that the customer service representative, agent or broker be well educated in the various policy provisions and benefits. That education suggests—though nothing guarantees—that the coverage will be in place when your parents need it.

Essentially, LTC insurance covers the cost of your parents' time in a nursing home. In some places, the coverage is even called nursing home insurance. Since the **pricing schedules of nursing homes are often designed** to use up your parents' financial resources and then maintain them on government benefits, middle-class and wealthier parents may need the protection.

3　Hospice Care

There's nothing harder than watching your mom or dad die a long, excruciating death. My dad's cancer had him in and out of treatment so much that I didn't know when the madness would stop or when either the cancer—or treatment—would take him. When we decided to stop chemo and radiation, it was time for hospice. I couldn't take care of him myself, the rest of the family lived far away...and the hospital would no longer admit him. I needed to find a place for him to peacefully endure what life he had left; he needed constant attention, continual meds and a good place to die. So he wouldn't be alone.

❧

It's hard to face reality when a parent has an illness you know may be his or her final one. Caring for a terminal illness is not something most laypeople are prepared to do; and it's even harder when the dying person is your parent.

Hospice care can help you and your parents deal with this difficult process. In this chapter, we'll outline how hospice care works and how you can make it work for your family during an often difficult time. When one or both of your parents are in their final stages of their lives, you'll want them to be in the most comfortable environment

possible—a place where they can live out the rest of their lives with minimal pain. This is what hospice care provides.

What Is Hospice Care?

Hospice is a comprehensive regimen of care to both patients and families facing a life-ending illness. It's a specific way of caring for a patient whose disease cannot be cured. Hospice is a care concept, not a specific place or facility. The concept originated over 500 years ago as a way for the sick and dying to find final rest and comfort.

Because hospice care only treats terminal cases, there is **no attempt to cure** the patient. Hospice care maximizes the remaining quality of life rather than quantity of life. The dying are comforted, medical care is provided and symptom relief is given. The patient and family are both included in the care plan and emotional, spiritual and practical support is given based on the patient's wishes and family's needs. Trained volunteers can offer respite care for family members as well as support to the patient.

Hospice care affirms life by treating dying as a normal process. It neither accelerates nor postpones death. Hospice provides personalized services and a caring community so that patients and families can attain the necessary preparation for a death that is satisfactory to them.

Those involved in the process of dying have a variety of physical, spiritual, emotional and social needs. The nature of dying is so unique that the goal of the hospice team is to be sensitive and responsive to the special requirements of each individual and family.

Hospice care is provided to anyone who has a **limited life expectancy**. Although most hospice patients have cancer, hospices usually accept anyone regardless of age or illness. These patients have made a decision to spend their last months in a homelike setting.

Hospice care is provided through a medically directed team. This team typically includes a physician, a nurse, a home health aide, a social worker, a chaplain and a volunteer.

- The hospice nurse makes regularly scheduled visits to the patient providing pain management and symptom control techniques. While the patient is under the care of hospice, the nurse keeps the primary physician informed of the patient's condition. Nurses provide skilled care and are available 24 hours a day, seven days a week.

- Home health aides provide assistance with the personal care of the patient.

- Social workers provide assistance with practical and financial concerns as well as emotional support and counseling. They evaluate the need for volunteers and other support services for the family and facilitate communication between the family and community agencies.

- Chaplains provide spiritual support to patients and families, often serving as a liaison between them and their religious community. Chaplains often assist with memorial services and funeral arrangements.

Finding a Hospice Center

Finding a program that meets your parents' needs may take some research, but it will be time well spent. You must consider the quality of care, availability of needed services, personnel training and expertise and medical services available. Here are several ways to start your search:

- **Local resources**. Your physician or hospital discharge planner can help you locate hospices in your area. Hospice care providers also are listed in the Yellow Pages or other

phone directory. Your community may have information and referral services available through your American Cancer Society, an Agency on Aging, United Way chapter, Visiting Nurse Association or your place of worship.

- **State level**. You may contact your state's departments of health or social services to obtain a list of licensed agencies or contact the state hospice organization. State health departments oversee certification of hospice services. Certification makes them eligible for Medicare and, in some states, Medicaid payments.

- **Internet resources**. Information about local hospices serving your area may be available on various Internet sites. You'll have to search the Web (basic search engines should do) for ones near you.

Common Hospice Concerns

One of the biggest worries related to hospice care is **when a family member should enter** a hospice program. At any time during a life-limiting illness, it's appropriate to discuss all of a patient's care options, including hospice.

By law, the decision belongs to the patient; but family members are often involved. Understandably, most people are uncomfortable with the idea of stopping aggressive efforts to "beat" an illness. Hospice staff members are trained to deal with these issues and are always available to discuss them with you and your family.

You don't have to wait until a doctor suggests hospice care for your parent. Feel free to discuss the prospect with the doctor at any time—even if you don't think your parent or parents need that kind of care yet. It's usually good to address the issue before you get to the point of hashing out the mechanics. You can include others in this talk, such as other health care professionals, clergy and friends.

If your family's physician doesn't know enough about hospice or the available programs for your parents, there are many other avenues to explore. Most physicians know about hospice, however. Ultimately, it's up to you to obtain the information and use your physician as an alternate resource.

> Information about hospice is available from the National Council of Hospice Professionals Physician Section, state hospice organizations or the National Hospice Helpline at 1.800.658.8898. You can also obtain information on hospice from the American Cancer Society, the American Association of Retired Persons and the Social Security Administration.

Many people wonder what happens when a patient shows signs of recovery and no longer needs hospice care. In the case of aging parents, this isn't common—but, if your mom looks as though she can benefit from regular medical treatment (that is, in a hospital) or be at home, you can **discharge her from hospice**. If she should later need to return to hospice care, Medicare and most private insurance will allow additional coverage for this purpose.

Admissions to Hospice

One of the first things the hospice program will do is contact your parent's physician to make sure he or she agrees that hospice care is appropriate for this patient at this time. (Most hospices have medical staff available to help patients who have no physician.)

Your parent—or you, if you have power of attorney[1]—will be asked to sign consent and insurance forms. These are similar to the forms patients sign when they enter a hospital. The so-called "hospice election form" says that the patient understands that the care is **palliative** (that is, aimed at pain relief and symptom control) rather than curative. It also outlines the services available.

1. Power of attorney and related issues are discussed in detail in Chapter 11.

The form Medicare patients sign also tells how electing the Medicare hospice benefit affects other Medicare coverage.

The hospice provider will assess your parent's needs, recommend any equipment and help make arrangements to obtain any necessary equipment. Often the need for equipment is minimal at first and increases as the disease progresses. In general, hospice will assist in any way it can to make the care as convenient and safe as possible.

Although there is no magic number for knowing how many people—besides yourself—that you'll need to make hospice work best, one of the first things a hospice team will do is prepare **an individualized care plan**. This plan will address the amount of caregiving needed by your mom or dad. Hospice staff visit regularly to answer medical questions, provide support and teach caregivers.

In the early weeks of care, it's usually not necessary for someone to be with the patient all the time. Later, however, since one of the most common patient fears is the **fear of dying alone**, hospice generally recommends someone be there continuously. While family and friends may deliver most of the care, hospices provide volunteers to assist with errands and to provide a time away for primary caregivers.

The Difficulties of Caring for the Dying

Once you've made the decision to use hospice care…and allow your mom or dad to pass while in the comforts of their own home…you'll face new challenges every day leading up to their actual death. At the end of a long, progressive illness, **nights especially can be long**, lonely and scary. Because of this, hospices have staff available around the clock to consult by phone with the family and make night visits if appropriate.

Hospice can also provide trained volunteers to provide "respite care," to give family members a break and/or provide companionship to the patient.

You can't underestimate how hard caring for a loved one on that final path can be on you. Make sure you have plenty of extra support from friends and other family members and don't underutilize those hospice workers. It should be a team effort.

Also keep in mind that hospice isn't there to make a death come sooner…or later. Just as doctors and midwives lend support and expertise during the time of child birth, hospice provides its presence and specialized knowledge during the dying process.

> **Although 90 percent of hospice patient time is spent in a personal residence, some patients live in nursing homes or hospice centers.**

Managing Pain

One of the largest jobs of hospice care is **managing pain**. Tending to a patient in a great deal of pain can be hard to see and deal with. If, for example, your dad is dying of terminal cancer and you have to help manage his bouts of intermittent pain, it can be hard to witness and manage effectively for the simple fact that he's your father.

Hospice believes that **emotional and spiritual pain** are just as real and in need of attention as physical pain, so it can address each. Hospice nurses and doctors are up to date on the latest medications and devices for pain and symptom relief. In addition, physical and occupational therapists can assist your parents to be as mobile and self sufficient as they wish, and they are often joined by specialists schooled in music therapy, art therapy, massage and diet counseling. Also, various counselors, including clergy, are available to assist family members as well as your parents.

Attaining a level of comfort that is acceptable to you and your dying parent is the goal. If your other parent is relatively healthy and part of the caring, your role as a child may be even more important as the primary decision-maker. It may be too difficult for your other par-

ent to handle the caring, the witnessing and the decision-making. You will most likely find yourself having to handle the emotions of your healthy parent amid all the activity. It's important to realize that the success rate of hospice in battling pain is high. Hospice excels in using the best combination of medications, counseling and therapies for making your patients reach a comfort zone.

Having said that, it's also important to note that an additional goal is to have the patient as alert as possible. Finding the balance between pain and comfort, as well as being able to walk and talk, is the ultimate goal for hospice. This usually is accomplished by constant consultation—of which you'll play a very important part.

Hospice and Medicare

Hospice coverage is widely available. It's provided by Medicare nationwide, by Medicaid in 39 states and by most private insurance providers. If your parent is not covered by Medicare or any other health insurance, the first thing hospice will do is assist you and your parents in finding out whether he or she is eligible for any coverage they may not be aware of. Barring this, most hospices will provide for anyone who cannot pay using money raised from the community or from memorial or foundation gifts.

For those covered by Medicare, hospice is available as a benefit under Medicare Hospital Insurance (Part A). Medicare beneficiaries who choose hospice care receive non-curative medical and support services for their terminal illness.

To be eligible, they must be certified by a physician to be terminally ill with a life expectancy of six months or less. While they no longer receive treatment toward a cure, they require close medical and supportive care that a hospice can provide. Hospice care under Medicare includes both home care and inpatient care, when needed, and a variety of services not otherwise covered by Medicare.

> Hospice focuses on care, not cure. Emphasis is on helping the person to make the most of each hour and each day of remaining life by providing comfort and relief from pain.

Medicare considers hospice a program of care delivered in a person's home by an approved provider. Reasonable and necessary medical services are furnished under a plan of care established by the beneficiary's physician and hospice team. Specifically, Medicare covers the following expenses under its version of hospice care:

- physicians' services;

- nursing care (intermittent with 24-hour on call);

- medical appliances related to the terminal illness;

- outpatient drugs for symptom management and pain relief;

- short-term acute inpatient care, including respite care;

- home health aide and homemaker services;

- physical therapy, occupational therapy and speech/language pathology services;

- medical social services; and

- counseling, including dietary and spiritual counseling.

That said, hospice care is available under Medicare only if:

- The patient is eligible for Medicare Hospital Insurance (Part A);

- The patient's doctor and the hospice medical director certify that the patient is terminally ill with six months or less to live if the disease runs its expected course.

- The patient signs a statement choosing hospice care instead of standard Medicare benefits for the terminal illness; and

- The patient receives care from a Medicare-approved hospice program.

Hospice care can be provided by an agency or organization that is primarily engaged in furnishing services to terminally ill individuals and their families. To receive Medicare payment, the agency or organization must be approved by Medicare to provide hospice services.

Approval for hospice is required even if the provider is already approved by Medicare to provide other services. Patients can find out whether a hospice program is approved by Medicare by asking their physician or checking with the organization offering the program. This information also is available from local Social Security offices.

Duration of Hospice Care Coverage

Special benefit periods apply to hospice care. A Medicare beneficiary may elect to receive hospice care for two 90-day periods, followed by an unlimited number of 60-day periods. The benefit periods may be used consecutively or at intervals. Regardless of how these periods are used, your parents must be certified as terminally ill at the beginning of each time period.

A patient may change hospice programs once each benefit period. A patient also has the right to cancel hospice care at any time and return to standard Medicare coverage, then reelect the hospice benefit in the next benefit period. If a patient cancels during one of the first three benefit periods, any days left in that period are lost.

Payments Made by Your Parents

Medicare pays the hospice directly at specified rates depending on the type of care given each day. The patient is responsible for:

Drugs: The hospice can charge 5 percent of the reasonable cost, up to a maximum of $5, for each prescription for outpatient drugs for pain relief and symptom management related to the terminal illness.

Inpatient Respite Care: The hospice may periodically arrange for inpatient care for the patient to give temporary relief to the person who regularly provides care in the home. Respite care is limited each time to a stay of no more then five days. The charge (currently 5 percent), which is subject to change annually, varies slightly depending on where your parents live.

When Medicare beneficiaries choose hospice care, they give up the right to standard Medicare benefits only for treatment of the terminal illness. If the patient, who must have Part A in order to use the Medicare hospice benefit, also has Medicare Part B, he or she can use all appropriate Medicare Part A and Part B benefits for the treatment of health problems unrelated to the terminal illness. When standard benefits are used, the patient is responsible for Medicare's deductible and coinsurance amounts.

What Benefits Are Not Covered

All services required for treatment of a terminal illness must be provided by or through the hospice. When a Medicare beneficiary chooses hospice care, Medicare will not pay for:

- Treatment for the terminal illness that is not for symptom management and pain control;

- Care given by another health care provider that was not arranged for by the patient's hospice; and

- Care from another provider that duplicates care the hospice is required to provide.

To determine whether a Medicare-approved hospice program is available in your parents' area, contact the nearest Social Security Administration office, their state or local health department or their state hospice organization. You can always surf the Medicare Web site for more information at www.medicare.gov. The site can provide you with useful links to local information and departments.

> Hospice provides continuing contact and support for caregivers for at least a year following the death of a loved one. Most hospices also sponsor bereavement groups and support for anyone who feels the need.

Questions to Ask

The following is a list of questions you and your parents might ask when deciding on a hospice program.

Accreditation: Is the agency accredited by a nationally recognized accrediting body, such as the Joint Commission on Accreditation of Healthcare Organizations? This means that the hospice organization has voluntarily sought accreditation and is committed to providing quality care. The JCAHO is an independent, not-for-profit organization that evaluates and accredits health care organizations and is an important resource in selecting quality health care services.

Admissions: How flexible is the hospice in applying its policies to each patient or negotiating over differences? If the hospice imposes up front conditions that do not feel comfortable, that may be a sign that it's not a good fit. Also, if you're not certain whether you or your parent qualifies for hospice, or whether you even want the service, is the agency willing to make an assessment to help clarify these issues?

Certification: Is this hospice program Medicare certified? Medicare certified programs have met federal minimum requirements for patient care and management.

Consumer information: Does the agency have written statements outlining services, eligibility criteria, costs and payment procedures, employee job descriptions, malpractice and liability insurance?

Costs: How does the agency handle payment and billing? Get all financial arrangements—costs, payment procedures and billing—in writing. Be sure to keep a copy. What resources does the agency provide to help your mom or dad find financial assistance if needed? Are standard payment plan options available?

Family caregiver: Does the hospice require a designated family primary caregiver as a condition of admission? How much responsibility is expected of the family caregiver? What help can the hospice offer in coordinating and supplementing the family's efforts or filling in around job schedules, travel plans or other responsibilities? If your parent lives alone, what alternatives can the hospice suggest?

Inpatient care: What are the program's policies regarding inpatient care? Where is such care provided? What are the requirements for an inpatient admission? How long can patients stay? What happens if your mom or dad no longer needs inpatient care but cannot return home? Can you tour the inpatient unit or residential facility? What hospitals contract with the hospice for inpatient care? What kind of follow-up does the hospice provide for those patients? Do nursing homes contract with the hospice? Does the hospice provide as much nursing, social work and aide care for each patient in the nursing home as it does in the home setting?

Licensing: Is the program licensed, if required by your state?

Patient's rights and responsibilities: Does the agency explain these? Ask to see a copy of the agency's patient's rights and responsibilities information.

Personnel: If you're dealing with an agency, are there references on file? Ask how many references the agency requires (two or more should be required.) Does the agency train, supervise and monitor its caregivers? Ask how often the agency sends a supervisor to your parent's home to review the care being given to the patient. Ask whether the caregivers are licensed and bonded.

Plan of care: Does the agency create a plan of care for each new patient? Is the plan carefully and professionally developed with you and your family? Is the plan of care written out and provided to all parties involved? Does it list specific duties, work hours/days, and the name and telephone number of the supervisor in charge. Is the care plan updated as the patient's needs change? Ask if you can review a sample care plan.

Preliminary evaluation: Does a nurse, social worker or therapist conduct a preliminary evaluation of the types of services needed in the patient's home? Is it conducted in the home, not on the telephone? Does it highlight what your mom or dad can do for him or herself? Does it include consultation with family physicians and/or other professionals already providing your mom or dad with health and social services? Are other members of the family consulted?

Questions: If you have questions or complaints, whom do you call? What is the procedure for resolving issues?

References: How many years has the agency been serving your community? Can the agency provide references from professionals, such as a hospital or community social workers, who have used this agency? Ask for specific names and telephone numbers. A good agency will provide these on request. Talk with these people about their experiences. Also check with the Better Business Bureau, local Consumer Bureau or the State Attorney General's office.

Services: How quickly can the hospice initiate services? What are its geographic service boundaries? Does the hospice offer specialized services such as rehabilitation therapists, pharmacists, dietitians or family counselors when these could improve the patient's comfort? Does the hospice provide medical equipment or other items that might enhance the patient's quality of life?

Telephone response: Does the agency have a 24-hour telephone number that you can call when you have questions? How does the hospice respond to the very first call? Do telephone staff convey an attitude of caring, patience and competence from the first contact, even if they need to return the patient's call? Do they speak in plain, understandable language, or do they use a lot of jargon about the requirements that your mom or dad must meet? What is the procedure for receiving and resolving complaints?

How a hospice responds to that first call for help may be a good indicator of the kind of care to expect.

Taking Time Off from Work

The Family and Medical Leave Act (FMLA) of 1993 requires covered employers to provide up to 12 weeks of unpaid, job-protected leave to "eligible" employees for certain family and medical reasons. Employees are eligible if they have worked for a covered employer for at least one year, and for 1,250 hours over the previous 12 months, and if the employer has at least 50 employees within a 75-mile area.

The FMLA is an important benefits law for anyone who has parents in hospice care. Since family members play an important role in providing hospice care, adult children may need to **use FMLA leave** at some point during their parents' final days.

Unpaid leave must be granted to care for an employee's parent who has a serious health condition. At the employee's or employer's option, certain kinds of paid leave may be substituted for unpaid leave.

The employee may be required to provide advance notice and medical certification. The employee ordinarily must provide 30 days advance notice when the leave is foreseeable. Leave may be denied if these requirements are not met.

Check with your employer to find out how it enforces the various application requirements; some are more demanding than others. Most require some form of **documentation or medical certification** to approve a request for leave related to your parent's health condition.

During FMLA leave, the employer must maintain your health coverage under any group health plan it offers. Upon return from FMLA leave, you must be restored to your **original or an equivalent position**—with equivalent pay, benefits and other employment terms.

The use of FMLA leave cannot result in the loss of any employment benefit that accrued prior to the start of your leave. FMLA also makes it unlawful for an employer to interfere with, restrain or deny

the exercise of rights provided under FMLA and to discharge or discriminate against any person for opposing any practice made unlawful by FMLA or for involvement in any proceeding under or relating to FMLA.

Conclusion

The medical advances of the late 20th and early 21st Centuries have extended life expectancies for just about everyone—and they've been especially good for older people living in developed countries. But there's been one ironic effect that may affect your parents: When people contract terminal illnesses, they can live in a limbo of high-tech near-death.

Many reasonable people choose not to prolong a life of worsening sickness. They opt, instead, for a more natural—and, for them, more peaceful—end of their days. Hospice care supports this second choice. And, to a large degree, the mechanics of both private-sector and government health insurance support hospice care.

If one of your parents has a terminal illness, he or she should be able to select a high quality hospice program. That program can take place in a hospice facility or in your parent's home with hospice workers making visits to provide medical care or equipment and assure basic levels of diet and hygiene.

As a child, you can best help in this situation by sharing in the physical and emotional care of your parent. You may also advise your parent that the hospice option is available (paid for by Medicare, if nothing else) and—perhaps—desirable.

4 Social Security

When my dad had a heart attack at 64, I started thinking about more than just his health. I started to wonder about his income, his spending habits and how he'd make it through the rest of his life without working part-time. When I started looking into things like Social Security, I discovered that he wouldn't get his full retirement benefits until he turned 65. I knew that he could sign up for Medicare at 65—but that, if he could put off Social Security for a few more years, he'd get a bigger check each month. I wanted to tell him what to do...but I didn't know how.

∾

The major source of retirement income for Americans today is Social Security, the federal government's pension program. Social Security pays cash benefits to more than 90 percent of people who are age 65 or older, and nearly two-thirds of the program's beneficiaries receive more than half of their income from Social Security.

But there are fundamental problems with the program. As more Americans live longer, Social Security is heading for an actuarial disaster. Currently, the program takes in more in taxes than it pays out in benefits. The excess funds are credited to Social Security's trust funds, which are expected to grow to over $4 trillion.

It's important to point out that Social Security trust funds aren't true trust funds. They are simply I.O.U.s, paper by which the government promises to pay itself back sometime in the future. If a private company used this scheme, the government would step in and put the people running the thing in jail.

In about 2017, the program will begin to pay out more in benefits than it collects in taxes. Once this happens, the government will need to divert money from other programs to Social Security to maintain the benefits it has promised. By 2041, the fictional trust funds will be exhausted and payroll taxes will—according to the government's own projections—only cover about 73 percent of benefits owed.

> **You probably don't need to worry about Social Security going broke before your parents pass away; but you should consider how its grim prospects will affect you.**

In this chapter, we'll look at how Social Security works and what it can do for your parents. It can be a beneficial tool for **supplementing your parents' income**—but it's likely to change throughout the 2000s and 2010s. Congress is constantly considering proposals to revise Social Security, in response to estimates by the system's Board of Trustees that Social Security will be insolvent by the late 2030s. (That terminal date varies according to assumptions made and the organization doing the estimating.)

How Social Security Works

Almost anyone who works knows that he or she pays into Social Security with every paycheck earned. If your parents are retired, they probably already receive their benefits—which are based on the earnings recorded under their Social Security numbers.

While your parents worked, their employer withheld Social Security and Medicare taxes from their paychecks, matched that amount,

sent those taxes to the Internal Revenue Service (IRS) and reported their earnings to Social Security. If your parents were self-employed, they paid all of their own Social Security taxes when they filed their tax returns and the IRS reported their earnings to Social Security. (They actually paid a rate equal to the combined employee/employer share; but they probably deducted the employer portion as a business expense.)

As you work and pay taxes, you earn "credits" that count toward **eligibility for future Social Security** benefits. You can earn a maximum of four credits each year. Most people need 40 credits (10 years of work) to qualify for benefits. Younger people need fewer credits to qualify for disability or survivors benefits, as I'll explain later.

Calculating Social Security Benefits

Social Security benefits are a percentage of earnings averaged over most of one's working lifetime. Social Security **wasn't intended** to be anyone's only source of income when retired or disabled, or any family's only income if the breadwinner dies. It's intended to supplement other income your parents have from pension and savings plans, investments, etc. That said, there are five major categories of benefits paid for through Social Security taxes:

- retirement;
- disability;
- family benefits;
- survivors; and
- Medicare (covered in detail in Chapter 1).

Retirement benefits are payable at **full retirement age** (with reduced benefits available as early as age 62) for anyone with enough Social Security credits. The full retirement age is 65 for persons born before 1938. The age gradually rises until it reaches 67 for persons

born in 1960 or later. People who delay retirement beyond full retirement age get special credit for each month they don't receive a benefit until they reach age 70.

Disability benefits can be paid to people at any age who have enough Social Security credits and who have a severe physical or mental impairment that is expected to prevent them from doing "substantial" work for a year or more or who have a condition that is expected to result in death. Generally, earnings of $780 or more per month are considered substantial. The disability program includes incentives to smooth the transition back into the workforce, including continuation of benefits and health care coverage while a person attempts to work.

If your parents are eligible for retirement or disability benefits, other members of your family might receive **family benefits**, too. For example, if your dad is eligible for either of these benefits, your mom is eligible if she is at least 62 years old or under 62 but caring for a child under age 16. You can be eligible if you are unmarried and under age 18, under 19 but still in school or 18 or older but disabled. If your parents are divorced, both are eligible for benefits on one earnings record.

When one or both of your parents die, certain members of your family may be eligible for **survivors benefits** based on how much the deceased earned in credits with Social Security during their working years. The family members eligible for these benefits include: a widow(er) age 60 or older, 50 or older if disabled or any age if caring for a child under age 16; you as a child if you are unmarried and under age 18, under 19 but still in school or 18 or older but disabled; and your grandparents if your parents were their primary means of support. (This is highly unlikely given the average age of baby boomer parents, but it's worth noting for your own sake.)

If, for example, your mom dies and is survived by your dad, a special onetime payment of $255 may be made to your dad or his minor children when she dies. Try not to spend it all at once!

If your parents were divorced, your dad could be eligible for a widower's benefit on your mom's earnings record. This would depend, of course, on your mom having gained the credits needed on her earnings record.

Supplemental Security Income Benefits (SSI) makes monthly payments to people who have a low income and few assets. To get SSI, your parents must be 65 or older or be disabled. Children as well as adults qualify for SSI disability payments. As its name implies, Supplemental Security Income "supplements" one's income up to various levels—depending on where one lives.

The federal government pays a basic rate and some states add money to that amount. Check with your parents' local Social Security office for the SSI rates in their state. Generally, people who get SSI also qualify for Medicaid, food stamps and other assistance.

> SSI benefits are not paid from Social Security trust funds and are not based on past earnings. Instead, SSI benefits are financed by general tax revenues and assure a minimum monthly income for elderly and disabled persons.

Applying for Benefits

Your parents should apply for Social Security or SSI **disability benefits** when they become too disabled to work and for survivors benefits when a family breadwinner dies. When your parents are thinking about retirement, they should talk to a Social Security representative in **the year before** the year they plan to retire. It may be to their advantage to begin receiving their retirement benefits before they actually stop working.

In most cases, your parents have already reached retirement age by the time they need your help. Still, it's important to **check the basics**. Do they have valid Social Security cards? Do their names appear correctly on the cards? Are these the names that they used throughout their working years?

If you are confused about Social Security and want to talk to someone before broaching the subject with your parents, you can call the toll-free number 1.800.772.1213. You also can use that number to set up an appointment to visit your local Social Security office.

When your parents file for benefits, they need to submit **documents** that show they are eligible, such as a birth certificate, a marriage certificate if they are applying together and their most recent W-2 form (or tax return if they are self-employed).

Earning Credits

Earning the credits to qualify for Social Security is key. These credits are what allow your parents to collect the benefits they have paid for their whole working lives. People earn Social Security credits when they work in a job in which they pay Social Security taxes. The **credits are based on earnings**.

During your parents' working years, their wages were posted to their Social Security earnings record, and they received earnings credits based on those wages. Credits also determine their eligibility for disability or survivors benefits if they should become disabled or die.

Each year the amount of earnings needed for a credit goes up as average earnings levels increase. In 2003, a person would receive one credit for each $890 of earnings, up to **the maximum of four credits per year**.

The credits earned remain on a Social Security record even if there is a change in jobs or there's no earnings for a while.

If your parents were—or are—self-employed, they earn Social Security credits the same way employees do (one credit for each $890 in net earnings, but no more than four credits per year). However, special rules apply if they have annual earnings of less than $400.

Not all employees work in jobs covered by Social Security. The following types of employees don't get the same credits as others:

- most federal employees hired before 1984 (but since January 1, 1983, all federal employees have paid the Medicare hospital insurance part of the Social Security tax);

- railroad employees with more than 10 years of service; or

- employees of some state and local government agencies that never elected to participate in Social Security.

However, if your parents were or are **in the military**, they earn Social Security credits the same way civilian employees do. They also may receive additional credits under certain conditions—contact your local Social Security or Veterans' Affairs office for details.

The number of credits your parents need to be eligible for benefits depends on their ages and the type of benefit in question. The great majority of baby boomer parents easily qualify for benefits, but to document, here are the details:

Anyone born in 1929 or later needs 40 credits to be eligible for retirement benefits. People born before 1929 need fewer credits.

For **disability benefits**, your parents' age and the time when one or both became disabled is important. The following chart shows the number of credits needed per age group:

Disabled At Age	Credits Needed
50	28
52	30
54	32
56	34
58	36
60	38
62 or older	40

Remember the most credits you can earn in a year is four.

Your parents must have earned at least 20 of the credits in the 10 years immediately before they became disabled. (Later in this chapter we'll take a closer look at the mechanics of disability.)

Survivor benefits work a little differently. The family of a deceased worker can qualify for survivor benefits even though the deceased worker had fewer credits than needed for retirement benefits.

If your dad dies and you are still a dependent, you may get survivors benefits if your dad had six credits in the three years before his death. These benefits could continue until you reach age 18 (or age 19 if you're still in school full-time). Your mom, as a widow caring for dependent children or disabled, might also be able to get benefits.

Of course, these rules usually don't mean much to baby boomers who are well-established on their own, are not considered dependents and have parents who easily qualify for Social Security. But, if you have younger siblings, these rules may apply to them.

Working and Getting Benefits

Some parents don't ever want to retire. If your parents choose to keep working, they still collect full Social Security benefits once they reach full retirement age. If your parents are under full retirement age but have started to collect retirement benefits, there are limits on how much they can earn without losing some or all of their benefits. These limits change each year.

To reflect longer life expectancies (and to save the system money), the definition of *full retirement age* was changed in the 1980s by **increasing from age 65 to age 67**. This change went into effect in 2003, increasing the full retirement age for people born after 1937.

The following is a formula to determine how much your parents' Social Security benefits are reduced by money they earn:

If your parents are under full retirement age when they start getting their Social Security payments, $1 in benefits will be deducted for each $2 they earn above $11,520. In the year they reach their full retirement age, $1 in benefits will be reduced for each $3 they earn above $30,720.

These are the **2003 numbers**. They increase slightly each year to reflect inflation.

> Put another way: If your parents decide to keep working past the earliest Social Security qualifying age (62 in 2003), they might as well commit to working until they reach their full retirement age.

Starting with the month your parents reach full retirement age, they'll get all of their Social Security benefits with no limit on how much they earn. This provision is a recent change to the way that Social Security benefits are paid. It's a great plus for older people who enjoy work and wish to continue—and whose health is good.

Earnings counted toward all of the annual limits I've described in this section apply only to pay your parents get **for work they do**. Pensions, annuities, investment income, interest or monies from other government programs **don't count** as earnings for Social Security.

> The Social Security Web site contains a retirement planning tool that can help you calculate your parents' benefits and find out how certain types of earnings and pensions can affect Social Security benefits. You can access the site at www.ssa.gov or call the toll-free number at 1.800.772.1213.

Income Tax and Benefits

Some people who receive Social Security benefits are required to pay federal income taxes on them. This will apply to your parents if

they also have other substantial income (such as wages, self-employment, interest, dividends and other taxable income that they have to report on their tax return) in addition to their Social Security benefits. No one pays taxes on more than 85 percent of his or her Social Security benefits and some pay on a smaller amount, based on the following IRS guidelines:

If your mom files a federal tax return as an individual and her combined income (the sum of her adjusted gross income plus nontaxable interest plus one-half of her Social Security benefits) is between $25,000 and $34,000, she may have to pay income tax on 50 percent of her Social Security benefits. If her combined income is above $34,000, up to 85 percent of her Social Security benefits is subject to income tax; and

If your parents file jointly, they may have to pay taxes on 50 percent of their benefits if they have a combined income (the sum of the adjusted gross income plus nontaxable interest plus one-half of the Social Security benefits) between $32,000 and $44,000. If their combined income is more than $44,000, up to 85 percent of their Social Security benefits will be taxed.

If your parents are still married and file separately in their tax returns, they probably will pay taxes on their benefits.

Every January, your parents will receive a Social Security Benefit Statement (Form SSA-1099) showing the amount of **benefits they received in the previous year**. In fact, the Social Security agency will send statements out to workers 25 or older, including those that are not getting benefits on their own records yet (these ones go out about three months before your birthday).

Statements do not go out to people age 62 or older who get benefits **on someone else's record**. So, if your 68-year-old mother is receiving benefits on your father's record, she won't get a statement. The statement that your parents receive in January is useful for determining whether they need to pay taxes on their benefits. It'll help them complete their federal income tax return.

Although your parents are **not required** to have federal taxes withheld from their Social Security benefits, they may find it easier than paying quarterly estimated tax payments. They can request that federal taxes be withheld from their Social Security when they apply.

If your parents are already receiving benefits or if they want to change or stop their withholding, they need a form W-4V from the IRS. You can download this form from the IRS's Web site at www.irs.gov or you call the IRS toll free at 1.800.829.3676 and ask for the form. Once your parents complete and sign the form, they return it to their local Social Security office by mail or in person.

Benefits to Other Family Members

As mentioned above, when your parents start receiving Social Security benefits, **other members** of your family may also qualify for benefits. For example, if your dad qualifies for benefits, your mom— even if your parents are divorced—can qualify.

Even if your mom has **never worked under Social Security**, she can receive at full retirement age a benefit equal to one-half of your father's full benefit amount and can qualify on his record for Medicare at age 65. (If she gets a pension for work not covered by Social Security, the amount of her Social Security benefits on your father's record may be reduced.)

Your mom can begin collecting the benefits as early as age 62, but the benefit amount will be permanently reduced by a percentage based on the number of months between her actual and full retirement age.

If your mom is still caring for **children who are receiving benefits**, she can receive the full one-half benefit amount no matter what her age is. She would receive these benefits until the child reaches age 16. At that time, the child's benefits continue, but your mom's benefits stop unless she is old enough to receive retirement benefits (age 62 or older) or survivor benefits as a widow (age 60).

What if you mom has also worked under Social Security? In this case, she's eligible for retirement benefits on her own record and So-

cial Security will pay that amount first. If, however, her benefit on your father's record is higher, she will get a **combination of benefits** that equals the higher amount. Social Security will check both records to make sure that she gets the higher amount.

If your mom continues to work while receiving benefits, the same earnings limits apply to her as apply to your father. If she is eligible for benefits and is also working, she can use what's called an earnings test calculator to see how those earnings would affect her benefit payments. (Your mom's earnings affect only *her* benefits; they don't affect your father's or those of any other beneficiaries on his record.)

Divorce and Benefits

If your parents are divorced, certain rules apply. Even if one or both has remarried, they may qualify for benefits on one another's record if they are 62 or older. In some situations, one of your parents may get benefits when the other is not receiving them yet. And, if your father will also receive a pension based on work not covered by Social Security, such as government or foreign work, your mom's Social Security benefit may be affected. In order for your mom to qualify under your father's record, or vice versa, your mom must:

- have been married to your for dad for at least 10 years;

- be at least 62 years old;

- be unmarried; and

- not be eligible for an equal or higher benefit on her own Social Security record, or on someone else's Social Security record.

If your mom continues to work while receiving benefits, the same earnings limits apply to her as apply to your dad. She should use the earning tests calculator to see how her earnings would affect her benefit payments.

The amount of benefits your mom gets has no effect on the amount of benefits your father or, if remarried, his current wife receives.

Starting Early and Starting Late

Your parents can start their Social Security retirement benefits as early as age 62, but the benefit amount they receive will be less than their full retirement benefit amount. If they start their benefits early, the benefits will be permanently reduced based on the number of months between their age at their early retirement and their full retirement age. If their full retirement age is 65, **the reduction is 6.66 percent for each year** they retire early. For example, their benefits at age 62 will be reduced 20 percent; at age 63, 13.33 percent; and, at age 64, 6.66 percent.

If their full retirement age is older than 65 (that is, they were born after 1937), they can still start their retirement benefits at 62. But the reduction in their benefit amount will be greater, up to a maximum reduction of 30 percent at age 62 for people born in 1960 and later.

Social Security benefits are increased (by a certain percentage depending on a person's date of birth) if retirement is delayed beyond full retirement age.

The benefit increase no longer applies when people reach age 70, even if they continue to delay taking benefits.

Increase for Delayed Retirement		
DOB	Yearly Rate of Increase	Monthly Rate of Increase
1930	4.5%	3/8 of 1%
1931-1932	5.0%	5/12 of 1%
1933-1934	5.5%	11/24 of 1%
1935-1936	6.0%	1/2 of 1%
1937-1938	6.5%	13/24 of 1%
1939-1940	7.0%	7/12 of 1%
1941-1942	7.5%	5/8 of 1%
1943 or later	8.0%	2/3 of 1%

Note: People born on January 1 of any year should refer to the rate of increase for the previous year.

Social Security Full Retirement
and Reductions by Age*

Year of Birth	Full Retirement Age	Age 62 Reduction Months	Monthly % Reduction	Total % Reduction
1937 or earlier	65	36	.555	20.00
1938	65 and 2 months	38	.548	20.83
1939	65 and 4 months	40	.541	21.67
1940	65 and 6 months	42	.535	22.50
1941	65 and 8 months	44	.530	23.33
1942	65 and 10 months	46	.525	24.17
1943—1954	66	48	.520	25.00
1955	66 and 2 months	50	.516	25.84
1956	66 and 4 months	52	.512	26.66
1957	66 and 6 months	54	.509	27.50
1958	66 and 8 months	56	.505	28.33
1959	66 and 10 months	58	.502	29.17
1960 and later	67	60	.500	30.00

* Percentage monthly and total reductions are approximate due to rounding. The actual reductions are .555 or 5/9 of 1 percent per month for the first 36 months and .416 or 5/12 of 1 percent for subsequent months.

Your parents can also retire at any time between age 62 and full retirement age. However, if they start at one of these early ages, their benefits are reduced a fraction of a percent for each month before their full retirement age.

As a general rule, early retirement will give your parents about the same total Social Security benefits over their lifetimes, but in smaller amounts to take into account the longer period they will receive them.

There are disadvantages and advantages to taking benefits before full retirement age. The **advantage** is that your parents collect benefits for a longer period of time. The **disadvantage** is that your parents' benefits are permanently reduced. Each person's situation is different, so it's critical to help your parents assess their retirement needs and decide the best age to begin collecting Social Security benefits.

Because Social Security benefits are no longer reduced for amounts earned after your parents reach full retirement age, it makes little sense to delay taking benefits—especially if they keep working. The increases in benefit amounts don't make up for the lost benefits that could have been collected at age 65.

> **Remember: If your parents decide to delay their retirement, be sure they sign up for Medicare at age 65.**

In some circumstances, medical insurance costs more if they delay applying for it. The previous page shows a chart for understanding "full retirement" and the amount of benefits your parents will receive based on their age. Remember, no matter what their **full retirement age** (also called "normal retirement age") is, they may start receiving benefits as early as age 62.

The Complicated Subject of Disability

If you have a parent who is disabled, then you probably already know how Social Security can provide valuable help. If your parents are considering applying for Social Security disability benefits, it's worth going to the Social Security Web site and looking at the disability planner. It explains the benefits available and how your parents qualify.

I explained earlier that a person needs a certain number of credits before qualifying for certain Social Security benefits, including the

system's **disability insurance**. In order for your parents to be covered, they must have worked in jobs covered by Social Security and have a medical condition that meets **Social Security's definition of** *disability*.

> Social Security pays monthly disability benefits to people who are unable to work for a year or more.

Benefits usually continue until a person is able to work again on a regular basis. There are also a number of special rules, called "**work incentives**," that provide continued benefits and health care coverage to help a person make the transition back to work.

If your parent is receiving Social Security disability benefits when he or she reaches age 65, those disability benefits **automatically convert to retirement** benefits—but the amount remains the same.

Whatever your parents' age, if one is disabled, he or she must have earned his or her required number of work credits within a certain period ending with the time he or she became disabled. His or her Social Security statement will show whether he or she met the work requirement at the time it was prepared. If this parent stops working under Social Security after the date of the statement, he or she may not continue to meet the disability work requirement in the future.

> Generally, a person needs 40 work credits, 20 of which were earned in the last 10 years ending with the year he or she becomes disabled, to qualify for this coverage.

The Definition of Disability

Disability is a word loosely thrown around in different kinds of conversations. It means different things in different social and political

arenas. What you may think is a disability may not be what the government thinks one is. The Social Security Administration defines the term disability differently than other government agencies do. Social Security pays **only for total disability**. No benefits are payable for partial disability or for short-term disability.

> **Social Security considers a person disabled if: 1) he or she can't do work that he or she did before; and 2) the agency decides that the person cannot adjust to other work because of his or her medical condition. If your parent finds some other kind of work and earns more than $700 a month, he or she probably won't qualify as disabled—no matter how much he or she was making before the illness or injury.**

This is a strict definition of *disability*. Social Security program rules assume that working families have access to **other resources** to provide support during periods of short-term disabilities, including accrued sick leave, workers' compensation, insurance and savings.

If you think you have a parent who is disabled, it's best to contact your local Social Security office and **ask for help**. It is the Social Security Administration that decides whether or not your mom or dad qualifies for benefits. And, if your parent is already past full retirement age, those benefits are automatically converted to retirement benefits.

Under certain circumstances, your parent's disability benefits can change based on his or her ability to go back to work or regain his or her health. The agency has work incentives that help people make the transition back to work. These include continued monthly benefits and Medicare coverage on a temporary basis.

Disability Benefits for the Blind

There are **special rules** for people who are blind or have poor vision. Social Security considers a person to be legally blind under its rules if he or she cannot be corrected to better than 20/200 in the

better eye, or if the visual field is 20 degrees or less, even with a corrective lens. Many people who meet the legal definition of blindness still have some sight, and may be able to read large print and get around without a cane or a guide dog.

If you have a parent who does not meet the legal definition of blindness, he or she may still qualify for disability benefits if his or her vision problems alone or combined with other health problems prevent him or her from working. If this parent is already retired, it's a different case.

There are a number of special rules for people who are blind that recognize the severe impact of blindness on a person's ability to work. For example, the monthly earnings limit for people who are blind is generally higher than the $780 limit that applies to non-blind disabled workers. This amount changes each year. More information is provided in a booklet offered by the Social Security agency, titled *If You Are Blind or Have Low Vision: How We Can Help*. This is available on-line or by calling the agency.

Death and Widow(er) Benefits

In 2002, there were about 5 million widows and widowers receiving Social Security benefits based on their deceased spouse's earnings record. And, for many of those survivors, particularly aged women, those benefits kept them out of poverty. If one of your parents is deceased, the other may already be receiving these benefits.

A widow or widower who has not remarried can receive full benefits at full retirement age or older or reduced benefits as early as age 60. As I mentioned before, disabled widows or widowers can begin receiving benefits as early as age 50.

But remember that, if your living parent also receives a pension based on work not covered by Social Security—such as government or foreign work—his or her Social Security benefit on your deceased parent's record may be affected.

> If your parents are divorced but were married for 10 years or more, then when one dies the other can qualify for survivor's benefits under Social Security—so long as that parent has not remarried. These benefits do not affect any other benefit rates to other survivors.

How much your family receives in benefits depends on your deceased parent's **average lifetime earnings**. The higher the earnings, the higher the benefits. Social Security calculates a basic amount as if the deceased had reached full retirement age at the time of death. (If the person already received benefits at the time of death, survivor benefits are based on that amount.)

The following are examples of benefit payments:

- widow or widower, full retirement age or older—100 percent of the basic amount;

- widow or widower, age 60 to full retirement age—71½ to 94 percent;

- disabled widow, age 50 through 59—71½ percent;

- widow, any age, caring for a child under age 16—75 percent.

- a child under 18 (19 if still in elementary or secondary school) or disabled—75 percent.

Percentages for a surviving divorced widow or widower would be the same as above.

There is also a maximum amount that your **family can receive together**; the limit varies, but is generally equal to about 150 to 180 percent of the deceased's basic benefit rate. If the sum of the benefits payable to the family members is greater than this limit, the benefits will be reduced proportionately. (Any benefits paid to the surviving divorced widow or widower won't count toward this maximum amount.)

There also may be a special lump-sum death payment. If the deceased earned enough credits, there is a special lump-sum benefit payment of $255 that can be paid to certain family members upon death. This payment can be made only to the surviving spouse or minor children if they meet certain requirements.

> If you are curious as to how much these benefits amount to if your mom or dad were to die today, you can use the Benefits Calculator on the Social Security Web site to estimate.

If the surviving parent remarries, there are even more rules to follow. If your surviving parent **remarries before age 60**, she or he cannot receive widow or widower benefits on your dead parent's Social Security record as long as that marriage remains in effect. If your surviving parent **remarries after age 60**, she or he will continue to receive benefits on your deceased parent's record. However, if your surviving parent's current spouse is a Social Security beneficiary, she or he may want to apply for a benefit on the spouse's record if it would be a higher amount. She or he cannot get both benefits.

If your surviving parent works while getting survivors benefits and is under full retirement age, the survivor benefits may be reduced if his or her earnings exceed the annual earnings limits I mentioned earlier.

Social Security Q & A

The following are questions common to Social Security and the benefits provided by the program. Program benefits are under constant change, specifically with regard to **earnings values**. For this reason, it's key to stay tuned in to recent figures.

Retirement
Q: Are benefits based on my parents' last five years of earnings?
A: No. Retirement benefit calculations are based on average earn-

ings during a **lifetime of work** under the Social Security system. For most current and future retirees, Social Security will average their 35 highest years of earnings. Years with low or no earnings may be counted to bring the total years of earnings up to 35.

Q: If my dad stops work at age 52, can he expect to get the same predicted benefit amount shown on the annual statement at age 62?

A: Probably not. When Social Security averages the 35 highest years of earnings to estimate benefits on a statement, it assumes that your dad worked up until age 62. If, instead, he has $0 earnings during those last 10 years, the **average earnings are probably less** and so are the benefits.

> It's understandable that people relying on Social Security spend a lot of time focusing on how their benefits are calculated. The more important point to keep in mind is that, even at their largest, these benefits aren't enough to support a middle-class lifestyle. Your parents will need to have some additional resources to maintain that sort of life.

Q: Do my parents' pensions—provided by their former employers—reduce the amount of Social Security benefits they get?

A: If the pension is from a job where your parent also paid Social Security taxes, it **will not affect** his or her Social Security benefit. However, pensions based on work not covered by Social Security (the federal civil service and some state, local or foreign government systems, etc.) will reduce the amount of a Social Security benefit.

Q: My parents both worked under Social Security. My mom's Social Security statement says she can get $850 a month at full retirement age and my dad's says he would get $1,450. Do they each get those respective amounts?

A: Since your mom's own benefit is **more than half** of your dad's amount, they will each get their own benefit. If your mom's own benefit were **less than half** of your dad's (that is, less than $725),

she would receive her amount plus enough from your father's record to bring it up to half of his total amount.

Q: If my mom works after receiving Social Security retirement benefits, will she have to pay Social Security taxes on those earnings?

A. Yes. Anyone who works in a job covered by Social Security **must pay** Social Security and Medicare taxes on their earnings, even if they are already receiving their Social Security benefits (and being covered by Medicare). The same is true if your mom is self-employed.

Disability

Q: How recently would my parents have had to be working to get Social Security disability benefits?

A: Some older people don't realize they need a relatively recent work history to qualify for Social Security disability benefits. Your parents need 20 credits **(five years) of work in the 10 years** before their disability started. Credits are assigned to calendar years based on the amount of their earnings for that year.

Q: If a disability must be expected to last at least a year in order to qualify under Social Security coverage, do my parents have to wait a whole year before they get benefits?

A: No. A disabled parent should apply for the benefits **as soon as possible**. If they are approved, payments begin after a five-month waiting period that starts with the month in which the disability began.

Q: Is there a time limit on how long my parents can receive disability benefits?

A: No. Benefits continue **as long as the medical condition** keeps them from working. If your parent is still disabled when he or she reaches full retirement age, the disability benefit is automatically converted to a retirement benefit of the same amount.

Q: If my mother is eligible for Social Security disability benefits, is she also eligible for Medicare benefits?

A: If she's getting disability benefits, she's eligible for Medicare 24 months after the date Social Security decided her disability began.

Q: Where can I get a list of the impairments that Social Security considers to be disabling?

A: *Disability Evaluation Under Social Security* (SSA Pub. No. 64-039) contains the **medical criteria** that Social Security uses to determine disability. It's intended primarily for physicians and other health professionals; but anyone can download a copy from the Social Security Administration Web site (www.ssa.gov).

Survivor Benefits

Q: My father died recently at age 65. Can my mother collect his Social Security benefits? She just turned 58.

A: Unless your mother is disabled, she would not be eligible for monthly survivors benefits based on your father's earnings record **until she reaches age 60**. At that age, her benefit would be 71½ percent of his basic benefit amount. If she waits until she reaches her full retirement age, she will receive 100 percent of his amount. (Disabled widows or widowers can receive benefits as early as age 50.)

Q: How can I determine whether my mother is listed on my father's Social Security record as his beneficiary?

A: Social Security records **do not have named beneficiaries**. The Social Security Act specifies which family members can receive benefits on any one record. Social Security will not pay benefits to people who don't meet the legal requirements, nor can the program refuse to pay benefits to people who do meet those requirements.

Q: Is it true that when my dad dies, my mom gets only a lump-sum death payment of $255?

A: While it's true that the only *cash* payment Social Security makes upon the death of spouse is a check for $255, the program provides **survivor benefits** that last as long as the survivor lives—and increase each year with increases in the cost of living. Your parents will each receive an annual Social Security Statement, giving estimates of their potential survivor benefits.

Conclusion

A comfortable retirement is everyone's dream. Because people are living longer, healthier lives, you can expect your parents to spend more time in retirement than your grandparents did.

Among the various resources that older Americans use to finance their retirement years, Social Security is the foundation on which most build their plans.

> **Most financial advisors say people need about 70 percent of their pre-retirement earnings to comfortably maintain their pre-retirement standard of living. For most retirees, Social Security currently provides about 40 percent of their pre-retirement earnings.**

That foundation is likely to shrink in the coming years...and certainly by the critical period between the years 2017 and 2020. But for now, your parents can benefit from the program and add more to their income. Social Security benefits go farther than you might think because they usually either fully or partly tax-free and come with automatic cost of living adjustments (COLAs). The COLA feature is very valuable—and rarely found in private pension plans.

The actuarial reckoning will more likely be *your* problem.

In the meantime, it's a good idea to check out the Social Security's Web site (**www.ssa.gov**) for complete and updated benefits information. You can download needed forms and publications as well as use the benefit planner for on-line financial planning. (You can also call the Social Security Administration toll-free at **1.800.772.1213.**)

If you compare what your parents had to pay for their Social Security benefits to what you're paying, it becomes clear that you are paying for your parents' Social Security. **Make sure that they get what you're paying for.**

5 Pensions

My father was an engineer. He worked for the same com-
pany for almost 20 years, before it was bought out by
another. And then that *one merged with another. My dad*
went over to GE for the last few years he worked. He
retired over 10 years ago and is having a hard time mak-
ing ends meet. I've asked him if he has any pension due
from his first company, but he doesn't know...and gets
defensive about not knowing. I've done all I can to un-
earth his lost pension—talked to useful contacts, spoken
with the IRS—to no avail. My father could really use this
money now, and I don't think it's fair that, after all those
years of hard work, it's gone missing.

᭡

Pensions are the oldest form of retirement income plan. More than 80 million Americans participate in some form of private-sector pension plan and about 14 million draw monthly retirement benefits.

You may have heard the term *defined benefit plan*, which is the technical term for a traditional pension. Some firms refer to plans by other names. Whatever the term, the idea is the same: In defined benefit plans, employers set aside money in some form of trust account for their employees' retirement. The money that the employees can

take out later is based on a formula (and is, therefore, *defined*); the amount of money that the employer has to put aside to cover those benefits is determined by rules set by the government.

The specifics of any plan can change from company to company and from year to year, depending on factors that range from the size of the company to how aggressively it invests the money put aside for the employees.

> For example, your dad may be entitled to receive 1½ percent of his salary for each year he worked at a company, payable monthly after he retires. If he worked for 25 years, he could retire and count on a pension benefit equal to 37½ percent of his average pay.

Plans may state the promised benefit as an exact dollar amount (for example, $250 per month at retirement) or may specify a formula for calculating the benefit (for example, $20 per month for every year of service with the company or a percent of a worker's salary times years of service).

The **employees are not taxed** on the amounts that employers contribute to find their pension benefits; and the employers get to deduct those amounts from their taxes. And **the trust accounts aren't taxed** on profits they earn while the money is put aside. However, the employees do have to **pay income tax** on the retirement money when they receive it.

Because these plans are costly and difficult to manage, **not many employers sponsor traditional pensions** today; instead, they use lower-cost alternatives like 401(k) plans.

But many larger employers and most government agencies still offer traditional pension plans. If your parents spent a significant part of their careers working for a big corporation or the government (including the military), the odds are that they have earned a substantial pension benefit.

Some Background

The Employee Retirement Income Security Act (ERISA) of 1974 changed the way pension plans were managed and secured. Until 1974, there was little or no protection for pensions. Many workers could lose their retirement benefits—and had no legal recourse if they did. With ERISA, Congress set strict requirements for private pension plans, making the U.S. Department of Labor (DOL) responsible for seeing that the plans were properly operated and that their assets were managed in a prudent manner. The Internal Revenue Service (IRS) was made responsible for regulating pension plan funding and vesting requirements...and for ensuring compliance with tax laws.

ERISA also established the Pension Benefit Guaranty Corporation (PBGC) to insure the pensions of workers covered by privately defined benefit pension plans.

Under ERISA, companies are required to fund pension plans; any assets that are part of the plan are invested to be able to meet benefit needs in the future. All plans covered by ERISA are kept in some form of trust and the monies invested, usually by professional money managers. If the plans meet basic guidelines, they are insured by PBGC.

Typically, there are two kinds of pension plans: **single-employer plans** or **multi-employer plans**. A single-employer plan, which *can be* collectively bargained, provides benefits for workers of one employer. A multi-employer plan, on the other hand, is *usually* a collectively bargained pension arrangement involving more than one unrelated employer. In this context, *collectively bargained* means the benefits are negotiated (and sometimes administered) by a labor union representing the employees covered by the plan.

The chief advantage of traditional pensions is that they offer workers a specific, predictable benefit for life. On the other hand, workers in **defined contribution plans**—like 401(k)s—have individual accounts

funded with their own contributions and perhaps **matching contributions** from their employer. The ultimate benefit available to people with defined contribution plans depends on the amounts contributed by the employee and the investment returns on those contributions.

> Compared to defined contribution plans, traditional pensions are much more reliable. To clarify the difference: In defined contribution plans, the financial risk—that investments decline or that contributions won't provide enough income in retirement—is borne by the worker.

Defined contribution plans became very popular during the 1980s and 1990s. As a result, the American pension system has shifted away from traditional pensions and toward defined contribution plans. According to the federal government, the number of defined benefit plans declined from 175,000 to 59,500 between 1983 and 1997.

The decline in the number of defined benefits plans resulted mainly from the termination of **a large number of small plans**. However, while the decline in the *number of plans* was larger among small plans, the decline in the *number of participants* was greater among large plans. The number of active participants in small defined benefits plans fell from 1.8 million in 1983 to 660,000 in 1997. In the same period, the number of active participants in large defined benefits plans fell from 28 million to 22 million.

Earning Pension Benefits

Your parents began to earn retirement benefits as soon as they became participants in a defined benefit pension plan. However, they probably didn't have a permanent right to the benefits—to become vested—until they worked a minimum period of time, as specified by the plan. If they left their jobs before becoming vested, they would have lost their accrued benefits.

> Being vested in a benefit means that a worker has completed
> sufficient years of service and is entitled to receive benefits
> accrued under the plan, whether or not the worker continues
> working for the company, until retirement.

Pension plans usually have one of two vesting schedules: **cliff** or **graded vesting**.

Under cliff vesting, workers must be fully vested after no more than five years of service with the employer. The plan, however, can specify a shorter period of service. Workers have no vested rights until this date. Although defined benefit pension plans require workers to meet age and service requirements before they can participate in a plan, workers cannot be excluded from participating **because they are too old**, even if they are hired within a few years of (or after) the normal retirement age specified in the plan. On the other end of the age spectrum, plans usually allow workers to participate if they are at least 21 years old and have completed one year of employment.

Under graded vesting, the worker must be at least 20 percent vested after three years of service and receive an additional 20 percent vesting for each of the next four years, with full vesting coming no later than at the end of seven years of service.

When a worker leaves a job in which he or she earned the right to a pension, the employer must provide information about these benefits. If your parents are about to retire, and they have vested pension benefits, it's important to verify their **earned benefits** before they leave. If they have pension benefits from different companies, it becomes key to stay organized.

> Things to keep clear when organizing pension benefits: each
> plan's name; nine-digit employer identification number;
> three-digit plan number; name and address of the plan ad-
> ministrator or other representative; and copies of individual
> benefits statements.

Calculating Benefits

Pension plans use formulas to figure the benefit amount earned. Usually, they involve salary and years of service (for example, a percentage of final or average salary multiplied by the number of years of service) or a flat benefit amount per year of service. The actual dollar amount will depend on such factors as:

- age at retirement;

- earnings (in plans that use salary to compute benefits); and

- years of service under the plan.

The longer someone works under the same defined benefit pension plan, the larger the retirement benefit.

Some plans are **integrated with Social Security** benefits. In these plans, the benefit earned is reduced or increased to reflect the Social Security benefits a retiree receives.

Your parents receive pension benefits when they reach the **normal retirement age** set by their plans. The normal retirement age is usually 65. Your parents should check their pension plans for the normal retirement age and become familiar with other benefit provisions.

Most pension plans allow workers to take **early retirement** upon completing a certain number of years of service and/or reaching a given age. But if your parents decide to retire early, they may receive a **lower monthly benefit** than they would at normal retirement age because the benefit will be paid over a longer period of time.

There are a variety of ways in which a pension plan can pay benefits. Payments can be made as annuities (equal monthly payments) or as onetime payments (lump sums). If, however, the present value of the benefit is **$5,000 or less**, the plan may pay the benefit in a single sum without the worker's consent.

If the benefit is worth **more than $5,000**, the plan must provide the benefit as a monthly payment—unless the participant has specifically elected otherwise.

Survivor Benefits

Defined benefit pension plans normally provide **survivor benefits** if a worker dies either before or after retirement benefits begin. In most cases, the surviving spouse would receive any vested benefits. However, if the worker specifically declines the survivor option at retirement in writing, this won't happen.

Why would anyone turn down a survivor benefit? Because it costs something. Typically, when a survivor benefit is chosen, the overall retirement benefit is reduced to reflect the longer **combined life expectancy** of the retiree and spouse.

If a worker dies before retirement, the plan does not have to pay the benefits to the spouse until the earliest date that the deceased worker could have begun receiving retirement benefit payments.

For example, if your dad dies at age 50, and the plan says that the earliest he could receive benefits is at age 55, your 50-year-old mom would have to wait five years to receive benefits. If he dies after retiring, your mom would receive at least 50 percent of the benefits your dad had been receiving if he was receiving benefits that included a minimum survivor benefit. The benefits would continue until your mom dies.

Pensions can't usually be attached for debts owed. However, in the event of a divorce or separation, a judge can order a plan to pay a share of a worker's pension directly to a spouse, former spouse, child or other dependent. For this to occur, the order must be a **Qualified Domestic Relations Order** (QDRO) and must meet strict legal requirements concerning the facts involved and benefits affected.

Funding the Pension Plan

Employers are responsible for funding the defined benefit plans that they sponsor. They usually contribute enough each year to cover

the normal cost of the plan, an amount that is at least the value of the benefits that participants in the plan earned that year. They may also have to make additional contributions to cover investment losses. If an employer fails to make the legally required contributions, it can be penalized in taxes for every year the deficiency exists. If, however, the employer is **facing financial hardship**, the IRS will work with the company and allow for a funding waiver…and the workers are notified of this waiver. In some cases, the plan may file for a lien (legal claim) against employer assets for unpaid contributions; or the employer may be forced to post security for a portion of the underfunding. These actions are taken to protect the pension beneficiaries.

> **The person who administers the pension plan is known as the plan administrator. This person's responsibilities include keeping the workers fully informed of their rights and benefits, making pension payments to retirees and beneficiaries, paying insurance premiums to PBGC and making reports to plan participants and to DOL, IRS and PBGC as required by law.**

Under federal law, a pension plan administrator must give workers the following information:

- **Summary Plan Description**. This document includes information on how the plan operates, when participants are eligible to receive their pensions, how participants can calculate the amount of their benefits and how to apply for them. This information must be given to workers within 90 days after they become participants in the plan. The plan administrator must notify participants about changes in the plan and, every five years, provide an updated version of the summary description if the plan has been modified.

- **Summary Annual Report**. This contains information on the financial activities of a pension plan and must be provided to workers annually.

- **Notice to Participants**. Participants in plans that are less than 90 percent funded must receive an easy-to-understand notice reporting the funding level of their pension plan, indicating how much of their pensions are currently covered by the plan assets. The notice also explains what benefits in the plan would be covered by PBGC's insurance in the event the pension plan terminates.

- **Individual Benefit Statement**. This statement shows the benefits a participant has accrued under the plan and tells whether the participant has a vested right to receive them. Participants can request this information annually and when they leave for another job.

If your parents ask for pension information and they fail to receive it, they should contact the Division of Technical Assistance and Inquiries, Pension and Welfare Benefits Administration (PWBA) at: U.S. Department of Labor, 200 Constitution Avenue NW, N-5625, Washington, D.C., 20210.

Pension Checklist

If your parents are covered by a private defined benefit plan, they should know the following key things:

- [] the name of their defined benefit pension plan;
- [] the plan's EIN (Employer Identification Number);
- [] the plan's PN (Plan Number);
- [] the name and contact information of the administrator;
- [] the date when they are vested in the plan;
- [] the age at which they can take early retirement, with reduced benefits;

- ☐ the age when they can retire with full benefits;

- ☐ the age of normal retirement;

- ☐ how their benefits are calculated;

- ☐ what their benefit would be if they die before retiring;

- ☐ what their benefit would be if they are disabled before reaching retirement age;

- ☐ whether their plan allows them to receive benefits in a lump sum and/or as an annuity in monthly installments for life;

- ☐ whether they declined in writing the joint-and-survivor option that would allow them to continue receiving a portion of their retirement benefit if one dies before the other; and

- ☐ the benefits covered by PBGC insurance if their plan is terminated and taken over by PBGC.

What You Can Do to Help

If there's one thing you can do as a son or daughter, it's ensuring that your parents receive the **benefits they have earned**. Every year, tens of thousands of Americans don't receive their full pension benefits. Why? The most common reason is an error by the employer, including employer ineptitude and confusion about federal pension laws. Benefits get miscalculated and no one ever checks them.

Check your parents' benefits before they are finalized. Make sure they request an **individual benefits statement**, a **summary plan description** and a **summary annual report**. If your parents ever left a job, retired or switched jobs, check for any benefits that might have been lost in the transitions. Calculations can get complicated, especially when mixed with other types of retirement plans, like 401(k)s and investment accounts. Having an actuary or accountant walk you though these calculations might be a good idea.

> Two of the biggest factors that cause problems in benefits calculations are length of service and salary.

There aren't supposed to be any fuzzy or gray areas in pension plans; but, sometimes, there are. Problems do arise and knowing when to hire a good actuary to help is key. Not only do employees have questions, but employers do, too.

Help your parents take charge of their pension benefits. If they haven't been getting and reviewing detailed benefits statements from their employers every two or three years, now is the time to do that—even if they are retired. These details should include how much they will collect in benefits and how the pension is calculated.

> Congress may pass legislation at some point that requires employers to provide workers with pension benefit statements at least once every three years. These statements would have to include how the benefits are calculated.

Make sure that your parents don't throw away employment records. It's up to you and your parents to make sure things are correct when it comes to the math; employers don't have as large an incentive to get the calculations right as your parents do. Furthermore, corporate cutbacks have pushed many people into early retirement—which complicates calculations. If your parents were among those who left jobs early, it's important to confirm what they took with them.

Missing Plans

What happens if one or both of your parents worked for a company, became vested in a pension plan and now can't find the company to collect their benefits? Let's say your dad worked for a medium-size company a long time ago and now that he's ready to retire,

he can't seem to locate the company. Does he still have his pension? Will he ever be able to find it? And if not, then where did it go?

Thousands of retired workers in the U.S. are not getting the pension payments they deserve because they **don't know where to look**. They may have worked for companies that moved, consolidated, became another company, merged, divided, gone bankrupt or simply closed its doors and disappeared.

In some cases, pension plans are lost; but, in others, money is sitting safely in a fund, waiting for a worker or surviving spouse to claim it. Tracking down a pension fund can be hard work; but, for those owed money, it's a worthwhile endeavor.

Hunting down a lost or missing pension plan involves many steps, including: determining if it's worth looking; organizing your paperwork and dates of employment; contacting various sources and following through the leads; and dealing with what you find at the end of your hunt.

Making sure that **your parents qualify** for a pension (that is, they are vested) is the first step. Most pension plans require at least five years of employment. But, prior to the mid-1980s, plans typically required 10 years. If your parents think they qualified for a pension at a job they worked prior to the mid-1970s, they may have had to work many years to get one. Before 1976, plans could require that they worked for the same employer until they retired.

People have more rights since ERISA was enacted. But rules that define the plan when a worker leaves determine whether a worker has a pension or not. If your parents left jobs before 1976—before ERISA took effect—they could be out of luck. So, knowing **when** they worked, **how long** they worked and the **requirements** for their pension plans is important.

Knowing what to expect when looking for lost benefits also helps. Here's what someone can expect to find with regard to benefits:

- an **inactive plan** (the company may have changed, but the plans may have been legally transferred to new managers who are now obligated to pay out benefits due);

- a plan that bought an annuity from an **insurance company**, which undertook the obligation to pay annuities to everyone entitled to benefits under the plan;

- a plan that was transferred to a **bank or a mutual fund**;

- a plan that was taken over by the **PBGC**, which then pays benefits up to a certain amount;

- a plan that was **terminated** by the employer with benefits paid to people who could be found; and

- a plan that has vanished—along with its monies.

Tracing the history of a pension fund can be exhausting. If your parents worked for companies that no longer exist and are hard to pin down, finding the fund is frustrating. They may have worked for these companies back when private pensions were unregulated. Only since 1974 have broad protections emerged to make sure that such funds remain managed and solvent. The IRS has also taken a role in the regulation of pensions.

Once you gather and organize any documents you find that reflect your parents' possible pension plans, keep everything in one place. These are valuable documents.

Your parents can contact the Social Security Administration (SSA) to obtain copies of their **earnings records**. This can help determine their employers' federal ID number, which in turn can aid in your hunt.

To request an earnings record, call 1.800.772.1213 and ask for Form SSA-7050-F3, otherwise known as Social Security's "Request for Social Security Earnings Information" document. Expect this kind of inquiry to take at least six weeks.

Also, each year pension plans are required to report to the SSA any benefits that have been earned by workers leaving the job. When those workers apply for Social Security benefits, the SSA is supposed to remind them of their old pensions. This notice doesn't always work as smoothly as it should, but the **SSA does keep records** of employers and pension plans.

Other useful resources for hunting down a pension plan include:

- **U.S. Department of Labor**. Particularly, the Pension and Welfare Benefit Administration (PWBA)'s Division of Technical Assistance & Inquiries (202.219.8776). There are also 15 field offices to provide assistance to people who are having problems with their pensions.

- **Pension Benefit Guaranty Corporation (PBGC)**. This agency has a computerized list of individuals who are entitled to benefits from pension plans that it has taken over but who can't be located. They also maintain—since 1994—a pension search program that accepts benefits from terminating defined benefit plans if the plan administrator has been unable to locate all participants.

- **Pension Counseling Projects**. You may be able to find local counseling services just by looking in the phone book. Several federally-funded agencies have sprouted up since the 1990s through the Administration on Aging.

- **Libraries**. Never underestimate the power of your local library, as well as the more sophisticated ones that have Internet access and powerful search engines. There are also specialized business libraries throughout the country; and college campuses also have business libraries with helpful tools.

- **Internet**. The Web can help you access the PBGC's computerized directory at *http://search.pbgc.gov*. Or you can

write to the PBGC Pension Search Program at 1200 K Street NW, Suite 930, Washington, D.C., 20005-4026.

> **Note: The PBGC provides short cuts for certain individuals. If your parents had a pension plan that closed down after July 1, 1974 and the sponsor of the plan was a private company that was not a religious organization and was not a professional office that employed fewer than 25 people, then locating the plan should be easy. The PBGC won't, however, be able to help your parents if their plan was paid for only by union dues or was administered by a government agency.**

If your parents can contact **former co-workers** to ask them about pension plans, your parents may be able to learn what happened to the company...and their benefits. If their former co-workers are receiving pension benefits, ask them where the checks are coming from. If they worked for a company that had unionized workers, they may be able to obtain information from the union. And, if they are confused about which union it was or how to locate it, they can contact their **state's labor federation**, local Chambers of Commerce where the company used to be and historical societies for help.

A plan's annual financial reports may identify the plan's administrator. These reports get filed with the PWBA about two years after the year that they cover, and they are kept by the PWBA for six years. Calling the PWBA's Division of Technical Assistance & Inquiries is a start.

Because **state governments** require annual reports from corporations, contacting the Secretary of State's office for guidance is helpful. By calling the main switchboard, you can get the name and number of the agency that collects these reports. The office of a county or municipal recorder of deeds can also lead to clues. And, don't forget: if the company was publicly-traded, required Securities and Exchange Commission (SEC) filings would list company information.

What to Look for Among Valuable Documents

☐ A notice that your parents are vested in a plan;

☐ A benefit statement;

☐ An exit letter, received when someone leaves a company, noting participation in the plan;

☐ A summary plan description showing the plan's rules;

☐ Any documents that show the full official name of the company and its IRS ID number;

☐ Any documents that show period of employment and earnings; and/or

☐ Old pay slips and W2 forms.

When all is said and done, and you've come to the end of your search, you may have found one of the following:

- the plan's administrator;

- the name of the insurance company where the funds reside; or

- the PBGC if it took over the pension plan's obligations or the plan was terminated and its plan administrator used the PBGC's missing participants program.

Lost and Found

Once you and your parents find their pension fund, your next step should be to **write to the plan administrator** or insurance company with as much information as you've gathered (i.e., the dates of employment, a copy of the most recent individual benefit statement, etc.). Ask if your parents were covered and what benefits they are entitled

to. You'll want a copy of the summary plan description to make sure that your parents qualify. If there's a disagreement over benefits, you'll need to get your paperwork in gear and be ready to fight.

The PWBA should be your first contact, then try a pension counseling project in your or your parents' area. A PWBA benefit advisor or a pension counselor will be able to examine the records and advise you on your case. If there's ample evidence that your parents are entitled to benefits, and they aren't getting them, then you'll most likely get some free assistance. The PWBA may intervene and negotiate a settlement with the plan administrator or insurance company.

A final option is, of course, the legal one. If you and your parents feel the need to hire an attorney, the National Pension Lawyers Network maintains a list of attorneys that handle pension claims. (You can call this group at 617.287.7332.)

Opting for legal action over a pension claim can be costly. It's advisable to ensure that the benefits outweigh the costs of such an action. The American Academy of Actuaries has a pension help registry of actuaries willing to volunteer to help people check their pension calculations. You can reach this group at 1720 Eye St., NW, 7th Floor, Washington, D.C., 20006.

One last source for information: The Pension Rights Center, 1140 19th St., NW, Suite 602, Washington, D.C., 20036; 202.296.3776.

Caring for Divorced Mom

The increase in the number of divorces has shifted the way older women support themselves through their later years when they don't remarry and can't rely upon things like pensions and 401(k)-style plans. Hundreds of thousands of women in their 60s are having to work because they lack the funds to retire. When they got divorced, many lost their husband's share of the pension among other things vital to living comfortably.

> Until the late 1990s, widows outnumbered older divorced women. But now, for the first time in history, divorced women outnumber widows.

If your mom is still working, she may be too embarrassed to come to you for help. She may have failed to negotiate well in her divorce and feel stuck in the working world for the rest of her life. Looking for ways to help her plan for retirement would be a great way to start communicating about money and her future. **Retirement is generally easier—financially—for men.** Often, women who took time off to raise children have a hard time meeting those pension requirements and saving sufficiently for their own retirement.

The point here: Don't assume that you mom is taking care of herself sufficiently, no matter how savvy you think her accountant and "friends" are. Help her take charge of her finances and get her set up for retirement.

> Although legislatures and courts have done much to assure that people (usually wives) get a fair share of employer-sponsored pensions, insurance and other benefits if their spouse dies, the situation is very different when it comes to divorce. In such cases, divorced moms can be left with nothing.

Many states have laws that automatically eliminate ex-spouses as beneficiaries of such things as employee benefit plans, insurance policies, annuities and individual retirement accounts. And questions about the intent of a dead ex-spouse have generated enormous amounts of litigation. The Supreme Court has ruled that when employee benefits are concerned, state laws are preempted by federal law. For example: The court, in a case from Washington state, held that the 1974 Employee Retirement Income Security Act (ERISA) overrides the Washington law. Thus, the beneficiary specified by the employee still gets the benefits even though the couple had divorced.

In that case, a Boeing worker, who had designated his wife as the beneficiary of his company-provided life insurance policy and pension plan, died following a 1994 car accident two months after divorcing her. He left no will and his ex-wife remained the named beneficiary on the pension and the $46,000 life insurance policy. For inheritance of such assets, Washington's law treated ex-spouses as if they had died on the day of the divorce.

Two of the man's children from a previous marriage sued, arguing that the Washington law disqualified the ex-wife as beneficiary and in the absence of a qualified named beneficiary, the proceeds should pass to them as the heirs.

The children lost in the trial court but won on appeal. But, finally, the U.S. Supreme Court reversed the appeals court decision.

Conclusion

Defined benefit plans—the things people usually think of when they hear the word *pension*—are the most **predictable and reliable** form of private-sector old age income benefits. ERISA, the federal law that controls pension benefits, sets strict rules for how defined benefits are administered.

For this reason, in part, not many companies offer traditional pensions anymore. This is probably bad news for you...but, the odds are, if your parents worked for any significant part of their lives they may have some form of defined benefits due them.

The challenge for many children helping their parents is to sort out their parents' work histories and find out exactly what benefits are due and from which companies they are due. This can involve some detailed detective work.

However—as with Social Security—some people rely too heavily on the pension benefits from the companies where they worked.

A defined benefits plan should be just one of several sources of retirement income on which an older person can rely. Your parents may not even have a pension plan ready to pay them when they are ready to retire, in which case they'll have to turn to other forms of cash, such as investments, 401(k) plans, sale of real estate or other assets, Social Security, immediate annuities and part-time work.

It's good to look at Social Security retirement benefits, pension income and immediate annuities as similar to owning fixed-income securities (like corporate or government) bonds. All three provide a predictable stream of income.

And, for your parents' financial well-being, fixed income investments are the best way to assure a steady cash flow...and a decent quality of retirement life.

6 401(k)s, IRAs, etc.

My mom is 67 and was still working full-time when she had a stroke a few months ago. She's been divorced from my father and living—happily—on her own for almost 20 years, so she wasn't prepared for someone else to take over her affairs. But, while she was in the hospital, my brothers and I agreed that I was the logical one to step in. It turns out she's okay financially...she's got good health insurance and some money saved up. But she doesn't want to work any more. And her retirement money is tied up in four or five different accounts from different jobs she's had. Now I've got to help her organize all of that.

Defined contribution plans have been around long enough (since the late 1970s) that the chances are good that your parents have some form of 401(k), SEP, Keogh or IRA as their main private sector retirement benefit.

By the time you step in to help your parents, you may find that their defined contribution benefits are a mishmash of accounts spread around various banks, brokerages or benefit administrators. In some cases, it may make sense for your parents to have their retirement money in different places. In most, however, it will make better sense for them to organize this money in a more basic structure. And the responsibility for that organizing may come down to you.

In this chapter, we'll consider the mechanics of defined contribution plans and the best strategies for organizing and managing them.

The Most Common Plans: 401(k)s

A 401(k) plan—the numbers and letter refer to the section of the U.S. Tax Code that allows them to operate—is a defined contribution retirement savings account set up by an employer. Workers can contribute money to the plan through direct deduction from their paychecks before they have to pay federal or state taxes on it. The money can then be invested in any of several options offered by the plan.

There are several variations on the basic 401(k) plan. **Keogh Plans** and **Simplified Employee Pensions** (SEPs) are similar but designed specifically for people who are self-employed or work for very small companies. **403(b) Plans** are similar but offered by nonprofit organizations such as schools and hospitals. The basic functions of these other plans are essentially like a 401(k)—though, in some cases, the other plans offer more flexible contribution terms.

The main appeal of these plans is that they are **tax-advantaged**. If your parents have them, they didn't have to pay taxes on the money they contributed…or on any investment profits on the money while it sits in the account. They do have to pay income tax on the money when they take it out; but, theoretically, this tax will be less than what they would have paid on the money when they were working.

Another appeal: Many **employers match** part of a worker's 401(k) contribution. If your parents' companies offered defined-contribution plans, they may have added anywhere from 10 to 100 percent of the amount your parents contributed.

> Although 401(k) funds can be invested in almost any manner, most plans offer participants a small menu of mutual funds and other conservative investments from which to choose.

By the time you're helping your parents, you might think investment strategies for their retirement money aren't important. But, remember, the 401(k) money has to last as long as your parents do, so **asset allocation** (*where* you invest the money) is important. Here are a couple of useful tips to remember:

- Don't use 401(k) funds to buy tax-free investments, such as municipal bonds (exempt from federal and sometimes state and local taxes)—because you don't pay current taxes on 401(k) earnings, anyway. Tax-free investments often make sense for older people *outside* of a pension plan; *inside* of a tax-advantaged plan, they're usually better off with investments that provide higher returns.

- Watch the administrative fees. They always hurt; but they especially hurt money that's going to be in the plan for a short time. If all of the investment options in the plan are mutual funds with high fees, ask the administrator (usually connected to the employer in some manner) to change the plan to include no-load or low-load mutual funds.

Borrowing from a 401(k) Plan

Many plans allow workers to borrow money against the funds in their accounts. If your parents have done this, they've essentially borrowed the money from themselves. The interest that they pay to the plan for the loan is just like any other earnings of the plan—it's tax-free. So, in some cases, plan administrators encourage the loans.

For a younger person, borrowing against 401(k) funds can be a good idea; but it doesn't make so much sense for older employees. They're more likely to need access to the money sooner. And they certainly need to be **earning interest instead of paying it**.

Unfortunately, some older people borrow against their retirement money…and haven't paid the loans back if they are forced to retire earlier than they had expected.

> Loans against retirement funds are usually limited by the government to the lesser of $50,000 or 50 percent of the account balance. So, even if your parents have borrowed, there should be some funds available to them.

If your parents quit, are fired or are forced (by their health or other factors) to retire early, 401(k) loans usually have to be **paid back right away**. If your parents don't have enough money to pay the loan back, the loan will be treated as if it were a regular **distribution**. Your parents will have to pay taxes at their marginal tax rate on the amount of the loan and—unless they're over 59½—a penalty equal to 10 percent.

Why the penalty? A 401(k) plan is intended to fund your parents' retirement, so they're not supposed to start taking out money until they are 59½ years old, they're seriously ill or they retire due to a permanent disability. Another problem with early distributions: The plan administrator may withhold an amount equal to 20 percent of the distribution for taxes.

The real advantage of a 401(k) is as a long-term investment. The benefits are difficult to beat and the ability to contribute pre-tax funds can really supercharge your parents' retirement savings. These benefits make up for the restrictions otherwise placed on the investment.

How 401(k) Money Gets "Lost"

If either of your parents has had several jobs (or just more than one) since the late 1970s or early 1980s, there's a fair chance that they have retirement money in several accounts in several places.

More often than you might expect, older people will simply forget where they have retirement money. This is especially true if they **had a job for just a year** or two...or if they worked at a company that went through **corporate ownership changes** (mergers, acquisitions, divestitures, etc.).

When your parents leave a job, it's not always clear what happens to 401(k) money. Basically, they have four choices:

- leave the money where it is;

- move the money to a 401(k) at the next job;

- put the money in "storage" in an Individual Retirement Account (IRA) or similar account; or

- take the cash.

If your dad accumulated more than $5,000 in a 401(k), his ex-employer has to allow him to keep the money in that plan until he retires or reaches 70½. Although your dad can't put any more money into *that* 401(k), his money continues to grow without paying taxes.

In some cases, especially if the money is well invested, it makes sense to leave it in place. In other cases, usually because your dad is intimidated by money management issues, it's simply *easiest* to leave the money where it is. Although your dad's old company isn't supposed to give him advice about what to do with the money, human resources may encourage workers to **leave their money in place**. (The larger the plan, the more attention the company will get from brokers and plan administrators.)

Of course, your parents may be able to get better investment options by moving their money to their new employer's plan.

Most employers will allow new employers to move money from their old plans into the new company's 401(k) immediately. The best way to move the money is through a tax-free transfer—called a **rollover**. This transfer can happen directly between the plan administrators (strictly speaking, the IRS doesn't consider this version a rollover, though everyone else calls it that) or it can involve a distribution to your parents that they reinvest within 60 days.

Occasionally, there's an error in the transfer of the money. The problem may be that the money is credited to the wrong account within a benefit plan; this problem is often self-correcting, if the plan administrator is competent and paying attention.

More often, if the transfer took the form of a distribution to your parents, they may have forgotten to reinvest it with 60 days. This can cause problems—especially if your parents ended up spending the money or putting it in an ordinary savings account. They're going to owe tax on the money.

If a new employer's plan won't accept money from another plan or won't accept it right away...or if your parents don't have a new employer...they can move their money to an IRA.

In most cases, your parents should keep this transferred money in a new, separate IRA set up specifically for this purpose. This avoids mixing the 401(k) money with any other, existing IRAs and allows it to be moved into another 401(k) at some future date.

> If your parents mix their old 401(k) with IRA funds, the funds can't be separated. This means they give up any benefits that 401(k) and other retirement funds have over IRAs.

Even though it's a good idea to keep retirement moneys from different jobs separate, the idea means—as you might guess—that some people end up with small amounts of money deposited in too many different accounts.

> This tendency toward multiple accounts is encouraged by the fact that most banks, brokerage firms and mutual funds are eager to *help* people set up numerous accounts. Even if the numerous accounts aren't really what the people need.

While this pushing of retirement accounts and selling of rollover kits isn't malfeasance on an Enron-like scale, it can work against your parents' best interest. They can end up with three, four...six or eight retirement accounts and a few thousand dollars in each. This makes a single account easier to forget. And it makes it more difficult for your parents to notice a misplaced transfer or other such mistake.

Most important: Having many accounts is expensive. Each account has its own fees, which compound over time. Combining all of your parents' accounts into one eliminates these **redundant fees**.

If your parents move their retirement money, it's best that they **avoid taking the money** from their old 401(k) in the form of a check.

If your mom has $10,000 in a 401(k) and she asks her former employer for a check, she'll only get $8,000 ($10,000 less 20 percent withholding, or $2,000). She'll have to come up with $2,000 out of her pocket to put in her new plan—and she'll have to do it within 60 days. Even if she can scrape together the $2,000, she'll have to wait until her next tax refund to get the $2,000 withholding back from the IRS. If she only puts the $8,000 into her new plan, she'll have to pay taxes on $2,000, plus (if she's under 59½) an additional 10 percent penalty ($200) for early withdrawal of retirement money.

The best person to help your mom with a direct transfer is the administrator of her new employer's 401(k) plan or the person at her bank or brokerage firm where she set up an IRA to receive the money.

The Second Most Common Plan: IRA

Individual retirement accounts are similar to 401(k) plans, as they provide tax benefits for long-term investments—but on a smaller basis. Your parents can set up an IRA account at most banks, brokerage firms or mutual fund companies.

An IRA is created by a written document. The document must show that the account meets all of the following requirements:

- The trustee or custodian must be a bank or other institution approved by the IRS to act as trustee or custodian.

- The trustee or custodian generally cannot accept contributions of more than a set amount ($3,000 in 2003 or $3,500 if the account owner is 50 or older).

- Contributions, except for rollovers, must be in cash.

- The account owner must have a nonforfeitable right to the amount at all times (this means he or she can't use the money as security for a loan, etc.).

- Money in the account can't be used to buy life insurance.

- Assets in the account can't be combined with other property, except in a designated common investment fund.

Your parents can have a traditional IRA whether or not they are covered by any other retirement plan. However, they may not be able to deduct all of their **contributions**, depending on what tax breaks they are already taking on other retirement accounts.

That said, your parents can make contributions to an IRA if:

- at least one of them received taxable **compensation** during the year; and

- they were not age 70½ by the end of the year.

What is *compensation*? Generally, it's money your parents earn from working. Wages, salaries, tips, professional fees, bonuses and any other amounts they receive for providing personal services are compensation. So are commissions.

If your parents are self-employed (proprietors of or partners in the business in which they work full-time), compensation is the net earnings from their business (provided their services are a material income-producing factor) reduced by contributions made on their behalf to retirement plans and a portion of their self-employment taxes.

For IRA purposes, compensation also includes any taxable alimony and separate maintenance payments either of your parents receive under a decree of divorce or separate maintenance.

Compensation doesn't include any of the following:

- earnings and profits from property, such as rental income, interest income and dividend income;

- pension or annuity income;

- deferred compensation received (compensation payments postponed from a past year);

- income from a partnership for which they do not provide services that are a material income-producing factor; and

- any extraordinary amounts excluded from income, such as foreign earned income and housing costs.

For any year in which your parent does not work, contributions cannot be made to the IRA unless he or she receives alimony or files a joint return with a spouse who has compensation. Even if contributions can't be made for a given year, the amounts contributed for previous years can remain in the IRA. Contributions can resume for any year that your parent has compensation that qualifies.

Contributions can be made to an IRA at any time during the year or by the due date for filing a return for that year, not including extensions. For most people, this means April 15 of the following year.

Roth IRAs

There are several variations on the traditional IRA. The most common of these variations is the so-called **Roth IRA** (named after the U.S. Senator who championed it), created by the Taxpayer Relief Act of 1997.

To simplify slightly, a Roth IRA **reverses the normal tax advantage** of a defined-contribution plan. In other words, it requires the account owner to pay taxes on the money that goes in but allows that money to be taken out tax-free.

Because Roth IRAs do not have required distributions, your parents can leave the accounts to grow tax-free as long as they wish. If they don't need the money they pass their Roth IRA on upon their death to heirs—who then have a lifetime stream of tax-free income.

If they qualify, your parents can deposit 100 percent of their earned income up to $3,500 each—even if they're currently covered by a qualified retirement plan.

Your parents can also **convert their traditional IRAs into a Roth IRA** as long as their income is under $100,000. If they are below that income threshold, converting can be very advantageous. Note that any income resulting from a conversion would not count toward the $100,000 limit.

For a single person, the annual contribution is phased out between adjusted gross income (AGI) of $95,000 and $110,000; for a married person filing jointly, between AGI of $150,000 and $160,000; and for a married person filing separately, between AGI of $0 and $10,000.

> **To convert a traditional IRA into a Roth IRA, your parents' current-year AGI may not be more than $100,000. When they convert, the funds that are applied to their Roth IRA are taxed as ordinary income (excluding any nondeductible contributions they made).**

Unlike contributions to traditional individual retirement arrangements, contributions to a Roth IRA are **not deductible** from gross income. However, distributions after five years that are made when the annuitant is 59½ years of age—or older or on account of death, disability or the purchase of a first home—are not included in gross income.

If paid as an annuity, an **inherited Roth IRA** must be payable over a period not greater than the designated beneficiary's life expectancy and distributions must begin before the end of the calendar year following the year of death. Distributions from another Roth IRA cannot be substituted for these distributions unless the other Roth IRA was inherited from the same decedent.

> Unlike a qualified IRA, your parents are never required to take distributions from a Roth IRA. As a result, they can allow their account to continue building on a tax-free basis for future use—at any age.

To convert, your parents have to **pay tax** on any pretax contributions contained in their traditional IRA along with any earnings on those contributions. If they have a 401(k) which only contains pretax contributions, and if they rolled that 401(k) account into a traditional IRA, they would owe income taxes on the entire IRA account balance upon conversion to a Roth IRA.

They can pay these taxes directly out of the IRA. If they have the cash, though, a better plan is to pay the taxes with money outside of the IRA. Doing so, your parents keep the IRA intact…and producing that much more tax-free income.

> There is one pitfall with conversion, however. As we discussed in the Social Security chapter, if your parents make more than a certain amount, a portion their Social Security benefits becomes taxable. And, any amount converted would count as income in the year of conversion—potentially triggering income tax on their Social Security benefits.

A different tax problem arises if your parents have a large IRA that they wish to convert. If the have a $500,000 traditional IRA that they wish to convert to a Roth IRA, the entire $500,000 counts as taxable income if they convert it all in one year. A conversion of this size would also certainly make their Social Security benefits taxable.

Your parents may be subject to a 6 percent tax on excess contributions if:

- they contributed to other individual retirement arrangements during the same tax year;

- their adjusted gross income for the tax year exceeds the applicable limits; or

- their compensation is less than the amount contributed by or for them for the tax year.

To avoid the excise tax, your parents would need to undo any excess Roth IRA contributions before their taxes were due for the year the contributions were made. In other words, they have between the end of the calendar year and the date they file their returns to make adjustments.

How could this be avoided? **There is nothing that requires the entire traditional IRA be converted in a single year**. Your parents, usually with the help of a CPA, can convert part of their traditional IRA each year, making sure that the amount converted doesn't trigger taxes on their Social Security benefits...and that they have enough other income to pay the taxes and keep the IRAs whole.

Why go to all of this trouble? Other than not having required distributions and being able provide an income tax free benefit to their heirs, converting to a Roth IRA can help **eliminate the taxes** that might have to be paid on their Social Security benefits.

The distributions your parents receive from traditional IRAs are included in their taxable income, which can, if large enough, make their Social Security benefits subject to tax. But the same is not true for Roth distributions. Because Roth distributions are tax-free they are not consider as taxable income and therefore do not count towards the income threshold that triggers taxation of their Social Security benefits.

Whether your parents should convert an existing IRA into a Roth IRA depends on many factors—their age, tax bracket and when they plan to begin taking distributions. The key question: **Will the taxes they pay today to switch be worth the tax breaks and flexibility later?** If your parents are already over 65, the tax bite today will probably not be so severe. So, the answer is more likely to be *yes*.

If your parents' only income was their Social Security benefits and Roth IRA withdrawals, **all of their retirement income would be then tax-free!**

IRAs vs. 401(k)s

Your parents can put away money tax-free into either an IRA or a 401(k)—but not both (unless their income is below a certain limit; in 2003 the limit was $60,000). An IRA isn't as attractive as a 401(k) primarily because your parents **can't put in as much money** on a tax-advantaged basis. However, an IRA is still a good way to put several thousand dollars a year in a tax-advantaged account. Although your parents need earned income in order to put money into an IRA, a nonworking spouse can put up to $3,500 (if he or she is over age 50) into an IRA. This means your parents may be able to put as much as $7,000 per year in an IRA, as long as they're both over 50.

If one of your parents is still working, they should know whether they are eligible for a 401(k) or equivalent plan. If they aren't, they should be putting money into an IRA.

If your parents aren't sure whether they're covered by a retirement plan, look at their W-2s—the employer is supposed to check a notice box if they're participants in any tax-advantaged plan.

If your parents are part of a 401(k) plan at work or make more than the limit for a deductible IRA, they can put additional retirement money in a Roth IRA.

By the time you're beginning to help your parents manage their finances, they're probably more interested in taking money out of their retirement plan than putting money in. But it's important to remember that **the years between age 50 and 70** offer some of the best, most tax-advantaged savings opportunity for Americans.

If your parents can work in their 50s and 60s—even if the work is part-time, related to a second career or stems from a hobby—they can put **more money into retirement accounts** than at any other time in their lives. In this sense, if no other, these are the golden years. (And it's a reason not to fret if they haven't reached critical mass yet.)

Consolidating Accounts

If your parents have a traditional, defined benefit pension, you don't need to worry too much about where the money is. But, if they have money in different defined contribution accounts, you may want to help them organize this money. IRA rules permit you to **transfer, tax free, assets** (money, investments or other property) from other retirement programs to a traditional IRA.

Generally, a rollover is a tax-free distribution to your parents of cash or other assets from one retirement plan that they'd contributed to another retirement plan. The contribution to the second retirement plan is called a "rollover contribution."

In most cases, your parents have to make the rollover contribution by the 60th day after the day they receive money from a defined-contribution plan. However, the IRS may waive the 60-day requirement where the failure to do so would "be against equity or good conscience, such as in the event of a casualty, disaster or other event beyond [a person's] reasonable control." If your parents didn't roll their money over in time because they're starting to have problems managing their affairs, you may be able to appeal on these terms.

> If your parents are consolidating accounts, it's important to keep things moving. Amounts not rolled over within the 60-day period do not qualify for tax-free rollover treatment. These monies are treated as taxable income after 60 days. In these situations, your parents (depending on their ages) may also have to pay a 10 percent additional tax on early withdrawals.

A key point: Your parents cannot deduct the amounts that they reinvest as part of a rollover. In most cases, they've already deducted this amount when they put it into the first account.

If your parents roll over any part of a distribution from a traditional IRA, they can't—within a one-year period—make a tax-free rollover of any later distribution from that original IRA. They also can't make a tax-free rollover of any amount distributed, within the same one-year period, from the IRA into which they made the rollover. But they can rollover two (or more) IRAs into a third.

> If your dad has two traditional IRAs, IRA-1 and IRA-2, and he makes a tax-free rollover of a distribution from IRA-1 into a new traditional IRA (IRA-3), he can also make a tax-free rollover of a distribution from IRA-2 (or any others) into IRA-3 within one year of the distribution from IRA-1. These can both be tax-free rollovers because he has not received more than one distribution from either IRA within one year. However, he can't—within the one-year period—make a tax-free rollover of any distribution from IRA-3 into another IRA.

If your parents withdraw assets from a traditional IRA, they can roll over **part of the withdrawal** tax free and keep the rest of it. The amount they keep will generally be taxable (except for the part that is a return of after-tax contributions) and may be subject to the 10 percent tax on premature distributions.

Before making a rollover distribution, the administrator of a qualified employer plan must provide your parents with a written explanation—often called a **rollover notice**. It must tell your parents about:

- their right to have the distribution paid tax free directly to a traditional IRA or another eligible retirement plan;

- the requirement to withhold tax from the distribution if it is not paid directly to a traditional IRA or another eligible retirement plan;

- the nontaxability of any part of the distribution that they roll over to a traditional IRA or another eligible retirement plan within 60 days after they receive the distribution; and

- other qualified employer plan rules, if they apply, including those for lump-sum distributions, alternate payees and cash or deferred arrangements.

Because restrictions and tax consequences vary, it will be **up to your parents to compare the plans** to decide whether or not they want to make the rollover.

A caveat: If your parents have less than $5,000 in an defined contribution account (or the distribution due is less than $5,000), the plan can simply cut them a check and force them to deal with the tax issues related to the money.

Dealing with Non-Cash Assets

So, your parents can roll over the money from various defined-contribution accounts into a single one without paying any taxes. The first question will be whether the single account should be a 401(k)—the parent who owns the other accounts has to have a job to make this happen—or an IRA.

The next question will probably involve how to deal with stocks and other noncash assets that your parents may have in their retirement accounts.

This issue can be complex because employer-sponsored accounts can include company stock, which many larger companies use as the matching portion of 401(k) contributions. And IRAs can include an even more diverse mix of noncash assets, including:

- annuities;

- real estate;

- stocks;

- bonds;

- collectibles (art, antiques, stamps, coins, etc.).

If your parents receive cash and noncash assets in an eligible rollover distribution, they can roll over part or all of the cash, part or all of the noncash assets or any combination of the two. But they can't switch noncash assets with an equivalent amount of cash—in other words, "cash out" the assets themselves. They must either roll over the noncash assets or sell them and roll over the proceeds.

> **An example: Your mom receives a total distribution from her employer's plan consisting of $10,000 cash and $15,000 worth of stock. She keeps the stock. She can roll over the $10,000 cash to an IRA but she can't roll over an additional $15,000 cash representing the value of the stock she choose not to sell. She'll have to pay income tax on the what she keeps.**

The silver lining to the rule that says your parents have to sell noncash assets: They don't have to pay any tax on profits that they make from those sales. As long as they roll all of the sale proceeds to the new account, it's tax-free.

Inherited IRAs

Generally, a spouse can inherit an IRA or the proceeds of a 401(k) without paying any tax. So, if your dad dies, your mom can roll his accounts over into an account in her name...or can simply treat the inherited IRA as her own. In fact, unless your mom makes some other arrangement, the federal government will *assume* that she is treating your dad's accounts as her own.

If your mom receives a distribution from a qualified plan as a result of divorce or similar proceeding, she may be able to roll over all or part of it into an IRA. To remain tax-free, the distribution must be:

- one that would have been an eligible rollover distribution (defined earlier) if it had been made to the employee; and

- made under a qualified domestic relations order.

If anyone other than a spouse inherits a lump-sum distribution from a traditional IRA or Roth IRA that he or she has inherited, some or all of it may be taxable. The rule here is that these **monies are taxed once**. If the dead person had put pre-tax money into the IRA, the beneficiary will have to declare the inheritance as taxable income; if the dead person contributed after-tax dollars, the beneficiary is free from taxes later.

Generally, Roth IRAs are complicated when inherited. So-called "qualified distributions" from a Roth IRA are not subject to tax. A distribution made from a Roth IRA is "qualified" if it is made after a **five-year period** beginning with the first tax year in which a contribution was made to any Roth IRA of the owner.

Furthermore, in most cases, the entire interest in the Roth IRA must be distributed by the end of the fifth calendar year after the year of the owner's death—unless interest is payable to a designated beneficiary over his or her life or life expectancy.

Defined Contribution Distributions

With the details of organizing defined contribution accounts established, we come to the matter of how the money in those accounts can be taken out.

As we've noted before, a penalty in the form of a 10 percent additional tax generally applies if your parents withdraw or use IRA assets before they are age 59½. These withdrawals are called **early distributions**.

However, anyone can usually make a tax-free withdrawal of contributions if they do so before the filing date for their tax return for that year. This means that, even if you are under age 59½, the 10 percent additional tax may not apply—though usual income tax will.

Beyond that, there are several exceptions to the age 59½ rule.

Your parents may not have to pay the 10 percent additional tax if they are in one of the following situations.

- They have unreimbursed medical expenses that are more than 7.5 percent of their adjusted gross income.

- The distributions aren't more than the cost of their medical insurance.

- They are disabled.

- They are receiving distributions in the form of an annuity.

- The distributions are not more than their qualified higher education expenses.

- They use the distributions to buy, build or rebuild a first home (including a first home belonging to a child, grand-child or other family member as described by the IRS).

- The distribution is due to an IRS levy on the qualified plan.

After they reach age 59½, your parents can receive distributions from their defined contribution plans without having to pay the 10 percent additional tax. But they can also leave the money in the accounts, increasing—everyone hopes—in value. In fact, as we've noted before, your parents can actually add more money to their IRAs through their late 50s and 60s than any other time. And that's the time to do so, if possible.

If your parents were born before 1936, they may be able to use some serious tax advantages—technically, things like capital gain credits and averaging treatment—when it comes to taking distributions out of qualified plans. In order to use these tools most effectively, your parents will probably need to consult a certified public accountant (CPA) who can review their finances in detail.

Required Distributions

Even though your parents can receive distributions after they reach age 59½, they are not *required* to take money out of a defined-contribution account until they reach age 70½. Because defined contribution plans are retirement programs (and not programs for allowing unlimited tax shelters), your parents will have to take out the money that they put in. The formula for figuring exactly how much they need to take out each year can be complicated—but there are some simpler tactics that they can use.

The penalties for leaving too much money in an IRA or 401(k) for too long are **even tougher** than the penalties for taking money out too early.

If there are no distributions from an IRA or 401(k), or if the distributions are not large enough, your parents may have to pay a **50 percent excise tax** on the amounts not distributed.

In case you're thinking about an easy loophole: Required distributions are not eligible for rollover treatment to a new defined contribution plan.

The specific requirements for distributing funds from defined contribution plans differ, depending on whether the person receiving the money is the owner or the beneficiary of the account.

If your parent is the owner of a traditional IRA, by April 1st of the year following the year in which he or she reaches age 70½, that parent must either:

- receive the entire balance in the IRA; or

- start receiving periodic distributions from the IRA.

If your parent doesn't receive the entire balance in the IRA by the required beginning date, he or she must start to receive periodic distributions over one of the following periods:

- his or her life;

- the lives of that parent and a designated beneficiary;

- a period that does not extend beyond the parent's life expectancy; or

- a period that does not extend beyond the joint-life and last survivor expectancy of that parent and a beneficiary.

If your parents choose periodic distributions, they must receive at least a minimum amount for each year starting with the year the account owner reaches age 70½. The money can be taken out as late as April of the following calendar year. But, from then on, the minimum distribution for any year must be made by December 31 of that year.

Example: Your dad reaches age 70½ on August 20, 2003. For 2003, he must receive the minimum required distribution from his IRA by April 1, 2004. He has to receive the minimum required distribution for 2004 (the first year after he reached 70½) by December 31, 2004.

Calculating the Minimum Required Distribution

So, when your parent pass age 70, they have to start taking money out of their retirement accounts. Fair enough. But how much do they need to take out?

As we noted, they can take out all of the money in their defined contribution plans. But, if they have a lot of money put away, that could mean a very large tax bite due all at once.

A better alternative is to set up a **schedule for taking out money**, as little as your parents need to live reasonably well…or as little as the tax rules allow. This minimizes or at least delays the tax bite.

According to the IRS, your parents calculate their minimum required distribution for each year by dividing their IRA account balance on December 31 of the preceding year by the applicable **distri-**

bution period or **life expectancy**. These periods—which vary according to your parents' age, the age of their spouses (especially if those spouses are more than 10 years younger) and the age of any beneficiary who's not a spouse—are published each year by the IRS.

Example: Your mom was born on October 1, 1931. She is an unmarried participant in a defined contribution plan. She reaches age 70½ in 2002. Her required beginning date is April 1, 2003. As of December 31, 2001, her account balance was $25,300. According to IRA tables, the distribution period for someone her age (71) is 25.3 years. Her minimum required distribution for 2002 is $1,000 ($25,300 divided by 25.3). That amount needs to be distributed to her by April 1, 2003.

Another plus to keeping as much money as possible in the retirement account is that it can continue to increase in value for your parents. In a good investment year, it can even grow faster than your parents withdraw money.

Same example: Your mom's account does well in 2002, growing to $26,400 on December 31. The account balance of $26,400 is reduced by the $1,000 minimum required distribution. Consequently, she uses an account balance of $25,400 to determine her minimum required distribution for 2003. It has increased slightly, even though your mom took money out.

The IRS has separate life expectancy tables for people whose spouses are more than 10 years younger than they are…or whose designated beneficiaries are young. These life expectancy numbers are longer than the standard ones—reflecting the younger participants. The longer numbers mean lower minimum required distributions. All three of the life expectancy tables are located in IRS Publication 590 and can be downloaded from the IRS's Web site.

If your parents have more than one traditional IRA, they have to determine the minimum required distribution separately for each IRA.

However, they can total these minimum amounts and take the total from any one or more of the IRAs.

Your parents can always take out more than the minimum required distribution; but they don't get credit for the additional amount when determining the minimum required amounts for future years.

Of course, your parents still reduce their IRA account balance by the amount they take out. They just can't count the extra amount distributed as an amount required to be distributed in a later year.

Example: Your dad became 70½ on December 15, 2001. His IRA account balance on December 31, 2000, was $38,400. He figured his minimum required distribution for 2001 was $1,466 ($38,400 divided by a life expectancy of 26.2 years). But, by December 31, 2001, he'd actually taken out distributions totaling $3,600—$2,134 more than was required. He can't use that $2,134 to reduce the amount he's required to withdraw for 2002, but his IRA account balance must be reduced by the full $3,600 to figure his minimum required distribution for the next year. So, his reduced IRA account balance on December 31, 2001, was $34,800. His minimum required distribution for 2002 is then $1,375 ($34,800 divided by 25.3). During 2002, he must receive distributions of at least that amount.

A last point to remember: Your parents can take a minimum distribution in installments (monthly or quarterly, for instance) as long as the total for a year equal at least the minimum distribution required.

Are Distributions Taxable?

In general, distributions from a traditional IRA are taxable in the year your parents receive them. However, there are some exceptions to this rule. Distributions may be tax-free or only partly taxable if the retirement accounts include nondeductible contributions.

If your parents made after-tax contributions to any of their retirement accounts, they will have a **cost basis** (investment in the contract) equal to the amount of those contributions. These after-tax con-

tributions are not taxed when they are distributed to your parents. They are a return of your parents' investment in their plans.

Only the part of the distribution that represents after-tax contributions (the cost basis) is tax free. If after-tax contributions have been made, distributions consist partly of those contributions and partly of pre-tax contributions, earnings and gains. Until an amount equal to all of your parents' cost basis has been distributed, each distribution is partly nontaxable and partly taxable.

Roth IRAs follow different tax rules. Because contributions to these accounts are made after taxes are paid, distributions from them—including investment earnings on contributions—are tax free, if withdrawn under rules I described earlier.

That also means that the rules about minimum distributions don't apply to Roth IRAs (although special tax rules do apply upon the death of the Roth IRA owner).

Calculating a minimum required contribution each year isn't difficult—but it may be more than your parents want to do. Some older people avoid the process by moving their funds into an **independent retirement annuity** that's exempt from minimum distribution requirements. But this can be a costly way to avoid some simple math.

I'll examine the mechanical details of retirement annuities when I consider life insurance in Chapter 7. But, for now, I'll note that combining various defined contribution accounts into a single IRA that takes the form of an annuity is the closest thing there is to retirement money on "autopilot."

Prohibited Transactions

I'll end this chapter with a quick note about defined contribution plan **dealings that the tax code discourages**.

Because these accounts often contain large amounts of money, the investment advisors and other people around your parents may be tempted to use or abuse the funds. That abuse may be criminal, sepa-

rate of tax issues. But the tax code does try to prohibit certain types of sleazy transactions.

Generally, a **prohibited transaction** is any improper use of an IRA account or annuity by your parents, their beneficiaries or any disqualified person. (Disqualified persons include any fiduciary and family members—spouses, ancestors, lineal descendants and spouses of lineal descendants).

> A fiduciary includes anyone who exercises any discretionary authority or discretionary control in managing an IRA or exercises any authority or control in managing or disposing of its assets; charges a fee to provide investment advice with respect to an IRA or has any authority or responsibility to do so; and has any discretionary authority or discretionary responsibility in administering an IRA.

The following are examples of prohibited transactions with an IRA:

- borrowing money from it;

- selling property to it;

- receiving unreasonable compensation for managing it;

- using it as security for a loan; and

- buying property for personal use (present or future) with IRA funds.

Generally, if your parents or their beneficiaries engage in a prohibited transaction in connection with an IRA at any time during the year, **the account stops being an IRA** as of the first day of that year. Your parents will have to pay taxes on the complete balance of the IRA as of that first day of the year; and they may have to pay the 10 percent additional tax on early distributions.

You may recognize these terms as the same that apply to forgiven loans or any other **early withdrawal of retirement monies**. Merely from a tax perspective, they are best to avoid.

If **someone other** than the owner or beneficiary of an IRA engages in a prohibited transaction, that person may be liable for additional, larger taxes. In general, there is a 15 percent tax on the amount of the prohibited transaction and a 100 percent additional tax if the transaction is not corrected within the year it occurred.

7 Life Insurance and Annuities

I was worried that my dad didn't have tons of money when he started getting sick, about two years ago. I was afraid that he was going to spend his last days in some rotten retirement home or a VA hospital. But, when I flew down to Florida to help him sort out his finances, it turned out that he was in much better shape than anyone thought. He had a really good life insurance policy that allowed him to take funds early to pay for nursing home care; and he had an annuity that guaranteed him another $1,000 a month in addition to his Social Security. He was smarter about this stuff than I expected.

 ❧

An often-repeated life insurance advertisement says: *Life insurance isn't for the people who die. It's for the people they leave behind.* And then the picture fades to a little kid playing with his young mother. This is a scare tactic that sells a lot of policies.

However, life insurance can be as useful to the person whose name is on the policy as to the beneficiaries. The life insurance industry is very smart about crafting policies that offer **benefits to insured people before they die**. And these benefits can be a big help to your parents...and you.

The life insurance market is also a crowded place, full of companies and brokers (some ethical, some not) vying for your parents'

money. Your parents—like any consumers—should proceed carefully. They (and you, if you're helping them) need to ask basic questions about what kind of life insurance coverage they need...and what they can afford.

Also, as we've seen before with medical coverage, they need to be very careful about replacing policies that they already have in place.

Two Basic Functions

Life insurance can be used as an investment...and it offers some tax breaks. But its basic purpose is to provide two things: **income replacement and liquidity** in the event of the policy owner's death.

Insurance can prevent a distressed sale of assets to raise cash for taxes or other costs. The proceeds can pay estate taxes, debts belonging to the dead person and cash to survivors.

No matter how hard it may be to think about, considering the costs related to death—medical, funeral and burial—is also necessary when it comes to dealing with aging parents. These costs can be surprisingly large and put an enormous amount of pressure on emotionally-sensitive family members following the death of a parent.

Funeral and burial is the third-most expensive purchase an older adult will make, following a home and an automobile, according to the AARP. According to a study released in 2002 by the National Center for Policy Analysis in Dallas, a senior near the time of his or her death can generate more than $50,000 in medical, funeral and burial costs.

Although Medicare and Medicaid cover an estimated 65 percent of and older person's medical costs, survivors can expect to owe an average of $5,700 after that older person dies. And funeral costs can run about $6,130—with a burial adding $2,000 more than that. (These estimates come from the National Funeral Directors Association.)

Clearly, it's good to have some insurance in place to help pay these bills.

A major advantage of life insurance is the income **tax-free transfer of proceeds** to the beneficiary. This is widely known to the public. What the public doesn't always appreciate is that the insurance proceeds can be included in a dead person's estate, if that dead person owned the policy (even if someone else gets the money).

Example: Mom owns a life policy on Dad, with the children as beneficiaries. She pays premiums with her own separate funds, so that Dad won't be deemed by the IRS to have strings attached. The proceeds of the policy, therefore, will not be included in his taxable estate. At Dad's death, the insurance money goes directly to the children. No estate tax is due (although Mom has made a taxable gift to the kids, for federal purposes, because she gave them the policy proceeds).

Life insurance proceeds pass to a spouse income and estate tax free (as can all other assets). However, if the proceeds go to an estate or to a family trust, etc., there are going to be taxes due. Local probate courts may also get involved.

Types of Life Insurance

You and your parents are probably familiar with the basic kinds of life insurance. But it's worth reviewing the general types.

Term life insurance—which has no value after a set period of time (its term)—is the most common and cheapest form of coverage. It's the kind of life insurance you see advertised on late-night television and scores of Web sites across the Internet.

Your parents won't want to buy a term policy if they're in their 60s or older. Age is a major factor in the pricing of term coverage and a term policy's **price advantage fades** considerably as the insured person get older.

> **Example:** Your mother, who's 62 and healthy, gets a reasonably-priced term life insurance policy for $100,000 that lasts 10 years. Ten years later, she's still in good health—but replacing the $100,000 policy could cost two or three times what it did before...if she can get one at all. (And this assumes, she's still in good health.)

Beyond term policies, there are some forms of life insurance that build **cash value** or equity over time. And these are of more value to your parents when they are older. Cash value policies include:

- whole life;
- universal life;
- blended whole/universal life;
- interest sensitive whole life;
- variable life;
- variable universal life; and
- variable blended whole/universal life.

In most cases, **cash value premiums** start higher than term premiums; but they stay level...and the policy accumulates a redeemable equity as time goes on. Once commissions and expenses to the policy are paid, the cash value of the policy increases over the long haul, thus making the long-term investment in a policy key.

A cash value policy makes sense if your parents:

- are accumulating cash for the future;
- need coverage for more than 15 years;
- are in a high tax bracket; or
- were over 35 when they bought their first policy.

The most common of these kinds of insurance is **whole life**. Whole life insurance is a permanent form of insurance protection that com-

bines a **death benefit** with **cash value accumulations**. In a whole life policy, the **face amount**—the amount paid if the insured person dies at any time while the policy is in effect—remains constant.

At retirement, many people use the accumulated cash value in a whole life policy to **supplement retirement income**. This gradually reduces the death benefit. So, if your dad retired last year and has started to use his whole life policy to add to his fixed income, the amount his policy pays when he dies will depend on how long he lives and how much he takes out from the policy.

> Whole life is preferred to other kinds of life insurance by most people because it combines protection and savings—two major factors in the financial plans of most families.

In addition to the death benefit or eventual return of cash value, a whole life policy has some other significant features. During a financial emergency, policy loans may be available. Some whole life policies also pay dividends.

The policy owner also has options as to how dividends will be received. They can be taken in cash or applied toward premium payments. They can also be held by the insurance company and earn interest—and then be transferred later. Finally, they may also be used to buy additional amounts of life insurance.

After a whole life policy has a cash value, certain values are guaranteed upon the lapse or surrender of the policy. Any of these options (which are known as nonforfeiture options) may be used to pay premiums and keep the policy in force.

Another common form of cash value coverage is **universal life**. With this kind of policy, your parents can pay premiums at any time, of virtually any amount. The amount of cash value the policy builds is based both on the **premiums paid** and on the **interest earned**. The insurance company subtracts money from the policy each month to cover the cost of the insurance and expenses.

> While universal life policies build cash value, they seek to compete in the term insurance marketplace. They offer standard rates that can be substantially cheaper—as much as 30 percent or more—than standard rates charged by insurance companies for comparable term coverage.

Some universal life policies feature **progressive underwriting** (which means it's easier to get coverage, even if your parents don't look insurable on paper). These policies usually are structured so that if your parents pay minimum annual premiums, coverage won't lapse for 15 or 20 years.

Another form of this insurance is **variable universal life**. It provides death benefits and cash values that vary according to the investment returns of stock and bond funds managed by the life insurance company. These policies also allow your parents significant discretion regarding the premiums paid each year.

For many people, variable universal life is as much an **investment tool** as a true insurance tool.

Target premiums are fixed in the first year—but policyholders, because of the flexible nature of the products, are not contractually entitled to those amounts in subsequent years. In fact, target premiums for variable universal life insurance are among the highest in the industry. This is why marketers sell variable universal so aggressively—because their commissions are often based on target premiums, so they can make more selling this than any other kind of life insurance.

In some cases, the **cost basis** of variable universal life becomes too uncertain for most people because of the open-ended method of premium payment.

Retirement Options with Cash Value

Buying a life insurance policy is time consuming—in the sense that you must research the various types, pick one and find a company

that: 1) has competitive premiums for the benefits your parents will receive; and 2) will be around when it comes time to collect.

Overfunding a policy—making big payments up front when the policy starts—is always a good way to earn earnings faster. Finding one with a low-load (i.e., one with low fees and commissions, such as less than 1 percent a year and 10 to 20 percent a year respectively) will also make for a healthier policy. But many of these points are moot for parents who bought policies decades ago.

Once your parents retire, they can use their cash-value life insurance policy in several ways. They can borrow cash values or annuitize payment plans. Both methods allow them to use their money for retirement, but each has distinct pros and cons.

Borrowing allows your parents to avoid income taxes; however, if they borrow all of their cash value and the policy terminates, they will be hit with capital gains tax on any amount in excess of the premiums they paid—for money they spent years ago. This kind of capital gains tax can be a nasty surprise at age 80 or 85, when most people are busy worrying about health coverage or estate taxes.

> **Depending on the individual policy characteristics (the crediting rate, the dividend, etc.) and the actual amount your parents decide to withdraw, they may be able to avoid paying back a policy loan. If they are careful to keep enough cash in the policy to keep it in force, upon their death, the life insurance proceeds will pay off the loan.**

A caveat: Be very careful about the **rate of return** your parents assume when figuring out how much money they can take out. Overzealous insurance agents sometimes will show illustrations that promise unrealistic retirement benefits. Your parents need to remember that illustrations are based on the *assumption* that the company will continue to credit the cash value of the policy at a certain rate. However, many people lost a lot of money on these investments in the

1980s, when interest rates fell and policies weren't performing the way consumers expected—and the same thing happened again in the early 2000s.

Annuities

Another option is for your parents to annuitize the cash value of their policies. This can be done either according to annuitization guidelines within the existing policy or by converting the cash value into a stand-alone annuity contract.

> Annuities play an important and growing role in the life insurance market. They are a special form of insurance that combines elements of basic insurance and fixed-income investment—and offer some tax advantages. Strictly speaking, they are not life insurance contracts, but they often are sold by life insurance companies and agents.

Life insurance is designed to protect against the risk of premature death. You may have heard annuities described as upside-down life insurance. From the insurance company's standpoint, an annuity presents the opposite mortality risk from life insurance: Life insurance pays a benefit when someone dies; an annuity only pays a benefit if someone or someone's beneficiary is living.

So, what is an annuity? Essentially, your parents agree to pay a certain amount of money to an insurance company, either in a lump sum or several payments. After a period of time, the company agrees to make a series of payments back to your parents. The earnings on the annuity are not taxed until your parents receive their distributions.

The basic function of an annuity policy is to liquidate a sum of money systematically over a period of time.

Annuity contracts offer a tremendous range of options. Your parents can buy an annuity with a single payment or a series of periodic

payments. They can schedule benefits to begin immediately or be deferred until a specific future date. They can choose an annuity that pays benefits for a specific period of time—or for the lifetime of one or two individuals. It can begin paying those benefits on a specific date (such as when they reach a stated age) or a contingent date (such as when one parent dies).

An annuity that pays benefits immediately typically will provide a steady stream of retirement income in return for the purchase. An annuity that pays benefits at a later date (a deferred annuity) typically will help accumulate money.

> **Usually, but not always, an annuity guarantees a lifetime income for the recipient.**

The **annuitant** is the insured, the person on whose life the annuity policy has been issued. As with life insurance, the owner of the contract may or may not be the annuitant. Unlike insurance, though, the annuitant *is* the intended recipient of the annuity payments.

Depending on the type of annuity and the method of benefit payment selected, a **beneficiary** also may be named in an annuity contract. In these cases, annuity payments may continue after the death of the annuitant, for the lifetime of the beneficiary or for a specified number of years. So, if your dad dies, your mom (as a named beneficiary) can keep getting the payments for the rest of her life.

Beyond these basic terms, it's hard to generalize about annuities because there are so many varieties, each tailored to fit an investor's specific needs. But they are useful tools to avoid outliving one's money...and could become important to your parents' financial health if they live a long time.

(In Chapter 8, we'll delve deeper into how you can use annuities to achieve specific financial goals. In this chapter, we'll focus more on the mechanics of how they work.)

You'll want to have a general understanding of what annuities can do for your parents over the course of their later years...before talking with the sellers of these policies. There's a lot of promotional material out there about annuities—and lots of salesmen, agents and "financial planners" ready to sell your parents with a good pitch.

Most investors think of annuities as souped-up certificates of deposit (CDs) or mutual funds that allow your money to compound free of taxes. And that's how one version—deferred annuities—works. But annuities were originally intended not as accumulation vehicles but as a way to convert assets into a steady income, a process known as "annuitizing" or "annuitization."

Fixed vs. Variable Annuities

There are two principal types of annuities: fixed and variable.

A **fixed annuity** is a fully guaranteed investment contract. Principal, interest and the amount of the benefit payments are guaranteed. In other words, what happens to the money in a fixed-income annuity is spelled out legally.

> **By guaranteeing both the principal and the interest, a fixed annuity is like a CD purchased from a bank. However, a CD is backed by the Federal Deposit Insurance Corporation (FDIC). A fixed annuity is not—its security is directly related to the financial health of the company selling it.**

There are two levels of guaranteed interest for a fixed annuity: current and minimum. The current guarantee reflects current interest rates and is guaranteed at the beginning of each calendar year. The policy also will have a minimum guaranteed interest rate—such as 3 or 4 percent—which will be paid even if the current rate falls below the policy's guaranteed rate. These minimum rates are set by state law.

In 2001 and 2002, with interest rates declining, fixed annu-
ities became hot investment properties again. But those same
low interest rates made it hard for some insurance companies
to meet the minimum rate requirements. So, some companies
increased fees and played other games to recoup money.

A **variable annuity**—like variable universal life insurance—is designed to provide a hedge against inflation through investments in a separate account of the insurance company, consisting primarily of common stock. If the portfolio of securities performs well, then the separate account performs well, so the variable annuity—backed by the separate account—also will do well. If the company's investments don't do well, neither does the annuity. In other words, there is investment risk involved; there is no guarantee of principal, interest or investment income associated with the separate account.

An insurance company or salesperson will provide a prospectus when your parents are considering a variable annuity.

Different annuities will offer people different investments,
which offer different degrees of risk and reward. The invest-
ment options include stocks, bonds, combinations of both or
accounts that provide for guarantees of interest and princi-
pal. By choosing among the available fund options, your par-
ents can create an annuity that meets their objectives—and
their tolerance for risk.

If the funding options your parents choose for their annuity perform well, they'll more than exceed the rate of inflation—or the rate for fixed annuities. If they don't, they may lose not only prior earnings, but even some of their principal. However, some policies will guarantee that the value cannot fall below a minimum level. A fixed account option will guarantee both principal and interest, much like a fixed annuity. This way, your parents have the option of dividing their money

between the low-risk fixed option and high-risk funding options, such as stocks, all in one annuity.

With either type of annuity, expenses are deducted from earnings. Either a fixed or a variable annuity can **guarantee expenses**, which means any deductions made to annuity benefits are guaranteed not to exceed a specific dollar amount or percentage of the account.

Mortality also can be guaranteed, which provides for the payment of annuity benefits for life.

Occasionally, you may decide that it's in your parents' best interest to purchase an annuity that offers some guarantees but also offers protection against inflation. This type of annuity usually is identified as a **combination or balanced annuity**.

Both sorts of annuities may be purchased with a single payment, or your parents can make periodic payments. A single-premium or single-payment annuity usually is purchased with money transferred from some other investment.

Example: Your parents convert a 20-year-old cash-value life insurance policy into an annuity that pays them a set amount each month soon after they retire. The advantage of this conversion is the deferral of any taxes that would be owed on the cash value if it were paid out in a lump sum.

Variable annuities also may be purchased with a variable-premium feature, known as a flexible-premium deferred annuity (FPDA) contract. Like variable universal life insurance, this type of annuity allows your parents to pay as much or as little as they like during each premium period—though there's usually a minimum payment required.

When...and How...an Annuity Pays

If your parents pay for an annuity in a single payment, the benefits may begin immediately (typically, within a month) or they may be de-

ferred. If an annuity is purchased with a series of periodic payments, then the benefits will be deferred until all payments have been made. (This second kind of annuity is commonly called a **periodic-payment deferred annuity**.)

There are two periods of time associated with an annuity: the **accumulation period** and the **annuity or benefit period**.

The accumulation period is the time during which your parents make contributions or payments to the annuity. The interest paid on money contributed during this time is tax-deferred. That interest will be taxed eventually—but not until they begin to receive the benefits. The contributions are placed in what is called a **separate account**.

The annuity period is the period following the accumulation of their payments (principal and interest), during which annuity benefits are received. Your parents can usually choose to receive income payments monthly, quarterly, semiannually or annually.

A variable annuity poses several other issues.

As evidence of participation in the separate account, **units of the trust** are issued. During the accumulation period, these units are identified as accumulation units. Both the number of units and the value of these units will vary in accordance with the amount of premium payments made and the subsequent performance of the separate account.

> **Example:** Jack invests $100 per month in his variable annuity. On the day the insurance company receives his $100 payment, the value of an accumulation unit is $10. Thus, Jack is credited with 10 additional accumulation units.

When your parents reach the annuity period, the **accumulation units** are converted to **annuity units**, and the number of annuity units remains constant, since no further money is being contributed.

While the number of annuity units remains constant, their value varies in accordance with the daily performance of the separate account. Accordingly, during the annuity period, the size of the monthly

benefit check will vary depending on the value of the annuity units at the time the check is issued.

Annuity settlement options determine when and how the annuity will pay—and to whom. Even if your parents elect one option when they buy an annuity, it may (and probably will) be changed at the annuity period to reflect your parents' changing needs. (These changes usually have something to do with retirement or the death of a spouse.) Both variable and fixed annuities offer the same options for settlement of the contract.

> The amount of money available during the annuity period is determined by the annuity option selected, the amount of money your parents have accumulated and their life expectancy.

A **life-only or straight-life** option provides for the payment of annuity benefits for your parents' lifetime—with no further payment following their death. There is a risk involved—in that they must live long enough once the annuity period begins to collect the full value. If they die shortly after benefits begin, the insurance company keeps the balance of the unpaid benefits. This option will pay the highest amount of monthly income, because it is based only on life expectancy, with no further payments after the death of one of your parents.

A **refund option** will pay your parents for life, too—but, if they die shortly after the annuity period begins, there may be a refund of any undistributed principal or the cost of the annuity. The refund may take the form of continued monthly installments or it may be in one lump sum (a cash refund annuity). This option assures them that the full purchase price of the annuity will be paid out to someone other than the company issuing the annuity. If they live well beyond the average life expectancy, then all of their investment in the annuity probably will have been paid and there will be no refund.

Life with period certain is basically a straight-life annuity with an extra guarantee for a certain period of time. (This is the most popular choice for payment option.) It provides for the payment of annuity benefits for, let's say, your dad's lifetime but, if he dies within the predetermined period of time, annuity payments will be continued to a survivor, such as your mom, for the balance of that period.

> The period certain can be just about any length of time—five, 10, 15 or 20 years. Most often, the period selected is 10 years, because 10 years is approximately the average life expectancy of a male who retires at age 65. Thus, if your dad retires at age 65, selects life with 10 years certain and dies at age 70, his survivor will receive the monthly annuity payments for the balance of the period certain (five more years).

The **joint-survivor option** provides benefits for one's lifetime and the life of the survivor. So if your dad has the policy, a stated monthly amount is paid to him and, upon his death, the same or a lesser amount is paid for the lifetime of the survivor—your mom. The joint-survivor option is usually **100 percent, two-thirds** or **one-half** of the baseline benefit.

The joint-survivor annuity option should be distinguished from a joint-life annuity, which covers two or more annuitants and provides monthly income to each of them until one dies. Following the first death, all income benefits cease.

If your parents turn $200,000 over to an insurance company and name each other as beneficiary, when one dies the annuity remains for the survivor. The size of payments may vary—from company to company—depending on each insurer's estimate of their life expectancies and how much each felt it could earn investing their money.

If you're really worried that your parents will outlive their money, you may want to consider a **deferred annuity**. For example, if your parents purchase an annuity deferred to age 85, they are insuring the

risk that they run out of money before reaching age 85. These annuities pay nothing if they die before age 85, so they are **much cheaper than the other annuities**. Payments commence when your parents reach age 85. Of course, they have to pay for these annuities long before they mature, thus taking money out of their portfolio that they won't see for some time. But these kinds of annuities can be worthwhile—especially if you're concerned about their ability to stay afloat in their later years.

LTC Riders on Life Insurance Policies

Among the other benefits life insurance policies offer is the **LTC rider**. As people live longer and need the benefits provided by long-term care insurance, such riders are becoming ever more popular. Insurance companies are responding by creating new kinds of policies that combine life and long-term care coverage, attaching a rider to a new issue of life insurance or possibly some other policy form, such as a disability income policy. With this marketing approach, there are two sales, the life sale and the LTC sale, which can be beneficial to the insurer, the policy holder and the agent.

This combination of benefits is marketed as a "living benefit" or "living needs" rider. It draws on the life insurance benefits for LTC coverage—the LTC rider is attached to the life policy "at no charge." It's like borrowing from the life insurance to pay LTC benefits.

> One of the big positives of the LTC rider is that the policy holder gets all of the advantages of both the life insurance and LTC policies, especially the life insurance policy's required nonforfeiture provisions that are not required for LTC policies.

Here's how the combined life/LTC insurance product works: Your parents buy cash-value life insurance and satisfy their coverage needs by adding a LTC rider to it. When they need long-term care,

they start taking money from the death benefit—usually on a prearranged schedule. These withdrawals are tax free. When they pass away, their beneficiaries get the insurance's death benefit minus whatever monies they have withdrawn. For example, taking $60,000 from a $100,000 policy leaves $40,000 to be paid to their beneficiaries.

Specific examples of this product include New York Life's *Asset Preserver*. Your parents put up a single cash premium—enough to buy a minimum of $24,000 of universal life insurance (specific costs vary, depending on age, sex and health) and then decide how many months they want the LTC benefits to run. They can take payments over as little as two years or as many as four years (after four years, New York Life extends its policy for another 18 months). The payments are guaranteed to last for the promised period.

A 65-year-old woman, investing $50,000 in this type of policy, would get $92,150 in death benefits and pay about $252 a year for the LTC protection. Currently, women account for roughly 70 percent of the LTC rider business.

CNA Insurance's version of this policy is called *Viacare*. It pays benefits at the fixed rate of 2 percent a month. John Hancock offers *Unison*—a variable universal life policy plus an LTC rider. With this policy, your parents invest their policy's cash value in mutual funds. The money available for LTC care will depend on how much your parents put into the policy and how the markets do.

Of the policies sold, the average face value in 2002 was about $450,000. If your parents are 55 and want to assume that their policy will earn 10 percent on its investments, they'd pay $5,839 a year plus $348 for LTC benefits. If they want to assume a 6 percent return, they'd pay $8,237 for the insurance and $360 for the LTC benefits.

LTC rider benefits can be similar to those found in an LTC policy. The benefit structure includes the following: elimination periods in the

range of 10 to 100 days; benefit periods of three to five years or longer; prior hospitalization of at least three days may be required; benefits may be triggered by impaired activities of daily living; levels of care include: skilled, intermediate, custodial and home health care. In addition, certain optional benefits may also be provided such as adult day care, cost of living protection, hospice care, etc.

The LTC rider includes an explanation of how the long-term care benefits interact with other components of the policy, an explanation of the amount of benefits, the length of benefits and the guaranteed lifetime benefits—if any—for each covered person, as well as any exclusions, reductions or limitations on long-term care coverage.

One difference with this "LTC package" is the method of determining LTC benefits. The benefits may be expressed as a specific daily amount: $50, $100 or $150 per day for example. They may also be expressed as a factor of the face amount of the life policy. For example, 2 percent of the face amount of the policy may be paid monthly as an LTC benefit up to a specified maximum.

Generally, the **living needs rider** provides funds for LTC expenses or expenses incurred with a terminal illness. Under this rider, the owner may be advanced life insurance dollars to cover these expenses. There are usually two options associated with this rider:

1) LTC option, which may provide up to 70 to 80 percent of the policy's death benefit to offset nursing home expenses.

2) Terminal illness option, which can provide 90 to 95 percent of the death benefit as a pre-death benefit to offset medical expenses.

In the late 1990s and early 2000s, insurance companies began offering policies that combined the investment advantages of **annuities and LTC insurance**. An annuity, designed to be a retirement vehicle, may be issued with an LTC rider in much the same way that the LTC rider may be attached to a life insurance policy. With this arrangement, the annuity provides necessary funds to help with LTC

expenses. This reduces the amount of money in the annuity and, consequently, the monthly retirement income that the annuity produces.

One final use of an **LTC rider is in combination with a disability income policy**. Disability income insurance is designed to protect a person's most important asset: the ability to earn an income. However, the disability income need normally ends at age 65 or retirement since the policy holder no longer has earned income.

LTC riders are fairly new to the life insurance business, so it's best to do some homework when deciding upon a policy and whether the benefits it provides are in line with the premiums your parents pay.

Life Insurance Trusts

We hinted at life insurance trusts briefly in the beginning of this chapter when we said how taking out a life insurance policy on a parent is a way of insuring certain hard-to-value family assets—like a business. More on this topic will be discussed in Chapter 12; but it's worth mentioning a **life insurance trust** here since it's a widely used but unfortunate name for an irrevocable trust used to buy insurance as an investment. (The trust can also be authorized to hold a range of investments, and not just life insurance.)

Remember that proceeds from policies your parents own will be included in their estate, even though the policies are paid to a third party. If an irrevocable trust owns the policy, however, death proceeds can be received by the family income tax free (as usual), yet not be included in your parents' taxable estate.

A trust is not necessary to get this result. If you—as a son or daughter—owns, pays for and is a beneficiary of a policy on the life of a parent, you can receive the policy proceeds with no taxes due. So, one of the smartest money things you can do as a son or daughter is fund estate taxes and other costs by taking out a policy on your parent's life. This may sound mercenary; but, if your parents have a big estate, it's smart.

Trusts that hold insurance provide for the use and management of the policy proceeds according to one's wishes. The beneficiaries might not be old enough to manage a sizeable lump sum of money.

Too often, an **irrevocable life insurance trust** is prepared by an attorney as part of a family estate plan, but little guidance is offered on avoiding taxes.

An existing policy can move out of your parents' estate if transferred to an irrevocable trust and if they retain no incidents of ownership. But your parents have to plan ahead to take tax advantage of this transfer. Policies transferred to a life insurance trust within three years of death will be included—and taxed—in the estate, anyway.

An unfunded irrevocable life insurance trust is an estate and income tax planning tool for use in solving a variety of problems. It can be used to:

- protect and preserve assets;

- manage assets professionally;

- avoid probate;

- provide a source of estate liquidity;

- create tax exempt wealth; and

- save taxes in general.

It accomplishes the last two points by:
- lowering or freezing the value of an estate by the grantor divesting himself of ownership of the property; and

- passing estate taxes by keeping the principal out of the estates of grantor and the grantor's spouse.

So, if you can't get your mom or dad to understand the value of a trust in the form of a life insurance policy that can shelter some of your family's **assets from being lost to taxes**, explain to them the benefits a policy can have on you and the people they leave behind (your siblings and any grandchildren).

Unlike what the name implies, a life insurance policy isn't necessarily about the *life* of an individual... but rather the **assets accumulated during that person's life**.

Life Settlements

There's a trend today among some retirees that isn't a smart thing to do: cashing out a life insurance policy through a so-called life settlement. This is when a company (the "life settlement" company—*not* the insurance company) persuades financially secure seniors to sell their life insurance policies.

The seller gets a payout greater than the cash value of the policy; the buyer keeps paying the premiums and eventually collects on the insurance payout when the seller dies.

Historically, terminally ill people have used this strategy (sometimes also called a **viatical settlement**) as a way to access much-needed funds for medical needs, but more retirees are doing it because they don't have other assets to meet immediate financial needs should they arise or they don't fully understand the importance of maintaining the full value of their life insurance.

In some cases, cashing out a plan may make sense, but your parents should be careful. **The industry has been marred by scams.** Only a handful of legitimate settlement companies exist; and fraudulent ones pop up to abuse vulnerable seniors, exaggerating the benefits and cheating people out of the protections their policies were meant to provide.

Your parents should sell their insurance policy only as a last resort. Although they may think they're getting a great deal by receiving thousands more than the cash value of the policy, they may not consider the tax implications of policy sales. And, even though your parents may think they don't need a policy anymore because you and your siblings are grown and educated, they should understand the benefits a policy provides when someone dies.

> If your parents want to cut their premiums, selling the policy isn't the answer. They can reduce the death benefit to lower the premium. Or, they can use one of the nonforfeiture options available from all insurance companies. If possible, they can trade a portion of their permanent policy in for paid-up term life insurance or convert it into an annuity.

Before your parents decide to sell their policy, they should seek advice from a certified public account who knows the tax implications. And, as a son or daughter you'll want to stay on top of this endeavor. Con artists in the settlement business can beguile the smartest of elders. You don't want to learn after-the-fact, that the policy has been sold to a shady company, April 16th arrives and your mom owes thousands of dollars (that she doesn't have) in taxes.

Insurance and Creditors

One of the unique features of life insurance is that the life insurance proceeds are **exempt from the claims of the policy holder's creditors** as long as there is a named beneficiary other than the policy holder's estate. Even the cash value of a life insurance policy is generally protected from creditors.

This can be a big deal, if you're anticipating a life-ending illness that may drain your parents of resources.

Although the life insurance contract is between the policy holder and the insurer, once that person has died, a contractual arrangement exists between the insurer and the beneficiary. The beneficiary has a right to sue the insurer if payment isn't received in a timely manner.

The **spendthrift clause** common to many policies is designed to protect the beneficiary from losing proceeds to creditors, assigning the proceeds to others or spending large sums recklessly.

The spendthrift clause is not applicable to lump sum settlements but is operative with settlement options. It only protects the portion of

proceeds not yet paid (due, but still held by the insurer) from the claims of creditors to the extent permitted by law. As long as proceeds are paid according to a settlement option in which the insurance company keeps the proceeds and sends a monthly payment to the beneficiary, then the amounts received by a beneficiary are exempt from the claims of the beneficiary's creditors.

This provision allows the insurer to select a beneficiary if the named beneficiaries cannot be found after a reasonable amount of time. To facilitate the payment of the death proceeds, the insurer may select a beneficiary if this provision is in the policy. This provision is found most often in policies with small death benefits, such as industrial life insurance. The insurer would usually select someone who is in the family's immediate blood line (a brother, sister, aunt, etc.).

Conclusion

As a son or daughter, finding out if your parents have a life insurance policy is the first step. Knowing how it can be used to provide some financial security should one or both of your parents die, is second. It's often an unnecessary expense to purchase one if your parents already have a nest egg large enough to support the family in the event of a death. However, if your parents have a particularly large nest egg—at least $1 million, which could generate estate taxes—then it's probably worthwhile to look into purchasing some insurance.

The goal for parents is to have enough money that it outlives them, allowing them to, in the least, live a good life until the end, or, better yet, leave something behind for their survivors. **Life insurance is sold in various packages by many insurance companies.**

If you log onto AARP's Web site (www.aarp.com), you'll notice that the organization that specializes in promoting the health and well-being of retired Americans promotes New York Life's products. But there are many options when it comes to policies so don't let one

company be your last stop. Compare prices and benefits, plans and stipulations. Gauging how long your parents will live isn't an easy thing to do; picking out the best policy for the best price to ensure their future is relatively easier.

In the next chapter, I'll give you strategies for helping your parents find the resources for living out the rest of their lives. Some of these strategies we've already begun to discuss, like annuities. I'll take a closer look at these as well as how your parents should begin to view money, their assets and their spending habits.

8 Outliving Their Money

I never expected Mom to be around this long! Honestly, I expected her to go soon after Dad died. That's when she started having some health problems...and then she started going senile. Her doctor says it's non-Alzheimer's dementia. But now she'll be 88 next year and her health has gotten better. Her doctor says she could live another five years—and I'll be pushing 70 by then. I hadn't been planning for her to live into her 90s. What if the money runs out? How will I take care of her? Dad did leave her some money...but I'm not sure how to make it last.

ᕙᕗ

The main issue that older Americans face: Outliving their resources. Having enough resources to last through your life is everyone's ultimate financial challenge.

The issue can affect a person badly in either of two ways. First, an older person **doesn't understand the risk** of outliving resources and mismanages them—spending too quickly when there may be decades left to live. Second, an older person **becomes paranoid about the risk**. The fear of living beyond his or her means becomes so strong that it warps an older person's ability to make good decisions about money.

You need to make sure that your parents have clear goals about what they need to live comfortably in their old age.

There are some basic ways to calculate your parents' needs and the resources they have, in order to estimate the time they have left and whether they are ahead of or behind the financial curve. These calculations rely on two kinds of information:

- **standard longevity tables** and some knowledge of your parents' health; and

- a rough understanding of the **money-management tactics** that apply to the needs of older people.

Life Expectancy: The Longer Your Parents Live...

It's no news that people are living longer. Advances in medicine and people's general awareness of what a healthy lifestyle means (i.e., diet, exercise, etc.) have dramatically changed life expectancy charts. There are also fewer accidental deaths today. If you are a 55-year-old female you can expect to live to 85; but if you're already 70, you can expect to live to 87. You get two more years because, if you've made it to 70, chances are you're in decent shape. Likewise, while a 75-year-old female can expect to live to 89, an 85-year-old can expect to live to 93. This goes on and on, and makes sense out of the phrase "The longer you live, the longer you live."

> You can find a chart with general life expectancies based on mortality rates by going to the National Center for Health Statistics, a division within the Centers for Disease Control and Prevention, at www.cdc.gov/nchs. But these statistics are only averages of how long your parents may live. A lot of lifestyle choices and genetic makeup go into the actual number of years your parents will be around. If they've lived to see 80 years, they'll probably live to see more.

The age-adjusted death rate in the United States reached an all-time low in 2000 of 872 deaths per 100,000 population. And life

expectancy reached a record high of 76.9 years at birth. If you're interested in "calculating" your parents' life expectancy, you can do so at www.livingto100.com. You'll be asked a series of questions that lead to an estimate of how long they'll live based on their lifestyle, genetics and family history. Meanwhile, consider these figures:

- the average life expectancy in 1900 was 49 years;

- some researchers say that 50 percent of baby girls born in the early 2000s will reach age 100;

- the average American expects to die at age 91.

A variety of upcoming medical breakthroughs will change how common ailments affect people. Medical researchers predict that, in the first half of the 21st Century:

- drugs will be available to fix the walls of blood vessels;

- heart disease will no longer be the leading cause of death;

- new therapies—including surgical procedures—will significantly reduce the risk of stroke;

- the most damaging effects of stroke will be reversible even up to 12 hours after the event.

Cancer may remain an enigma, but by 2010 many of the 300 different cancer treatments being developed during the early 2000s will be commercially available.

All this means that you need to plan for **a longer retirement** for both you and your parents. Since this book focuses on your parents, we'll help you decide whether or not your parents have assets that will last as long as they do.

A Stockpile of Assets

In most cases, your parents have spent a great deal of their lives stockpiling assets, adding more along their way so that at some point,

they can turn those assets into income that will carry them through the rest of their lives.

If your parents did little advance planning, that's where you come in. You may find yourself helping your parents manage their withdrawals so they don't run out of assets before they run out of time. This can be more challenging than filling that warehouse.

Pulling Money Out As They Need It

When it comes to converting investments into spendable cash, one way is simply to pull the money out as needed. This means that your parents live on **interest and dividends** from fixed-income investments or that they **withdraw a certain percentage** of their portfolio's value each year and adjust that amount for inflation to maintain purchasing power.

This method allows them to maintain **complete control** of their assets. If they get hit with sudden expenses, they can boost their withdrawals to meet those expenses. They decide which stocks or fund shares to buy or sell and can work tax laws to their advantage.

The "as you need it" approach does have some setbacks. First, it requires **regular attention** and management. Some people don't want to do that. Your parents could **invest badly** and lose their money. If neither you nor they are good about how to estimate the length of draws on assets before running out, they might find themselves in a jam when they're still kicking but are out of money.

> **Don't assume that, if life expectancy charts say that your mom is 65 now and she's expected to live to 85, you should only plan for her living that long. She might live to 95. Or 105!**

A life expectancy of 85 means that roughly 50 percent of the 65-year-olds alive today will have died by age 86. The other 50 percent, however, will live beyond 86, in many cases well beyond. In fact, a

65-year-old woman today has about a 15 percent chance of making it to age 95 and a 4 percent chance of living to 100.

The second problem with the withdrawal system is the tendency to be too optimistic about their money. The markets can be sketchy; anything can happen to change the ball game and make for a very stressful life. Based on average annual returns of about 15 percent for stocks and 10 percent for bonds during the 1980s and 1990s, you might think that an inflation-adjusted withdrawal rate of 10 percent is reasonable. Many people do. But those recent averages are well above historic norms and they become irrelevant during a market downturn like the one that started in 2000, where many stocks lost 30 percent or more of their value.

If something happens in the market that trims your parents' portfolio down considerably, they won't be able to maintain their usual withdrawals over the long haul.

> **Example: Someone retiring at the beginning of the 1973 to 1974 bear market with a portfolio invested 60 percent in stocks and 40 percent in bonds would have run out of money in less than eight years with a 10 percent withdrawal rate. Even a change in the withdrawals to a rate of 5 percent would have kept the portfolio going only another 13 years.**

Financial planners often suggest that retirees need between **two-thirds and three-quarters of their pre-retirement income** to maintain their standard of living. That's based on the assumption that spending in retirement declines as expenses such as commuting, business clothing and the shrink disappear.

Your parents can reduce the chances of their portfolio running dry by starting with a lower withdrawal rate or by reducing their withdrawals during market setbacks. They can also think about changing the mix of their portfolio, weighting it with some stocks to decrease—though not eliminate—their odds of running dry. But unless they choose a withdrawal rate in the neighborhood of 3 to 4 percent or they are

fortunate enough to be retired during a time when the financial markets rack up impressive returns, they face a small but significant risk that their money will run down before they die.

Life on the Investment Margins

Old people, like professional investors, live and die at the **margins of investment returns**. Small increases or decreases can make for big increases or decreases in their quality of life.

This is the opposite of the way people in the beginning or middle of their working lives—you, in most cases—are advised to think about money. You're probably accustomed to hearing advice about taking advantage of compounding...and of keeping your retirement money working in long-term investments so that the ups and downs of daily stock market swings don't matter.

While a stock-market decline is painful for everybody, younger people saving for retirement actually benefit because they can buy shares cheaper. Likewise, a drop in interest rates is a boon for younger Americans who can refinance their mortgages to slice their payments. But cheaper shares and lower rates are an entirely different story for retirees who are selling shares and depend on fixed-income instruments for money to live on. They can't afford the long-term view anymore. They need steady income and can't ride out downturns.

The 4 to 5 Percent Approach

If you're wondering how much your parents should be withdrawing from their nest egg on a monthly basis to cover expenses, it's good to know about the 4 to 5 percent rule. Although the actual withdrawal amounts will vary with age and health, under this approach your parents should target spending no more than 4 to 5 percent of their accumulated assets. So, if they have a nest egg of about $500,000, invested in stocks, bonds and cash equivalents, they can safely with-

draw about $2,000 a month, or $24,000 a year, regardless of the returns each year. This reduces your parents' risk of losing it all in a down market. Because they are taking out a fixed percentage, when the market rises, they can take out more each month; if it hits a rocky period, they automatically take out less.

> Most investment experts will tell your parents to divide their nest eggs between equities and fixed-income securities. They should be focusing on the total return of their portfolio instead of just income. During stable markets, stocks can be income producers because they can keep up with inflation.

With this strategy, your parents build a balanced portfolio of typically 40 percent stocks and 60 percent bonds and settle on a 4 or 5 percent withdrawal.

If your parents adopted a 5 percent withdrawal rate, retired with $400,000 and their investments grew 5 percent a year, they would pull out $20,000 in the first year of retirement, $21,000 in the second year, $22,050 in year three and so on. (The withdrawals would increase or decrease each year, in proportion to their investments.)

This approach usually combines dividend and interest payments with asset sales to maintain the steady withdrawals. Not surprisingly, retirees like the idea of getting increasing income every year. But there's a hitch: If your parents slavishly follow the strategy, they could rapidly deplete their nest egg if markets are unkind.

Baltimore's T. Rowe Price Associates calculates that, with a balanced portfolio and a 5 percent withdrawal rate, there is a 42 percent chance they would run out of money over a 30-year retirement.

The Critical Mass Approach

If you listen to Bob Brinker's *Money Talk* radio program, you are familiar with the **critical mass approach** to investing. Brinker

described this approach as having accumulated enough wealth that you only have to work if you want to. I'll try to quantify this approach mathematically.

Assume that your parents need $65,000 a year in income to retire comfortably. If, combined, they get $20,000 a year from Social Security, they'll need another $45,000 in retirement income. How big would their portfolio need to be to earn them this much money?

Count any recurring income from defined benefit pensions. If your mother worked as a teacher and can count on $20,000 in annual pension income, you're already down to $25,000.

So, your parents investments will need to generate $25,000 a year. The 5 percent rule means that they would need to have $500,000 in investment assets to reach critical mass.

Obviously, having half a million dollars above their pension benefits is going to tough for most middle-class people to accomplish. In most cases, your parents' home is going to be the largest single asset that they have to contribute toward this number—that is, if they sell it or use some form of financing to get money out of it.

In many cases, though, the critical mass approach is going to impress on your parents that they need to work longer and save more.

Other Approaches

There are other strategies that lessen the risk of outliving their portfolio—of course, each of these poses different risks of its own. But, they are worth considering. The options include:

Income for Life. During the 1990s and early 2000s, immediate-fixed annuities became a popular choice among financial advisers. In its simplest form, an immediate annuity involves your parents handing over a chunk of money to an insurance company. In return, they get a check every month for the rest of their lives.

In most cases, an annuity pays more than your parents could get by putting the same money into safe fixed-income investments.

Of course, your parents have to give up access to their money in order to get these better returns.

> The question with annuities comes back to mortality. If you think your parents are going to live a long time, you need to make sure they transfer their assets to an annuity. They may want to keep some of those assets outside the annuity in order to meet unexpected expenses, fund occasional splurges...or provide for heirs like you. As we said in Chapter 6, lumping their tax-deferred, defined contribution plans together into one account and then purchasing an annuity with those funds is a smart move.

Another big problem is inflation, which can gradually erode the value of an annuity's fixed payments. Because of inflation and because of the risk that your parents don't live long enough to get much benefit from an annuity, they might put just 25 or 30 percent of their retirement nest egg in one of these products and then invest the rest in a mix of stocks and bonds.

Lifestyle Based on Income. An old financial rule of thumb says you can spend your dividends and interest income, but you should never touch your capital. Some call it *clipping coupons*. And, in many ways, this is just a conservative version of the critical mass approach.

This is the strategy that most people have followed in the past and it's still used by many retirees—even those who can't articulate their spending discipline. But it's a very conservative approach.

If your parents are heavily invested in stocks, they may find that their portfolio **generates scant spending money**. Stock dividends have generally gone down as a percent of stock price over the years, as companies have put more emphasis on maintaining earnings for future growth instead of paying dividends. This makes some sense because, from a corporate perspective, dividends are taxed twice— once as corporate income and once as individual income to the investor receiving them.

They could, of course, compensate by putting more in bonds...but this could leave them **vulnerable to inflation**. If their interest income doesn't grow and inflation runs at a modest 3 percent a year, the spending power of their interest income will be cut in half after 23 years. And there's another drawback: By refusing to dip into principal, your parents may force themselves to scrimp unnecessarily. In Chapter 10, we'll look into some lifestyle changes that your parents may have to make, no matter which income option they choose to follow, if they find their cash flow thinning...and life going strong.

Using Annuities

As I've mentioned before, annuities are good tools for matching financial resources to life expectancy. An individual retirement annuity is an IRA set up with a life insurance company through the purchase of a special annuity contract. These annuities are probably the best vehicle to protect your parents **from outliving their money**.

An individual retirement annuity operates like a traditional IRA. The main difference is that an individual retirement annuity involves purchasing a contract from an insurance company.

Retirement annuities are described in the federal government's Internal Revenue Code Section 408(b)—right after the section that describes traditional IRAs. **An annuity is a reverse loan.** It's a systematic withdrawal from an investment as a return of interest and principal. Your parents deposit a lump sum (usually from a retirement account) and withdraw a portion each year until it is all returned.

Annuities offer flexibility as to how income is paid. A popular option is "**life with period certain**" distribution, which guarantees an income will be paid out for the life of the annuitant, regardless of total payout—and guarantees that a specific number of payments will be made, regardless of how long the annuitant lives.

Most annuities **guarantee a minimum interest rate** that will be credited to the annuity cash value. The guarantee rate is typically 3 to

4.5 percent when the contract is annuitized. Guarantees are based on the creditworthiness of the company issuing the annuity.

Distributions from the annuity must begin by April 1 of the year following the year the owner reaches age 70½. Until that time, investments in a retirement annuity are usually **tax deferred**.

Your parents can set up an individual retirement annuity by purchasing an annuity contract or an **endowment contract** from a life insurance company. An individual retirement annuity must be issued in **an individual parent's name** as the owner; only the owner and either your **other parent or a named beneficiary** who survives the owner can receive payments.

An individual retirement annuity must meet all the following requirements:

- Your parent's entire interest in the contract must be non-forfeitable.

- The contract must provide that your parent cannot transfer any portion of it to any person other than the issuer.

- There must be flexible premiums so that if your parent's compensation changes, the annuity payments can also change.

- The contract must provide that contributions cannot be more than $3,000 in 2003 (or $3,500 if your parent is 50 or older), and that your parent must use any refunded premiums to pay for future premiums or to buy more benefits before the end of the calendar year after the year in which your parent receives the refund.

- If your parents borrow money against an IRA annuity contract, they must include in their gross income the fair market value of the annuity contract as of the first day of their tax year. And they may have to pay the 10 percent additional tax if they're younger than 59½.

That last point is a killer. Your parents shouldn't borrow against a retirement annuity.

Moving money into a retirement annuity is relatively easy. Your parents can tell the trustee or custodian of their traditional IRA or other retirement account to use the amount in the account **to buy an annuity contract** for them. Documentation from the former custodian must be provided to clarify the tax status of the rollover distribution. As long as the tax status of the rollover is consistent, your parents will not be taxed when they receive the annuity contract—but, in most cases, they will have to pay income tax when they start receiving payments under the annuity contract.

An important thing to point out is that a particular insurance company may not have anything that it calls an individual retirement annuity for sale. Often, the annuities go by other names:

- **Single Premium Deferred Annuity (SPDA)**. With an SPDA, your parents contribute a lump sum of money into an annuity policy and defer an income payout until a later date (usually after age 59½.)

- **Flexible Premium Deferred Annuity (FPDA)**. With an FPDA, you make flexible payments into the annuity contract and defer taking an income from what you have contributed until a future date (usually age 59½).

- **Single Premium Immediate Annuity (SPIA)**. With an SPIA, you contribute a lump sum of money into the annuity, and start to receive an immediate income for a specified period of time.

Annuities vary from insurance company to insurance company. Many pay out **bonus interest rates** in the first year, but drop the interest rates significantly into the following years. Ultimately these annuities are less attractive than they may initially appear.

Your parents should pay close attention to the financial strength of the insurance company issuing the annuity. In most cases, annuities

are not insured by the government. Your parents' money will be invested with this company—so, it's important that the company is in good shape.

If your parents already have an annuity or **endowment contract** (an annuity that also provides life insurance protection) they may be able to use it as a retirement annuity. All endowment contracts issued before November 1978 can qualify as individual retirement annuities.

The important point to remember: No tax deduction is allowed for amounts paid under an endowment contract that are allocated to life insurance. For purposes of making the allocation, the cost of the current life insurance protection under a qualified endowment contract is the product of the net premium cost (determined by the IRS) multiplied by the excess of the death benefit payable under the contract during the taxable year over the cash value of the contract.

Why use an annuity to fund an IRA?

- It is the only funding device that guarantees a retirement income your parents cannot outlive.

- It guarantees a minimum rate of interest for the full accumulation period.

- It guarantees a minimum payout rate at retirement.

- It can be arranged to guarantee income for the lifetime of one of your parents, should the other die.

An Inflation Fighting Tool

Inflation is always a concern to people living on retirement funds. It can erode the critical mass that your parents have achieved…and it can negate the advantages of annuities. But the investment markets are quick to respond to investors' needs.

One good inflation-fighting tool is the **Treasury I-Bond** sold by the federal government. I-Bonds are special for two reasons:

1) they are indexed to inflation, so that bondholders do not have to worry about rising prices eating into the value of their investments;

2) all interest paid by I-Bonds is tax-deferred until received by the bondholder (which makes I-Bonds perfect as retirement investments).

The problem with I-Bonds is that they don't pay as much interest as other fixed-income investments. As a result, your parents would need to buy about $625,000 in I-Bonds to generate $25,000 (or its inflation-adjusted equivalent).

Spending Patterns and Locations

In the late 1990s and early 2000s, hundreds of thousands of Americans took some form of early retirement and headed to Florida, Nevada and other low-tax states for a long life of leisure. The booming U.S. stock market had pressed the retirement accounts of many people earning $30,000 to $60,000 a year into the $500,000 range. Real estate prices in most regions had held up nicely, further increasing paper net worth.

Armies of part-time financial planners had positioned middle-class people to profit from the flush markets...and many decided it was time to take the money and run.

Within three years—by early 2003—the stock markets had lost many of the gains they'd earned in the 1990s. And interest rates were so low that they kept the money earned on bonds and government securities down. Many early retirees who'd left money in the stock market (even through mutual funds) had lost as much as a third...or even half...of their savings.

To many financial advisers, the late 1990s and early 2000s looked like the 14-year decline in the stock market following 1968. Many

workers who retired in 1968—and withdrew 5 percent of their retirement portfolio annually—ran out of money within about 12 to 15 years. This is the main argument against the 4 to 5 percent rule.

How can you make sure your parents avoid the problem?

Divide up your parents' expenses into two groups: **essentials** (food, clothing, housing, medical costs and the like) and **discretionary** (leisure travel, entertainment, gifts and charitable donations). Then ask: Can they cover the essentials with income from fixed lifetime sources like Social Security, corporate pensions and annuities? Then, do they have any money left for discretionary items?

The main retirement expense reductions come from **lower taxes** and **savings needs**—and, sometimes, **housing**. The savings reduction comes from not having to put money away for college...or retirement. Most other expenses remain as they were during working years. And other costs—think medical costs and prescription drugs—will increase for your parents when they retire.

According to a March 2001 study, published by Chicago-based human resources consultants Aon Consulting and Georgia State University, a one-earner family of a retired worker aged 65 and a spouse aged 62 and a pre-retirement income of $50,000, overall spending declines only $603 a year in retirement.

The study used data from the Bureau of Labor Statistics' consumer expenditure survey, which had data on some 5,000 working singles and families and more than 3,000 retirees. It calculated what it called the "**replacement ratio**" needed to maintain a pre-retirement standard of living at various income levels.

Among the study's other findings:

- Post-retirement spending was rising, so the replacement ratio at most income levels was rising. In 1997, a couple with pre-retirement income of $60,000 could maintain their standard of living on 67 percent of that amount. The 2001 study put the level at 75 percent.

- Saving by active workers as a percentage of income was declining. In the 1997 study, a couple aged 50 to 64 and earning $60,000 was saving an average of 5.1 percent of income. In 2001, they were saving 4.2 percent.

- Taxation of Social Security benefits—or lack of it—played a key role in how retirees fared.

The study assumed that retirees would receive the normal Social Security benefits specified by law and that the remainder of their income would come from taxable sources. Social Security benefits for low-income people generally are not subject to federal income taxes. Only after certain thresholds are passed does 50 to 85 percent of the benefit become subject to tax.

As a result, middle-income retirees generally see their taxes drop drastically as payroll taxes end and a big chunk of their remaining income becomes exempt from income tax.

In the early 1990s, a new law boosted taxation of Social Security benefits for higher-income retirees, and it added 3 to 5 percentage points to the replacement ratio of people in the $70,000 to $90,000 income range. So, **low-income and high-income workers need more retirement income** relative to pre-retirement income than do those in the middle.

Taxes (or the end of them) cause this inverted bell curve. Lower-income workers pay lower taxes, so when they stop having to pay them, their expenses don't fall all that much. High-income workers pay a lot of tax but also have higher incomes in retirement. These higher incomes mean they are in higher tax brackets, but they also result in more of their Social Security benefits being subject to tax.

A one-earner couple with pre-retirement income of $20,000 a year would need 83 percent of that income to maintain their standard of living in retirement. Likewise, a couple with pre-retirement income

of $150,000 would need 85 percent of that amount to maintain their standard of living and a $250,000 couple would need 87 percent.

Marital status plays a significant role. For example, in the lowest income levels, pre-retirement taxes are higher for singles than for married couples, so when taxes cease, there's a bigger impact on singles and the replacement ratio is less than for a couple.

Singles at higher incomes face much higher taxes in retirement than couples. For them, the thresholds for taxation of Social Security benefits are lower and the income tax brackets rise more rapidly than for a couple.

At higher incomes, **replacement ratios are generally lower for two-earner couples** than for one-earner couples, both because their Social Security benefits are greater and because there have been two payroll taxes on both incomes.

Conclusion

In the next chapter, I'll take a look at how your parents' biggest assets of all—real estate—can help support them through the later years of their lives.

One thing to think about, however, when you're tallying up the costs of keeping your parents healthy, happy and solvent, is the average standard of living of **where they are**. Do they live in an Upper Eastside brownstone in Manhattan and worry about affording cab fares for another 20 years? Or do they live on a golf course outside Palm Desert, California, and never have to vex over playing another round of golf?

The gap in housing costs between San Francisco and Miami is huge. According to www.BestPlaces.net, a Portland, Oregon, company that keeps figures for 330 metropolitan areas using a housing cost index that also takes rental prices into account, San Francisco lands at 310 while Miami is at 113; both of these numbers are based on the national average of 100. So, a house that would sell for $372,700

in San Francisco would go for $135,200 in Miami. The national average is $128,500.

> If your parents earn $100,000 a year in San Francisco, they need only $57,670 to maintain the same lifestyle in Miami. And that assumes they still have a mortgage, so think about how much less they would need if their home were paid off and they had no work-related expenses.

Leaving a city like New York or San Francisco can mean huge savings for your parents. Such a move would require a lifestyle change, but it may make for a better standard of living. Less worry for you and more flexibility for your parents when it comes to money matters...and any fears they have of outliving their money.

The best prospect for your parents is to avoid becoming either ignorant of or paranoid about outliving their money. The best way to assure this is to make sure that they have their money in some form of annuity and that they do all they reasonably can to reduce their costs of living.

9 Real Estate and Reverse Mortgages

*It horrified me to come across my parents' loan state-
ment that detailed the status of the house. I thought they
had paid off the mortgage years ago...but what I found
was exactly the opposite. They had been underwater for
some time, having taken out a second mortgage, a third—
and even a home-equity loan in order to do some repairs.
No wonder they were so willing and able to help pay for
their grandchildren's education and give me money when
I started my business 10 years ago. But now what? I don't
want them to lose the house... .*

❦

Real estate—a primary residence—is the most valuable asset most
people own. So, in most cases, the largest asset your parents will
have is the house or condominium in which they live.

The good thing about real estate is that it's fairly easy to identify
and evaluate. If your parents need to sell it, they usually can. They
may not be able to get the price they want, but real estate is often a
stable and reliable investment. When it comes time to cash out equity
in a home—especially for parents who've had decades to let their
property appreciate in value—little stands in the way.

Real estate can be difficult to maintain. And, in some families, it
can be the source of a lot of emotional conflict. Your parents may
have a strong attachment to their home...the place where they raised
a family and marked most of their lives' key moments.

The emotional conflict may not be limited to your parents. In many situations, other family members—your siblings or cousins or uncles or aunts—may have strong feelings (or worse, legal claims) about your parents' property.

If you're stepping in to help your parents manage their affairs, real estate is a good place to start. Unlike other types of investments, the **terms and conditions of most real estate dealings are fairly standard**...and, for that reason, people are often more willing to talk frankly about their homes or condos.

If you've ever stood through a cocktail party where people compared mortgage rates in excruciating detail, you know this is true.

In this chapter, we'll consider the real estate issues that you're most likely to face...and the things you can do to make sure your parents get the best use out of the real estate they own.

Evaluate the Real Estate

You don't have to be Donald Trump to understand that the most valuable real estate is property that has the greatest **equity**—in other words, the smallest amount of attached debt (mortgages, tax liens, etc.) in relation to its appraised value. A $3 million estate in Beverly Hills that's carrying $2.9 million in mortgages has $100,000 of equity; a modest $200,000 duplex on the outskirts of Fresno that you own free and clear has a value twice that of the Beverly Hills estate.

So, right away, you need to answer three questions:

1) Do your parents own any real estate?

2) What's the appraised value of each property?

3) How much do your parents owe on each?

The first question is usually the easiest to answer. If you've been in regular contact with your parents, you probably know the answer already. Even if you haven't been close, you can simply ask them—or any lawyers, accountants or other family members who might know.

However, the answers to simple questions can be complicated. If your relations with your parents have been strained...or if they're already having memory problems and can't say or don't know what they own, you'll have to do some more detailed research.

In these cases, the best mechanism for finding out what—if anything—your parents own is to follow the **property taxes**. If you have access to their financial papers, you should find some notice of property taxes due...or accounts of taxes collected.

Compare the tax documents to the addresses and information that you know or think you know about where they live. In most cases, the information relating to their primary residence will match up—if there were problems, they would usually have surfaced first. But, if they own investment property or vacation homes, make sure you know the proper addresses and title information; inconsistencies are more likely to occur with places where people don't live every day.

If the paperwork doesn't offer any solid information about ownership, your job becomes a little more difficult. But following the property taxes is still your best bet. You can go to the **tax authority** for the area in which your parents live (the authority is usually a County Tax Assessor, but in some areas it goes by a different name) and ask for a search of each parent's name and Social Security number. If they own property in that area, the answer will surface.

A caveat: Each tax authority sets its own terms for who can ask about ownership. In some, anyone can ask—as long as you have the owner's name. In others, you'll need the name and Social Security number. In still others, you may need to have a document showing that you have a court order, power of attorney or similar authority to ask.

In the increasingly few areas where there is no property tax, the Hall of Records or County Court will usually serve the same function as the tax authority.

Aside from your uncertainty about what your parents own, the government may also be uncertain. This doesn't mean its records are fuzzy; it usually means that there's **no clear title** to a piece of property. This can happen for a number of reasons—and none of them is good for you.

Some of the reasons that title to real estate becomes cloudy or uncertain include:

- your parents bought the property in partnership with someone else;

- your parents have executed a quitclaim deed or other legal transfer to someone else;

- your parents did either of the above...and botched the paperwork in some way that's created a legal question;

- creditors like mortgage companies or the very same tax authority have started foreclosure proceedings or put liens on the property for more than its appraised value; and

- as a result of a lawsuit or other action, your parents owe someone money...and that person has filed a lien on the property.

If any of these scenarios apply, you are going to have to resolve them before you can take any other steps to get the most out of the property's value. In some cases, you may be able to negotiate a solution. If your parents executed a botched transfer to another family member, you may be able to explain to that person that no one's going to own the property while the title is unclear. You may be able work out a deal to nullify the botched transfer as part of a larger restructuring of your parents' finances.

Mortgage companies and tax authorities are usually less willing to negotiate. However, if your parents have some money and let payments slip by accident, you may be able to reach an agreement to catch up late payments or **reinstate a mortgage** out of foreclosure.

The point here is that, before you do any of the smart things that we'll discuss in the rest of this chapter, you need to make sure that your parents have clear title to their property. Once you've determined that your parents own real estate, the next question involves figuring out what it's worth.

> **The procedure for appraising real estate is fairly well-established. It's built around the business of making and refinancing real estate loans. Even if you're not planning to borrow against your parents' real estate, you can take advantage of the related appraisal tools.**

Basically, what you're looking for in an appraisal are **comps**—or the **comparable values** of similar real estate sold in the same area at about the same time. In most cases, the banks or mortgage companies that loan money on real estate in the area will keep the best comps for property in a given area. When these lenders need to make a decision about how much to lend on a house or piece of land, they use these numbers—in additional to other factors—to reach a number.

Like so much market-related data, comps are well-suited for delivery via the Internet. In fact, a quick search of any major search engine will turn up dozens of services that will give you detailed comps for just about any given property in any part of North America. Usually, all you need to get this information is the address in question and a credit card for paying the $30 to $100 fee.

In most cases, these services are consumer versions of information that the providers keep for big bank customers (i.e., they are less detailed). Obviously, these numbers will be somewhat approximate. For $50, you're not going to get information about matters like development potential, historic importance or custom design elements.

If you think a property is worth more than what an "off the shelf" comp service is likely to indicate, you can hire a real estate appraiser to evaluate the property in person.

In these cases, you may prefer to use an appraiser who belongs to the American Society of Appraisers in Washington D.C. or the Appraisers Association of America in New York. Both groups can provide you with a directory of members:

- American Society of Appraisers, 555 Herndon Parkway, Suite 125, Herndon, VA 20170; 1.703.478.2228, fax: 1.703.742.8471; e-mail: asainfo@appraisers.org; Web site: www.appraisers.org.

- Appraisers Association of America, 386 Park Avenue, Suite 2000, New York, N.Y. 10016; 1.212.889.5404, fax: 1.212.889.5503; e-mail: aaa1@rcn.com; Web site: www.appraisersassoc.org.

If you log on to either of these two sites, you can plug in information about where your parents reside and be directed to comp services that cater to that location.

Like brokers or agents, real estate appraisers must adhere to a series of professional guidelines designed to make their evaluations as objective and reliable as possible.

Generally, an appraiser charges between $100 and $300 for the most basic evaluation (sometimes called a drive-by) of a residential property. This fee will go up if the house is unusually large or otherwise distinct. It will also be higher if the property includes a commercial building.

If you hire an appraiser to evaluate a piece of property, the resulting estimate will usually not be something that a bank will accept for a loan, reverse mortgage or other financing mechanisms. Banks typically require their own appraisals at the time of a deal (even if that appraisal ends up being performed by the same appraiser). But the private appraisal will be good for telling you what the property is worth...and can be useful for tax or estate planning purposes.

> One thing to keep in mind when you're evaluating your parents' real estate: Older people often underestimate the value of the assets that they own.

We've mentioned this in passing before—it's probably worth discussing in more detail here. It also leads to the final question that you need to ask in evaluating your parents' real estate: **How much do they owe** on their real estate?

Although there are many exceptions, it is a frequent reality that older people tend to think very conservatively about the value of the things they own. In terms of real estate, this usually means living in a house that doesn't have a mortgage attached...or has a relatively small mortgage. It may also mean that the property is underinsured.

But, generally, the conservative bent that older people share can be a good thing. The slow and steady effects of inflation, appreciation and compounding can build considerable—and useful—equity.

> To calculate how much equity your parents have in their real estate, you need to know how much they owe on it. Again, the tax authorities will have a lot of this information if no one else does.

All parties—people or companies, including mortgage companies—that hold liens on real estate have to file those liens with the state or county government. These **liens are public records**, just as the ownership of real estate is. However, these public records can sometimes be tough to find.

This is another field in which numerous for-profit enterprises have stepped in to offer the speed at relative ease of on-line searches. If going down to the county hall of records where your parents live is either inconvenient or impossible, you can contact a title search company (it's usually best to find one in that area) to do the digging for a fee.

> You might want to contact the American Land Title Associa-
> tion, a Washington, D.C.-based trade group for the industry
> that can direct you to a company that conducts title searches
> in your or your parents' area: 1828 L Street, NW Suite 705
> Washington, D.C.; 20036; 1.202.296.3671; 1.800.787.ALTA;
> www.alta.org.

Of course, mortgage companies aren't the only parties that may
have liens on your parents' property. After first and second mortgage
holders, the most common type of lien is related to unpaid taxes. The
Internal Revenue Service and any of various state or local tax agen-
cies may have attached claims to the property related to income, capital
gains or property taxes that your parents haven't paid or are disputing.

If the liens for unpaid taxes are large enough, the tax agencies may
either take possession of the real estate or force a sale. This can be a
devastating loss for the owner of the real estate…in some cases, the
tax liens represent only a fraction of the property's market value.

Unpaid taxes are often a problem for older people who have
started to forget the details of daily living. This is one of the most
important reasons to stay informed about your parents' financial well-
being…long before they start forgetting to pay their taxes.

Other liens that may be on your parents' property include:

- mechanics' liens, related to unpaid bills to contractors, main-
 tenance or repair companies;

- court-ordered liens, usually linked to a judgment or fine
 related to some form of lawsuit;

- bank liens for credit card debt and consumer loans; and

- bail bonds.

If your parents' property is encumbered with these other liens—
and, especially, if one person or company has placed several of them—
you may want to investigate the filings in detail. In some areas that
have lots of older residents and property owners, unscrupulous con-

tractors will file liens related to bogus or exaggerated work. They hope that the property owner doesn't have a will or family who cares—and will pass away, leaving valuable real estate ripe for the taking.

How does a lien work? It's a legal attachment to the value of an asset (it can be any asset but is usually real estate) related to an unpaid debt. Liens are expensive and time-consuming to file; so, they usually make economic sense for larger debts—like mortgages, back taxes or legal judgments. In most cases, a lien holder **can't force the sale** of the asset—especially if the asset is the owner's primary residence. So, the lien holder has to wait until the asset is sold, at which point he or she can force payment of the underlying debt (plus interest).

Calculating and Using Equity

The equity that your parents have in real estate or other assets is simply the appraised present value minus any mortgages or liens attached. Once you've calculated this number, you may want to consider the various ways to react.

If your parents don't have any equity—or have negative equity—the news is bad but your choices are simple.

This situation usually stems from heavy borrowing: Your parents have a mortgage and perhaps a second or third mortgage or an equity credit line that, taken together, add up to more than the current value of the real estate. With aggressive lenders promoting mortgages and lines of credit of up to 125 percent of a home's value, some people can owe more on their real estate than the assets are worth.

This situation can also come from numerous tax liens or court judgments placed against the value of the real estate.

Most lenders—even aggressive ones—won't make 125 percent loans to people over 60 years old. But, in some areas, there are lenders that will...and, in some cases, your parents may have been carrying the heavy debt for years.

If your parents' real estate has **little or no equity** value, the best solution is probably to sell. In this situation, the property is merely serving as security for the loans your parents have taken. Even if they are paying their monthly obligations from earnings or other income, they could probably use that income better to build some savings or pay for their costs of the daily living.

If the loans against the real estate are significantly larger than its market value—in other words, if the property has **negative equity** (or is "underwater" in real estate parlance)—a sale will not resolve the debts completely. In this situation, some people are tempted to keep making payments and let the lenders try to settle their accounts after their parents have passed away. This approach only works if your parents have no other assets in their estate...and it doesn't always work even in that case.

> Some people may think about simply walking away from the over-leveraged real estate—if it's the only asset they have and they are having trouble keeping up the payments. This may make some sense, from a tactical point of view. However, the lenders are likely to sell the property in foreclosure and then file legal proceedings against the borrowers personally.

If an older person doesn't have any assets—other than Social Security payments and some form of pension benefit—he or she may be **judgment proof**. This means that creditors have nothing to seize as security for debts...and little prospect for forcing the person to make regular payments. In most situations, courts will not allow creditors to seize or claim Social Security and monthly pension benefits.

The first priority for older people is to keep their **finances as liquid as possible**. Real estate is not liquid. In many ways, owning it becomes an increasing luxury for people as they get older.

Of course, many people remain emotionally attached to real estate. You may hear your parents talk about keeping "the house where

we raised our family" or "the home we built." If they have enough money and income elsewhere to keep these assets, they can afford this affection.

If not, you may want to think about buying the house from them. This kind of transaction can take several forms:

- If the existing mortgages allow, you may be able to assume the loans and have your parents transfer the title to the property to you;

- You can simply buy the property from them; or

- You can help them set up a trust in which you and they share ownership and/or control of the property.

The analysis and suggestions we offer in this chapter apply to residential real estate. They don't apply to income or invest- ment properties. Real estate that generates rental income should be treated like any other fixed-income investment when you evaluate your parents' financial situation. (See Chapter 8 for tips on handling these assets.)

Simplify Investments

If your parents have more than one home that they use for their own residence, you should encourage them to sell one of these. In many cases, as people get older, they sell and move out of the home that had been their primary residence and move into a second or vacation home—which is often smaller, easier to manage and located in a warmer climate.

As we've mentioned before, your parents can keep the home that they sell in the family—if it has emotional or financial value that's worth keeping. Their goal should be to **move the illiquid asset** off of their personal balance sheet and onto someone else's...even if that some-

one else is another family member or a trust that works for the benefit of other family members.

Simplify the Financing

You may wonder why a solution can't be a conventional **home-equity loan** to get at the equity in your parents' home. Home-equity loans are secured by the excess of the fair market value over existing debt on the property. They won't solve cash flow problems because they provide a lump sum of cash and require your parents to make monthly payments to the lender.

Furthermore, interest rates on home-equity loans can usually be adjusted every quarter, and if interest rates increase, your parents' required monthly payments will also increase. Most importantly, if they are unable to make their required home-equity loan payments, they could lose their home to foreclosure. So, if your parents need extra cash flow but can't take on the burden of making monthly payments, a home-equity loan will not work for them.

To qualify for a home-equity loan your parents need to be **earning income** that is both steady and quantifiable. The lender wants to make sure they have sufficient income to pay the home-equity loan's required monthly payment. If they have enough income to qualify for a home-equity loan, they probably don't have cash flow problems in the first place. There's an old saying that banks will make home-equity loans to people only if they really don't need they money.

Reverse Mortgages

One great tool for creating liquidity from relatively illiquid real estate is the reverse mortgage. A reverse mortgage is real estate's version of an annuity.

If your parents find themselves without enough usable cash flow, and have considerable equity in their home, a reverse mortgage can

be used to generate the extra cash flow your parents need to maintain their standard of living.

Being land-rich and cash-poor is a long-standing problem first addressed in Europe over 100 years ago. European real estate investors bought homes from elderly owners and then allowed them to live in the home rent-free for the remainder of their lives. This process is still popular in Europe today.

After WWII, the concept was imported to the United States and became known as the **reverse mortgage** or **home-equity conversion loan**. The first reverse mortgage programs in the U.S. were sponsored by local government agencies and had limited benefits, with payments usually available only for property taxes and home repairs.

In 1989, the U.S. federal government started its own program through the Department of Housing and Urban Development (HUD). The program, called the Home Equity Conversion Mortgage (HECM), is administered through the Federal Housing Administration (FHA) with loans required to be submitted by FHA qualified lenders.

In 1995, the Federal National Mortgage Association (Fannie Mae or FNMA) began its **Home Keeper program**. Due to Fannie Mae's high profile, Home Keeper brought a lot of momentum to the reverse mortgage market. The Fannie Mae program is similar in structure to the HECM but has higher home value limits.

Through the late 1990s, various private sector lenders followed Fannie Mae's lead and moved into the reverse mortgage business.

When lenders issue a reverse mortgage, a home is used as collateral to structure a loan in the form of monthly payments, a line of credit or a onetime payment. As a rule, the more money your parents receive from the lender, the more of their home's equity will ultimately belong to the lender. The amount of cash that your parents will receive from the lender depends on your parents' age (they must be at least

62), the value of your parents' home and the borrowing limits erected by the lender they select.

The older your parents are, the more money they will get. A 62-year-old could expect to get something like 70 percent of what a 76-year-old would receive. This is due to the shorter life expectancy of the 76-year-old.

Along with a reliable source of monthly income, the amounts received subject to a reverse mortgage have the following benefits:

- a reverse mortgage is a loan, so the payments your parents receive are **tax free**;

- reverse mortgages **do not affect** your parents' Social Security or Medicare benefits;

- reverse mortgage payments will **not be counted as income** when your parents apply for Medicaid, so long as they spend the money they receive in the month they receive it; and

- if they stay in their current home, your parents can receive monthly payments for as long as they live there—even if the lenders **end up paying more** than the home is worth.

It's worth repeating the last point: No matter how much your parents borrow with a reverse mortgage, the lender can never take their home away. Nor can lenders lay claim to their income, their other assets or your assets when it comes time to settle the loan's final costs. The loan is "settled" when your parents move, die or decide they want the loan to stop.

Though reverse mortgages have some obvious benefits, you shouldn't assume that they are without cost. Lenders hedge their bets, and you bear these costs. First, lenders typically only lend 50 to 70 percent of the appraised value of your home. To reduce their risks, all loans are covered by mortgage insurance. This insurance helps the

lender cover expenses if your parents, for example, live in their home until age 100 and opt to receive monthly payments.

Also, if your parents' home needs work, lenders will delay the loan until needed **repairs are made**. Lenders don't want to get stuck with a loan on a property that's decreasing in value because needed maintenance is not being done. If your parents don't want to make the repairs, they won't get the loan. If they cannot afford to pay for the repairs, the costs of repairs can be paid through their loan.

> The costs—points, closing costs, origination fees, monthly service charges, mortgage insurance and mandated repairs—can make reverse mortgages very expensive loans, especially if they are only used for five or fewer years. The longer your parents keep the loan, the more cost effective it will be.

Your parents must also realize that even after entering into a reverse mortgage they **still have all the responsibilities** of homeowners. They must still pay homeowners insurance premiums and property taxes. Failure to cover these expenses can result in a lien being placed on the property and the lien could lead to foreclosure.

Before they even qualify for a loan, borrowers usually have to undergo some form of **counseling**, administered by a government-approved agent. This counseling reviews the terms and costs of the loan. The agent also goes over the loan's repercussions and discusses alternative ways to raise money—if there are any.

All of this said, reverse mortgages work if your parents have considerable equity built up in their home and it makes sense for them to continue living there. A reverse mortgage makes the most sense for a single parent, at least 75 years old, who owns his or her home free and is clear of all debts.

Of course, the size of your parents' **estate will be reduced** by the amount of the reverse mortgage. This, however, should not be a concern because of your parents' awareness to their underfunded

cash flow position. Remember that an efficient solution to your parents' cash flow problems may be simply to sell the house.

The reverse mortgage market has a potential to reach the $2 trillion dollar range, so it's no surprise that lenders are preparing to handle the demand. In 2002, there were nearly 15 million seniors eligible for reverse mortgages in the U.S. And there are more each year.

Home Equity Conversion Mortgage

As mentioned earlier, the Home Equity Conversion Mortgage (HECM) was established in 1989 and is the oldest and most popular reverse mortgage product. HECMs are available to **homeowners age 62 or older** and are insured by the federal government through the Federal Housing Administration (FHA), a part of the U.S. Department of Housing and Urban Development.

Only FHA-approved lenders may originate HECMs, and owner-occupied properties must meet FHA minimum property standards. The size of an HECM loan varies by the **borrower's age**, the **value of the home** and **current interest rates**; it also depends on the FHA loan limit, which varies from area to area and is usually adjusted annually. In 2002, the FHA loan limit varied from $132,000 to $239,250.

Borrowers can choose to receive the proceeds from an HECM as a **lump sum** payment, **fixed monthly payments** (for 10 years or for as long as the borrower occupies the home), a **line of credit** or a combination of monthly payments and a line of credit.

The line of credit is a popular option. Borrowers are able to draw out money as they need it by simply making a phone call to the lender. The lender then transfers the requested amounts into the borrower's checking account. Interest accrues only on the amounts used, adjustable monthly. The unused portion in the credit line increases about 6 percent annually to reflect inflation, another selling point of this option.

The fee that a lender can charge your parents for an HECM is limited. This **origination fee** can't exceed $2,000 or 2 percent of the FHA loan limit, whichever is greater. The origination fee and other closing costs may be financed as part of the mortgage.

HECM borrowers must also pay an **FHA insurance premium**, equal to 2 percent of the loan amount up-front, plus an annual premium thereafter equal to 0.5 percent of the loan amount.

The interest rate charged on an HECM adjusts monthly or annually—the borrower chooses. However, these adjustments don't alter the monthly payments that your parents receive (if they have chosen the monthly payment option). Instead, the adjustment affects the total interest charged on the loan, which is added to the loan balance while the loan is outstanding and is paid when the loan becomes due.

> **Again: Your parents don't make any mortgage payments during the life of the HECM. The HECM becomes repayable, in full, when the sole remaining borrower dies or no longer occupies the home as a principal residence (e.g., through a sale or a permanent move out of the home). The repayment obligation is equal to the sum of the total funds received by the borrower, interest and any closing costs and other charges financed as part of the loan.**

A reverse mortgage doesn't mean you have to sell your parents' house when they die. You—as an heir—can pay off the loan and keep the home. If not, the lender is repaid when the home is sold. If the sales proceeds exceed the amount owed, the excess goes to your parents' estate. If the proceeds are less than the amount owed, **FHA absorbs the shortfall** and makes an insurance payment to the lender.

Home Keeper for Home Purchase

Headquartered in Washington, D.C., Fannie Mae is the nation's largest purchaser of home mortgages and a large investor in reverse

mortgage products. Fannie Mae purchases reverse mortgages from financial institutions that are approved by Fannie Mae.

In 1996, Fannie Mae developed its **Home Keeper** reverse mortgage as a supplement to the federally insured HECM program. Home Keeper was developed to address unmet needs that could not be served by the HECM program, such as individuals with higher property values, condominium owners and seniors wishing to use a reverse mortgage to purchase a new home.

> As with the HECM, the amount of funds available to the borrower under a Home Keeper loan is determined by a formula and varies with the age and number of borrowers at the time of application, the value of the home and current interest rates. Home Keeper loans can be larger than HECMs because Fannie Mae's maximum mortgage limit is almost always larger than the FHA maximum mortgage limit.

The consumer may choose to receive the funds from a Home Keeper mortgage as fixed monthly payments for life (i.e., for as long as the borrower occupies the home as his/her principal residence); a line of credit; or a combination of monthly payments and line of credit.

Home Keeper borrowers are charged an **origination fee** (that may not exceed $2,000 or 2 percent of the value of the home, whichever is greater), a **onetime up front fee** equal to 1 percent of the adjusted home value, a monthly servicing fee ($15 to $30), and other closing costs. Many of these can be financed in the mortgage.

The interest rate charged on a Home Keeper mortgage adjusts monthly and is equal to **a fixed spread above an index rate**— usually the weekly average of the one-month secondary market CD rate, which is published by the Federal Reserve. The rate may never rise by more than 12 percentage points above the initial rate; there is no cap on a monthly adjustment other than the lifetime cap. This interest rate is generally **lower than other reverse mortgages**.

Questions to Ask Reverse Mortgage Lenders

The following questions can act as a checklist to help your parents differentiate among the different reverse mortgage lenders.

- What's the specific financial benefit or benefits?

- What does it cost me? What's the loan origination fee? What's the monthly servicing fee? What are the closing costs?

- Will you provide the total annual loan cost (TALC) disclosure?

- What are the payment options?

- Does an annuity need to be purchased?

- Does the loan require repayment after a certain number of years? (A loan with this feature should be avoided.)

- Will I have to pay, from the proceeds of the loan, any outside fees for consulting or financial planning?

- Are you an approved FHA lender? Approved FNMA (Fannie Mae) lender?

- Are you a licensed lender?

Getting a reverse mortgage may not solve all of your parents' cash flow problems. But it's often a good start. You and your parents should research their options to determine whether a reverse mortgage is right for them. And you may need to ask your parents' tax attorney or CPA if there are any options available to your parents that can generate tax-free cash flows for your parents more effectively than a reverse mortgage.

If nothing else, a reverse mortgage is a good standard against which to measure other investment options.

It's also important to find the right reverse mortgage. Some good background material can be found at the Web site www.reverse.org or on the AARP's primer at www.aarp.org/reversemort Web site. You can also find out more information by contacting a lender, HUD, Fannie Mae or the National Center for Home Equity Conversion.

Steps to the Loan Process

For HECM loans, **counseling** is mandatory and must be received from a HUD-approved counseling agency. For Fannie Mae Home Keeper loans, consumer education is also required—and usually provided by a HUD-approved agency or by a Fannie Mae specialist over the phone. Counseling protects your parents by informing them about what a reverse mortgage means and how it will affect them. The counselor explains different options available and makes certain that they are eligible for a reverse mortgage.

Applying for the loan is also a step in the process. Your parents fill out an application for a reverse mortgage with the lender and select a payment option: fixed monthly payments for life, fixed monthly payments for a finite period, lump sum payment, line of credit or a combination of the above. The lender discloses to the consumer the estimated total cost of the loan, as required by the Federal Truth in Lending Act. The lender then collects money for a credit report (if applicable) and home appraisal.

Credit standards for reverse mortgages are usually easy to meet. However, some credit problems—personal bankruptcies or other major problems—may make a reverse mortgage difficult to arrange. Bad credit may mean lower loan amounts.

Your parents will need to supply the lender with required documents—photo identification, verification of Social Security numbers,

copies of the deed to their home, information on any existing mortgage on the property and a counseling certificate (if required).

The lender **processes the loan**, orders an appraisal to determine the value of the home, title work, lien payoffs, credit report and verification of deposit. The appraiser prepares an **appraisal report**. If your parents' home is suspected to have structural problems, a physical inspection of the home will be required.

After receiving all pertinent information and data, the lender finalizes the loan parameters with your parents, packages the loan and submits the package to the underwriting department for underwriting and final approval.

Following approval, a **closing of the loan** is scheduled. The loan's interest rate is set. The interest rate impacts the amount of funds available to your parents. Also impacting the fund amount is the age of your parents and value of their home. Closing papers and final figures are prepared. Closing costs are normally financed as part of the loan. Previous payments by a consumer for appraisal and credit reports may be refunded or used to reduce the closing costs financed. The lender (or title company) has your parents sign the loan papers.

Right of Rescission

Your parents have **three business days after signing papers** in which to cancel the loan ("three-day right of rescission"). After the rescission period elapses, the loan is paid to your parents in the form of the payment option selected (i.e., monthly checks, etc.).

Any **existing debt** on your parents' home is paid off. A new lien is placed on the home. Your parents may use the loan proceeds for any purpose. During the life of the loan, the lender sends monthly payments to your parents (if this option is chosen), advances line of credit funds to your parents upon request, collects any repayments by your parents on the line of credit and sends your parents periodic statements.

Some people use at least part of the proceeds of a reverse mortgage to buy some form of annuity. In many cases, this is a smart idea. If your parents purchase an annuity as part of the transaction, the annuity will usually provide continued monthly income—even **after they sell or move out** of their home.

Sale-Leaseback

An alternative to a reverse mortgage is a sale-leaseback. In this case, **you or some other family member** assume the role that the bank plays in a reverse mortgage.

The advantage of this arrangement is that the benefits that accrue to the bank in a reverse mortgage accrue to you, allowing you to provide your parents with a better "deal." Plus, sale-leasebacks avoid many of the fees associated with a reverse mortgage, further reducing the costs, and therefore increasing the return to your parents.

How does a sale-leaseback work? The mechanics are as follows:

1) You buy your parents' house directly from them, financing the purchase using a mortgage that is owned by your parents. Your parents act as the lender, owning the mortgage that would normally be owned by a mortgage lender. This is no different than "owner financing"—buying a house with the former owner financing the purchase.

2) You then lease (or rent) the house back to your parents. This is no different than you buying a property as an investment, covering your costs by renting out the property.

The advantage of this arrangement versus a reverse mortgage is that you keep your parents' home in the family with less of a burden on your parents. You assume all the responsibilities of a landlord, including paying the property taxes, insurance and the upkeep and maintenance of the property. Your parents then will no longer have to concern themselves with these homeowner duties. Because the home

is your rental property, you get all of the tax advantages of a real estate investment. You can **deduct the interest** you pay your parents, the taxes, insurance, maintenance and depreciation on the property. You need to work with your tax attorney or CPA to determine if this arrangement makes financial sense for you. You also need the **free cash flow** necessary to finance this transaction.

As far as the monthly cash flows work, you can choose to make a down payment on the house to your parents or finance the entire transaction; it's really a function of what your parents' immediate cash needs are. Instead of exchanging checks with your parents each month, you could deduct their rent from the monthly interest and principal payments you make to them.

All of this said, sale-leasebacks make the best sense if your parents have **considerable equity** built up in their home and the home has enough future value that it makes sense to be part of your investment portfolio.

In a sale-leaseback, you will be assuming all of the risks associated with any other real estate investment. This risk can be mitigated by your insight on your parents' home's intrinsic value and the "psychic" reward of facilitating your parents' ability to continue to live where they are most comfortable.

Conclusion

What to do with the house is a dilemma for many families with aging parents. Your parents may still be living in a house that is better suited for a young family with minor children. Your parents may have raised you and your siblings there…and don't want to leave even though the house is far too large and drafty to maintain.

It's important for you to know what the state of your parents' real estate assets—and burden—are. This is especially important if they own more than one property or share ownership with other people. Facing potentially bad news, such as your parents being severely un-

derwater with their mortgage, can be hard. But if you face the facts now, you'll have better success managing their assets.

In the next chapter, we'll take a look at how you can evaluate the current state of their overall lifestyle—from driving to spending habits—and decide whether or not you need to urge them to make some lifestyle changes. This can be a tricky endeavor, but one that every family encounters at some point.

10 Lifestyle Adjustments

When I got the call that Mom had had another accident, I knew it was time for us to come to terms with the whole driving situation. This was the second time she'd mistaken the accelerator for the brake pedal. Good thing she didn't hit anyone. But the car was smashed up. And she could have hurt herself—had she not been in that huge Cadillac. When I told her that I wasn't going to help with the repair bills because I didn't think she should drive anymore, she was seething. Besides, just keeping up with the gasoline was getting tough for her. It was tough, but I held firm.

~⁊

We can discuss the mechanics of managing your parents' finances and other affairs for hundreds of pages and miss the basic issue that lies underneath the tension so many people feel: **Getting older means people have to change their lifestyles**. And many fight this reality as hard as they can.

In many cases, you can help your parents as much by easing them into lifestyle adjustments as by managing their finances well. Easing people into lifestyle changes can be more difficult. Balancing your mom's checkbook is a black-and-white process; convincing her that she shouldn't be driving anymore…or that she needs to move out of her house…requires an artful mix of strength and diplomacy.

These matters are tough for many reasons. Old people cling to activities and surroundings as their hedge against encroaching illness

and death. American culture emphasizes independence and personal autonomy as essential elements to a good life. Happiness often comes with being able to **do things for yourself**—dress, drive, cook, bathe, shop, plan and make important decisions. When it becomes hard to do basic lifestyle chores like fixing breakfast or going shopping, frustration and depression can set in.

Sons and daughters often shy away from making critical suggestions because they fear the **reversal of parent/child roles** that becomes inevitable as parents age. If it's time to tell Dad to stop driving, it's time to face a lot of issues about life and death.

In this chapter, we'll consider the various lifestyle adjustments that advanced age requires...and some tactics for easing your parents through them. The process can be difficult and often includes evaluating how your parents spend money, where it all goes...and where it needs to go in order for them to continue to live comfortably. But it's as important as any of the other help you give your parents. It may be time for you to take on a new role in their lives.

Driving

Driving serves a useful metaphor for all of the changes that occur to family dynamics as your parents get older.

Transportation can be challenging to an older person's ability to **live independently**. Some people remain good drivers into their nineties. Others face physical problems that can make driving unsafe.

But cars can have more than just a psychological meaning. Public transportation systems, whose routes and schedules are often designed to take people to work rather than to stores, medical appointments or visits to friends, often don't meet the needs of older people. In many communities, driving a car is essential, because there are few or no alternative forms of transportation.

Hanging over all of this: The reality that physical and other **changes associated with aging** can affect your parents' ability to drive safely.

Older parents and adult children often see driving issues differently. You might think it's a simple matter of safety and common sense; but your parents may resent having their driving ability questioned. Underneath the resentment, **they may realize** that their reflexes aren't as sharp as they used to be; but they worry that, by giving up or limiting their driving, they'll restrict their daily lives and become dependent on others.

Older drivers have a low frequency of accidents and fatalities overall, but a higher rate of accidents and fatalities per mile driven (second only to that of drivers ages 16 to 24). Drivers over age 70 number about 18 million today, up from about 13 million a decade ago. Individuals over 65 are the most likely to die in car wrecks, according to the National Highway Traffic Safety Administration (NHTSA).

Age alone cannot predict fitness behind the wheel. Driving skills vary enormously among individuals. In general, these skills begin to decline at about age 55. While no scientific data supports the need to reassess driving ability on the basis of age alone, poor eyesight, hearing loss, **slower reaction times** and reduced muscle strength and flexibility that many older people experience can affect driving ability.

When older people decide to give up driving, other issues surface, like how to get around and how to ask for help. Some may have no one to ask for rides. Family may be far away and friends may no longer drive as well.

You can help your parents continue to drive safely, assess abilities realistically, and—if necessary—find alternative sources of transportation. The first step: Try to make an **objective assessment** of your parents' driving abilities. Recent accidents or traffic tickets could signal a problem. Observe their abilities by driving with them or asking someone else to observe. This will give you information so you can be specific when you discuss the situation. Watch for such things as:

- changing lanes without signaling;

- going through stop signs or red lights;

- slow reaction times;

- problems seeing road signs or traffic signals;

- straying into other lanes;

- going too fast or too slow for safety;

- problems making turns at intersections (especially left turns); and

- jerky stops or starts.

But, if they're driving like this, how should you respond? Like when you're dealing with money matters, you want to **avoid the two extremes**—harsh criticism and condescending happy talk. Be sensitive to the fact that their sense of independence (or, perhaps more to the point, their fears of humiliating *dependence*) are tied up in their ability to get around. More specifically:

- Avoid criticizing them or making them feel attacked.

- Express positive and supportive feelings for them.

- Talk about ideas you have for keeping them on the road, rather than demanding that they give up driving. Suggest that they avoid driving in difficult situations (night time, bad weather). This is easier to face than stopping completely.

- Provide reinforcement to correct shortcomings and overcome fears.

- Be understanding if your parent resists change.

- Just talking about the issue can help you gradually work toward better answers.

And, as with other matters, **focus on the mechanics**. Literally.

Make sure your parents' cars are in good shape. Specifically:

- Can your father still see easily over the dashboard?

- Do your mother's feet reach the pedals easily?

- Are the steering wheel, mirrors and seats adjusted properly?

- Are windows and mirrors free of clutter?

- Is the car in safe operating condition?

If your parents are agreeable, AARP has a skills assessment booklet you can order. You can also check with local colleges or universities, occupational therapists, hospitals, outpatient rehabilitation facilities or the American Automobile Association (AAA).

If reaction time is slowing, a driver should allow more space between his or her car and the one in front. He or she can also avoid driving during peak traffic times or in crowded areas. Driver refresher courses or even behind-the-wheel driver education courses, such as the AARP 55 ALIVE/Mature Driving Program, are other options.

Encourage habits that make for safer driving. Some of those habits include:

- Avoiding night driving, rush hour and being on the road in bad weather.

- Limiting trips to shorter distances.

- Planning and knowing the route in advance.

- Having regular medical checkups, including hearing and vision.

- Exercising regularly to maintain strength and flexibility.

- Making sure medications don't interfere with alertness or ability to drive.

- Avoiding potential vision problems, such as tinted windshields and windows.

Include your parents as an active part of all discussions and decisions. Your parents should feel that **you respect their ability to direct their own lives**. The motivation to change must come from them, both for their safety and for your relationship.

Involve others if driving is dangerous and your parents refuse to make changes to stop driving. A doctor, a member of the clergy or a family friend may be able to help. As a last resort, you can contact the local Department of Motor Vehicles and report unsafe driving. Most states will contact older adults, have them take a driving test, and, if necessary, revoke their license.

All states ask driver's license applicants if they have certain health problems that could impair driving. For a "yes" answer, the applicant may be sent to a physician. Or a medical board may decide if driving restrictions are needed.

Although states are taking more steps to keep roads safe for everyone, most find that imposing driving restrictions based on age is politically difficult.

Elderly parents with serious physical or mental impairments who still are driving are a big problem for their adult children. There are about 27 million drivers older than 65 in the U.S., a number expected to double by 2030.

Taking the keys from mom or dad is a wrenching experience that often signals the start of a role-reversal for parent and child. So, how do you do this difficult task? You start by talking…and you keep talking. Most importantly, **don't turn away** once your parents give up the keys. That's when your assistance really becomes critical:

- Help parents who no longer drive find other means of transportation.

- Work with your parents to identify what public, private and community transportation services are available.

- Consider how your parents might get rides and pitch in when it's possible.

- Talk about what they might do for someone else in exchange for transportation.

- Find out about any discount or reduced rate programs for older adults.

Emotional Factors

In the U.S., children aren't legally responsible if their impaired parent drives, but many adult children feel morally obliged to their parents and to others on the road. Many children worry. Parents going senile don't always grasp that their driving ability is impaired or will **sometimes forget** that they have agreed to stop driving.

How do you get a person with a weapon to stop pointing it at himself and everyone else? You reason with him. You show him love and support. You point out the damage a serious or fatal accident would do to his family—and other families. You hope this works.

Families everywhere will recognize the dilemma: **How can you help your parents yet respect their autonomy?** What if the parents resist help? How do the children know when to step in, when to step back? The answers involve a renegotiation of parent-child roles that happens in every family whose members live long enough.

Many emotions coalesce when it comes time to take the keys away from a parent. You realize in a basic way that dad is getting older...and weaker...or that mom can't be the same *mom* anymore. Some adult children resist these realities until a crisis emerges—mom hits somebody or dad hurts himself.

Other adult children fret and nag long before they need to. Most psychologists agree that the height of **death anxiety** occurs when you are in your forties and fifties. You begin to calculate how many

years you've got left—and you begin to look at your parents, if they're alive (and your children, if you have them), in a whole new light.

Before you can confront a parent about something like driving, you need to confront your own emotions and be ready to deal with your mom or dad's emotions when it's time to tackle the tough issues.

> Acknowledge that you're probably more worried about losing your parents than about their driving. If you're in regular contact with your parents, it may be easier to broach these tough topics. But you might also consider bringing in a third party—a sibling, friend, doctor, neighbor, lawyer or religious figure (priest, rabbi, etc.) to help move the conversation.

Before you attempt to convince a parent of anything:
- Understand your own emotions;

- Know what you want to get out of the conversation;

- Pick your battles (i.e., don't mix a conversation about giving up driving with one about how to hire a gardener);

- Think about how to best approach the topic(s) and under what circumstances—keeping in mind the option of having someone else there to help you through it; and

- Be aware of the difference between **autonomy** and **safety**.

This last point deserves some attention. There's a clear difference between not letting your parents make decisions for themselves and allowing them to do what they want, as long as they're safe and don't pose danger to anyone else. You may want to stop the way they let junk mail pile up in the house or let the garden grow weedy, but **these matters may be trivial** as long as your parents are paying their bills and watching their health.

In most cases, as long as your parents are safe with their decisions, you need to let them make some decisions for themselves. It's

critical to make a parent feel in charge. They can let the garden grow weedy and do their best to maintain it; they can let the mail pile up. These things won't hurt them or anyone else for that matter—and they get the feeling that they are in control of their own lives.

> Balance the need to take control of some facets of your parents' lives with the need to let them make certain decisions for themselves. So long as they are safe and pose no danger to others, they should be able to make the choices they want.

Even if you have a parent with mild dementia, you don't need to dictate everything that goes on in his or her life. **The challenge for you** is to find a way to take charge of the essential things (making sure they don't get swindled out of their retirement savings) and let go of the things that won't affect their well-being...but enhance their sense of self-determination (the increasingly odd way they dress).

A Shift in Dependency

The term *role reversal* is frequently used about adult children and older parents. No question: **dependency shifts**. Some children help parents with everything from housekeeping to daily physical care; but money is the most common issue that children face when stepping in to help their parents manage their daily lives. Many broader lifestyle adjustments start with money problems.

In the next part of this chapter, we'll discuss how to help them evaluate their management skills. It's best, however, to start with how *you* handle money and manage its many faces. Only then can you best turn to your parents and see clearly what you need to do in order to help them out.

You need to ask yourself: *What kind of money person am I?* To prevent this question from spinning out of focus, consider how your finances relate to each of the following common issues.

Timeliness. Do you pay bills on time? Do you save regularly? Do you adjust your plans with the births of children, sale of a home or other large asset, marriage or divorce, death of a family member, re-location? Any of these everyday facts of life can make your financial plans out-of-date.

Organization. Do you have a detailed inventory of what you own, what you owe and where accounts or assets are located? Wills and trusts often include these inventories; but they can become obsolete as circumstances change. That's why smart planners keep separate asset inventories…and update them at least once a year.

> Make sure everything is on the list—cash, liquid investments, business interests, loans or notes, real estate, collectibles, personal papers, etc.

Clear (or clearly-defined) title. Do you know precisely who owns the assets in your estate? For example: How is the title to any real estate structured? Are you the sole title holder? Are you a joint tenant with a spouse? These matters control how the assets are transferred.

Communication. Do your family members know what you want? Many problems arise because beneficiaries or distributees (the heirs getting the money) don't know what the grantors (people leaving the money) wanted.

Beneficiary designations. How do you define who's *family* when it comes to money. Part of this is mechanical: Naming a revocable trust as a beneficiary will usually force accounts to be liquidated and subject to income tax after you die. Part of this is personal: Naming specific heirs often means someone doesn't like the result.

Gifts. Are you generous? And how? One of the smartest ways to transfer money is to give it to family members slowly and steadily. You can give up to $11,000 per year to any person free of gift tax. Some people are hesitant to do this because they think it means losing con-

trol. It doesn't have to; but it will require financial discipline over a long period of time...so you hope.

The point of this exercise is to help you realize what kind of money person you are. Have you made plans that deal with the issues described? Have your parents? If you can answer a "yes" to all of these points, you (and your parents) are conscientious planners who are already ahead of the game; if you only answered "yes" to one or two, you don't like thinking about money—and you need to start. And if **your parents never thought well about money**, you need to start...not only for your sake, but for theirs.

Savers and Spenders

Some financial planners insist there are two kinds of people: **accumulators** of wealth and **distributors** of wealth. The two are different sorts—different attitudes and inclinations. Accumulators are savers and planners; distributors are builders and spenders.

Of course, there are exceptions to that absolute stance. It seems more accurate to say that different people—at different stages in life—may be savers or spenders. It's certainly easier to accumulate when you're single and unencumbered than when you're putting a couple of kids through college.

And even incorrigible distributors of wealth want to leave their worldly goods to the people they care about most. After all, someone who's spent more than he or she has saved over the course of a lifetime should have a lot of cool stuff.

> You can be a spender and a planner. In fact, if you are a spender, you need to make a concerted effort to plan...precisely because it may not come naturally to you. If your parents were planners, hopefully you followed their lead and are ahead of your game. Knowing how to manage money will help you best assist your parents when they need you.

Instilling the right attitude about family money in family members requires a certain aggressiveness about using resources and financial devices. Instilling it in your parents can be an Oedipal battle.

Although there may not be any profound *moral* distinction between spenders and savers, savers have one key tactical advantage over spenders. They tend to be on the winning side of **compounding**.

Compounding is the most important financial tool anyone can use. If your parents have been compounding money over their lifetime, then surely you have an idea of what this means. In short, it's the **progressive effect** that earning interest (or, on the other hand, paying interest) has over a long period of time.

> For the saver, incremental growth is the key to accumulating wealth. Usually, the effect of compound earnings over 20 or 30 years of steady investment will mean as much—if not more—than any individual investment decision.

For the spender, the flip-side advice is: **Avoid debt.** Compounding can work *against* you as steadily as it can *for* you. **The paths to many personal bankruptcies are paved with finance charges.** And financing finance charges. If your parents are moving balances from credit card to credit card or to equity lines or other loans…stop them. Balance shuffling is never good, but it may be a tolerable necessity when you're 30. It's a sign of serious trouble when you're 65.

If your parents don't have enough money to pay their bills at the end of each month, there are only two ways to fix the problem: They have to make more or spend less. If they're borrowing to support their lifestyle…stop them. You may need to help them make lifestyle adjustments to lower the amount they pay out each month. Earning more is tough and usually relies on external factors (the job market or investment market).

Spending less is the best way to improve their financial health. Start by asking them: Where does all of your money go?

Answering that question takes a bit of work, but it's a key step to building—and maintaining—their financial well-being.

Encourage Them to Keep Detailed Records

There are long books dedicated to the practice of **making household budgets**. But there's a mechanically simple process for checking your parents' finances.

To start, buy a small receipt book. A notebook will work…a day-planner is great. Also, buy one packet of blue pens and one packet of red ones. Keep one red pen and one blue pen with the receipt book at all times.

For one month, help your parents save all of their receipts. Work with them to keep the paperwork…or keep a detailed record of everything they spend. **Make it an experiment**: From whatever tomorrow is to that same numbered day next month, encourage your parents to create a record of every expense.

Have them put the receipts in the receipt book once a day. Using the red pen, **list the expenses**—amount, date and party paid—in the book at least every other day…in a clear, chronological order. If you have to help them, do it. Include everything—from the 50 cents they gave your daughter for an 'NSync sticker to the $2,500 check they wrote for this month's mortgage payment.

Make a note in blue of every deposit your parents make into their bank account (if they have multiple accounts, focus this effort on whichever one they use primarily). Count every kind of deposit in this list—salary, bonus, dividends, transfers from other accounts, loans from friends, money from family. Try to keep the deposits in chronological order with the expenses…but don't sweat it if the order gets a little mixed up. **The main point is to include everything.**

Keep these records for the full month. Resign yourself to being an anal-retentive bean counter. At the end of one month, it's time for analysis.

The main question: How do the blue total and red total compare? Don't be surprised if the red total is larger. This is usually explained by credit cards, lines of credit and interest expenses. If your parents net out payments (usually by check) to consumer finance companies, they should end up with numbers that come close to matching.

> If credit card charges account for more than 20 percent of their total expenses, they are probably using the things too much...and should be cutting back.

Analyze Spending Patterns

Once you've balanced their records, you can begin to characterize the ways they spend their money. Go back through the list of red expenses and give each expense one of the following numeric codes:

1—Shelter. This includes rent on their apartment, mortgages on their home. Insurance. Repairs and maintenance. Utilities. No taxes—those go in a separate category.

2—Health. This includes health insurance premiums, if they pay them themselves. It also includes copayments or deductibles that they pay out of pocket, money they spend on drugs—prescription or not, and expenses for seeing chiropractors, therapists or anyone else who tends to their well-being. And any medical equipment they buy.

3—Food. This includes groceries and kitchen-related expenses like water service, etc. This should *not* include the costs of eating out, though some people count prepared food they bring home.

4—Transportation. This includes car payments, car insurance, gasoline, repairs and maintenance. Also, other related expenses: Bus fare, the chauffeur's salary, etc.

5—Clothes. Everything that they wear—whether functional or outrageous—goes here: work clothes, weekend clothes, funky thrift-shop coats, Armani tuxedoes, Nikes. Most jewelry. Dry cleaning and tailoring.

6—Education. This includes the costs of your children's education, if your parents help make payments. Also, anything they spend on classes that they take.

7—Recreation. This will be the first of several broad categories. It should include things like health or country club memberships, athletic equipment, hobby supplies, collections, etc. Most people who use this system include travel and vacation expenses in this category.

8—Entertainment. This includes eating in restaurants; drinks with friends; concerts, plays, sporting events or movies; movies they rent, books, magazines or newspapers they buy. It also includes gourmet coffee, lunches, online computer services or memberships, etc.

9—Taxes. This includes everything they pay directly to the federal, state or local governments. Include income taxes withheld from paychecks or distributions. Also include property taxes that are escrowed (that is, included) in any mortgage payments. Leave out sales tax for this exercise.

10—Communication. This includes their home phone bill and—importantly—any cell phone bills. Also, you probably should include things like home DSL lines and/or Internet service fees, answering services, if they use them, pagers, phone hardware, etc.

11—Religious and charitable donations. This may include cash contributions and prorated commitments (for example: one-twelfth of an annual gift that they've prom-

ised). The prorated commitment may be a little tough to calculate; keep it to actual pledges that they've made. Usually churches or charities will send you some kind of paperwork describing the commitment.

12—Interest and finance charges. This includes interest on consumer debt—credit cards and the like. It should also include bank fees charged to their account and finance charges for things like cash advances, overdraft protection and specialized transactions. It includes late fees for tardy payments. You don't need to include interest on things like mortgages or margin loans...though some people do.

You may feel that particular expenses deserve their own categories, or that these 12 categories don't do justice to their complicated life. But the purpose of this exercise is to make basic conclusions about where money goes.

Most retired people spend roughly:

- 25 to 30 percent of their net income on shelter;

- 25 to 30 percent on medicine and health;

- 10 to 15 percent on food;

- 10 to 15 percent on transportation;

- 5 to 10 percent on entertainment;

- 5 to 10 percent on recreation;

- 5 to 10 percent on clothes;

- 5 to 10 percent on education and daycare;

- less than 5 percent on taxes;

- less than 5 percent on communication;

- less than 5 percent on charitable donations; and

- less than 5 percent on finance charges.

Use this list as a guide or to indicate trouble areas. If one item is way out of range, it may be a problem. Pay particular attention to the items near the bottom of the list. The expense categories that surprise more people are communications, entertainment and interest/finance charges. If any of these are more than 10 percent of your monthly spending, you probably need to cut back.

This exercise isn't intended for people with *urgent* money problems. Make gradual, lasting adjustments rather than radical change.

Curbing Bad Spending Habits

Most of us have at least a few bad spending habits—whether we are spenders or savers. What follows is a review of some of the worst, but most common, spending habits that mess up people's financial lives. Check your parents' habits against these patterns.

Buying on credit is probably the worst habit anyone can have, let alone an elder parent who lives on a fixed income. If your parents have problems with buying on credit, they shouldn't feel alone. American consumers have more short-term, unsecured debt than any other group on the face...or in the history...of the planet.

> **People who avoid using credit are sometimes seen as cranks or eccentrics—unwilling to play by the conventional financial rules. But there's a lot to be said for avoiding revolving consumer debt. Especially if you're over 65.**

Borrowing money to buy things that lose value over time means **you lose twice**—once in the interest costs of borrowing the money and twice in the shrinking value of the item purchased (*depreciation* is the accountant's term).

Consumer lending is designed to lull the consumer—in this case, your parents—into a false sense of financial security. That's why Circuit City, Bloomingdales and Nordstrom are happy to issue store credit

cards. But **credit cards are the worst form of borrowing**. Once they've encouraged you to spend beyond your current means, they charge you anywhere from 15 to more than 20 percent interest.

Help your parents break this habit by explaining to them the pitfalls of buying on credit. They can make credit purchases if it's related to education, transportation or their home, but even those should be carefully evaluated. Most everything else should be paid in cash or paid off when they get the credit card bill.

Keeping up with the Joneses is another bad habit. Thanks to a natural competitive instinct and billions of dollars spent every year by advertising geniuses, we have been brainwashed into judging ourselves by whether we have the same material goods as our friends.

This is the familiar rat race of consumption—more money to support a fancier lifestyle, which then requires even more money. And that word *lifestyle* doesn't just mean buying fancy cars and beach houses. It applies to just about anything: the amount of time spent on the Internet; the number of times you see your favorite band in concert; the food you eat, booze you drink or clothes you wear.

Buying without goals is a bad spending habit that even careful people can suffer from. For many people, making a good salary or inheriting some money means feeling that they have to spend it to show they've got it. This is the flip side of the debt problem—and a variation of the status issue.

Most people are average financially—they don't make that much more or that much less money than other people their age. Some people are simply better at using their money to reach their goals.

Retirement...and Family

The problem with making general statements about retirement is that people head into it with all sorts of different assumptions about

what they want. Some, having worked hard for many years in jobs they didn't like or for companies they didn't respect, feel entitled to a high standard of living. They want to drive nice cars, live in plush surroundings and travel as they please.

Others, having lived their lives keenly calibrated to the society around them, see little more than continuing to live in lockstep with the people they know. They want to live around their friends...or at least people like them. They want to belong to clubs. They want to follow traditional patterns of residence, activity and travel.

Others want to be around their families. They want to help raise grandchildren and grandnieces or -nephews. They want to offer support and advice when needed. They look forward to becoming the matriarchs or patriarchs of large clans.

These are just three scenarios. There are hundreds of variations. All of them can be wonderful; all of them can be taken to extremes. And all of them can cost a lot.

The specifics of how your parents live their retirement usually matter less than **the attitude that they bring into it**. As with all things in life, building family wealth involves a long series of choices. In this case, you may need to make the decision for your parents that a decent condo in Miami or Phoenix allows them to play a lot of quality golf—and keep their money earning. Let someone else's parents give in to the need to consume conspicuously in Boca Raton or Scottsdale. You and your parents should have longer-term goals.

Regardless of one's age, the best way to build and maintain family wealth is to **live beyond money**. Earn it. Invest it. Respect it. **But don't fear it...or worship it**.

Changing Face of Retirement

Another important thing to remember is that retirement—at least the version of it that dominates commercial breaks during the evening news—is a relatively recent creation. Historically, people's roles in

family or other community changed as they got older; but they didn't bolt for Leisure World and 20 years of golf cart races. The elders remained involved in the life of the village or clan.

Americans, as a culture, may be heading back in that direction. Through the 2000s and 2010s, American retirees will continue to retire to a higher quality of life than those who've retired before them. But, starting in the mid-2010s, financial pressures on the Social Security system in the U.S. will probably start reducing the benefits available to able-bodied elders. This will come as a shock to the more than half of all Americans who've never even sat down to run the numbers about how much money they'll need to live.

Some things to keep in mind:

- Set spending goals with your parents;

- Don't agonize over specific investments they made or didn't make;

- Evaluate the state of their tax-advantaged retirement plans, if any;

- Realize that their expenses will change; and

- Help them to accept their potential need to work in retirement.

In the end, retirement is a critical test of your parents' attitudes about money because it's usually their largest opportunity to plan carefully and act selflessly. You can teach your family members a lot—by lesson and by example—from the way you handle money and your parents' own old age.

Conclusion

Attitudes are subjective. The challenge to being with family members who share your attitudes about money is that attitudes are subjective things. What your family considers a healthy disdain for mate-

rialism, you may see as irresponsibility. Of course, if you're in charge of the money, you can enforce your opinions...financially. But lording over family members is risky; you can make enemies of the people closest to you.

You probably inherited some of your attitudes about money from your parents—but these attitudes may have changed from your own experience. By the time you need to take stock of your parents' financial situation and their lifestyle, you and your parents may stand on opposite poles. You have ideas about what they should do with their money and they have their own ideas.

Finding the balance can be hard. As we mentioned in the first half of this chapter, it's up to you to distinguish between what's good for you and what's good for your parents. So long as they remain financially stable and afloat, allow them the room to make some of their own decisions...or at least try to include them the best you can in any decisions you enforce upon them. Only then will you be able to manage the money issues and the emotional issues gracefully and well.

11 Transferring Authority

My mother made it to 82, taking care of herself. Then, she fell in the bathroom at her house and broke her hip. She was in the hospital for a month. While she was there, she asked me to help her keep her bills paid and every-thing. And I knew that meant everything. *So, my husband and I looked around for a place where she could still have her own space...but would have people around to keep an eye on her. And I looked into adding my name to her accounts. This caused some problems, though. When it came time to sign the documents, she hesitated. She felt she was giving up too much of her authority.*

Talking in general terms about helping your parents is fine. But, when it comes to the actual transfer of financial and legal authority, things can get difficult. The best way that you can prepare for this difficulty is to have a working knowledge of the various types of legal agreements that allow children to take actions for their parents.

Then, when the time for the transfer comes, you can offer your parents several choices for how to arrange their affairs.

> In this chapter, I discuss various legal forms and offer a few examples. However, the laws related to financial and legal authority are specific to each state. Make sure to consult an attorney or eldercare expert before signing any document.

Power of Attorney

The most common—and most effective—tool for assuring a smooth transfer of authority from your parents to you is a **durable power of attorney**. This is a legal document that grants you the ability to take care of your parents' legal, financial and medical affairs in the event that they become incapacitated.

> It is important to have this legal arrangement set up as early as possible because, once your parents become incapacitated, it is too late to set up a durable power of attorney. That is because it can only be granted if your parents are competent.

Keep in mind that a durable power of attorney is different than a **simple power of attorney**. A simple power of attorney gives you the legal right to act in your parents' behalf pursuant to whatever action the document describes. For example, they could grant you the power to act on their behalf if they were unable to attend the closing of a real estate sale. All rights granted by a simple power of attorney expire once the grantor becomes mentally incapable—therefore, a simple power of attorney would not allow you to continue acting in your parents' behalf once they became incapacitated.

The durable power of attorney was invented to be able to bridge the fact that the **grantors can no longer legally allow** another to act in their behalf once they've become incapacitated.

One version of a durable power of attorney is a **springing durable power of attorney**. The springing version only becomes operational upon the grantor becoming incapacitated. Your parents can choose who determines their competence—a doctor (or several doctors) or an attorney that they name. The springing durable power of attorney is useful if your parents are in fine health and are unwilling to grant anyone power over their affairs, but recognize the value of having a power of attorney in place if their health fails.

What happens if your parents become incapacitated and they have not set up a durable power of attorney? For you to be able to act in their behalf, you would need **a court to name you as their guardian**, a much more costly and onerous process.

Setting Up a Durable Power of Attorney

You can have a durable power of attorney set up by your parents' lawyer at the same time you and your parents make any modifications to their will. A good practice is to have as much of what you are allowed to do under the durable power of attorney out in the open for all of the other family members to see. This should avoid resentment caused by other family members not knowing what's going on.

Some of the provisions that you can have added to the durable power of attorney that allow powers to be shared include:

- Have the durable power of attorney require that all transactions be accounted for and reported to other family members through a regular statement. Statements can be issued as frequently as once a month. Transactions accounted for include payments made, tracking of all investments, and any income received. This will allow any interested party to have a full accounting of your parents' affairs.

- For large transactions, have the durable power of attorney require approval (via signature or written consent) from another family member or an outside interested party. This allows for consensus with regard to the management of your parents' financial assets.

- Allow for you to be replaced by another person named in the durable power of attorney. This prevents any family problems from nullifying the entire agreement and interfering with what's best for your parents.

Have copies of the document distributed to all interested parties. Original signed copies should be provided to **hospitals and banks** so that these institutions have a copy on file and therefore actions will not be held up because they are unaware of the powers granted to you by the power of attorney.

A power of attorney **does not have to be drawn up by a lawyer** to be legally binding. Blank forms are readily available on the Internet and elsewhere. Most states do not require a durable power of attorney to be notarized and they do not have to be witnessed, as do wills. But, to avoid problems later, it's usually a good idea to invest some time and money in making sure the agreement is solid.

> A durable power of attorney document should be either drafted—or at least reviewed—by an attorney with some knowledge of elder care law in your state. Like any contract, a badly drafted power of attorney can end up causing more trouble than it resolves.

Health Care Power of Attorney

A **health care** or **medical durable power of attorney** empowers someone to make only health care decisions on your parents' behalf if they're unable to do so.

A health care power of attorney usually takes effect anytime your parents are unable, even temporarily, to communicate their wishes regarding medical treatment. The key feature of this arrangement is that it allows your parents to state in advance **whom doctors should consult** about medical decisions while they are incapacitated. This can be especially important in situations where family members are likely to disagree on care or where the patient wants a nonrelative to be the decision-maker.

Depending on how the paperwork is drawn up, a power of attorney can be quite limited—with clear specifications for how medical

services are to be used. For example, if your mother wants 24-hour home health care, she can put this in writing—and restrict you from putting her in a nursing home.

Some Problems with Powers of Attorney

What if you parents' change their mind? As long as they are competent, their **power of attorney can be revoked**. All they need to do is revoke the power of attorney in writing, sign their revocation in the presence of witnesses with notarization, and provide the revocation to all parties involved with the original power of attorney.

All sides need to be careful with powers of attorney because they can be abused.

With a durable power of attorney, your parents' social security checks can be cashed; investments sold and cashed out and bank savings withdrawn. These sorts of frauds occur more often than you would think. Unfortunately, if your parents become mentally impaired and have assets, they are potential victims. The attorney that seems too secretive and too hard to get hold of, or the new "friend" that all of the sudden has taken a liking to your parents, can be after more than your parents' good graces.

Some states have laws that limit what actions can be taken under a power of attorney. In California, for example, a durable power of attorney must expressly convey authority to the agent to make gifts of the principal's property when it is in the principal's interest, such as when disposal of assets is necessary to qualify for Medicaid or as a planning device to avoid probate. Otherwise, an agent who is also a relative may be prohibited from transferring assets to himself or other family members, even when he knows the grantor would concur.

Durable powers of attorney for financial decisions present pitfalls for the unwary. Unscrupulous "caretakers" could pressure your par-

ents into signing such documents on the premise that they would handle your parents' routine affairs more easily. Once the durable power of attorney has been established, however, they could drain your parents' finances.

If you find that your parents have been taken advantage of, you can contact your state's Adult Protective Service office, whose job it is to protect vulnerable adults from being taken advantage of. The U.S. Department of Health and Human Services Administration on Aging (www.aoa.gov) has a listing of the Adult Protective Service offices nearest to you or your parents.

> **The key to avoid having someone fraudulently obtaining a durable power of attorney is to know your parents' caregivers and be on top of their financial affairs. The person helping your parents could be doing so to steal from them.**

Living Wills

Of the various alternates to a power of attorney, a **health care declaration** or **advanced health directive**—more commonly called a **living will**—is often most effective. It documents your parents' wishes concerning medical treatment when those wishes can no longer be personally communicated.

Every state in the U.S. has laws that permit individuals to sign documents stating their wishes about health care decisions when they cannot speak for themselves. The specifics of these laws vary, but the basic principle of listening to the patient's wishes is the same. The law gives great weight to any form of **written directive**. If the courts become involved, they usually try to follow the patient's stated values and preferences, especially if they have been written down.

A living will usually goes into effect when a patient is not expected to regain consciousness. This document states the patient's wishes for

end-of-life care—such as breathing and feeding tubes, last-ditch surgeries and palliative care. There is no appointed "agent" to see that the patient's wishes are carried out…but, as a practical matter, hospitals often will consult the patient's agent under a health care power of attorney, if there is one, to verify the provisions.

In most cases, a living will states that your parents **do not want** extraordinary medical treatment, artificial nutrition or hydration used to keep them alive if there is no reasonable hope of recovery. A living will gives their doctors permission to withhold or withdraw life support systems, under certain conditions.

> Putting wishes in writing assures doctors that these issues were carefully considered while your parents had the capacity to make such decisions. It can provide doctors with a defense, if family members later challenge medical decisions made on behalf of an incapacitated patient. Failure to express such wishes in writing can put hospitals and doctors in the position of having to decide which of several family members' preferences about the patient's care to follow.

In the absence of anyone being granted power of attorney or being named a court-appointed guardian, medical institutions try to consult—in order of importance—a surviving spouse, adult children, parents, adult siblings or other close relatives or friends.

Oral discussions that the patient previously had with friends or family members carry some weight, if nothing exists in writing. But this consideration can cause more problems.

The result of uncertainty is often that, in an effort to avoid wrongful death liability, medical professionals will use every effort to keep a patient alive as long as possible.

Because of the legal risk if they discontinue treatment without unanimous family agreement, hospitals keep providing ventilators, feeding tubes and other care that your parents may not want.

> **Encourage your parents to draft a living will. The odds are that they haven't. According to several surveys, only about one in five Americans has written advance directives: a living will or a health care power of attorney.**

The large number of people (especially older Americans) who do not have any sort of written directive may be surprising, considering that every hospital and nursing home **must ask older patients** upon admission if they've handled advance care planning. A federal law took effect in 1991 requiring medical institutions to provide the reminder, though no one is required to act on it.

As with powers of attorney, your parents **don't need a lawyer** to draft a living will. Many local medical associations and bar associations offer standard living will and health care power of attorney forms that meet local guidelines and are understandable to lay people.

If your parents want to draft their own living will, they should follow some basic guidelines:

- The living will must contain specific statements, not vague abstractions about health care.

- Your parents should declare that they do not want their doctors to use extraordinary means or artificial nutrition or hydration if their condition is terminal and incurable or if they are in a persistent vegetative state.

- They should make clear, consistent choices about appropriate care in various situations. If they make inconsistent choices, the living will may be nullified because it's confusing to health care providers.

- They usually must sign a living will in the presence of two qualified witnesses (no relatives, heirs or doctors) and either a notary public or the clerk of superior court.

> Beware of using a living will form that appears on an Internet Web site, in a magazine article...or even in this book. These forms may not contain the statements required to make them valid in a specific state.

Living wills, like powers of attorney, can be revoked. Your parents can revoke a living will by communicating this desire to their doctors. They can use any means available to communicate this intent. In most cases, their mental or physical condition is not considered—so **they don't need to be of sound mind**. And, if you have power of attorney or are your parents' closest relative, you may be able to revoke their living will. But you have to request this clearly to your parents' doctors.

If your parents make a new living will, be sure that they revoke all prior living wills that may be inconsistent with the new one. As we mentioned before, inconsistency can result in nullification.

Clear Communication Is Important

Obviously, a living will is a device for communication between your parents and their doctors. So, they work best when they are part of a pattern of communication.

It's important that your parents discuss their health care preferences with their providers. No matter how busy the doctor, no matter how stressed the HMO, make sure your parents have spoken at least once with their primary physician about what they want.

Frankly, a doctor is **more likely to honor** requests that have been communicated directly. And he or she may be able to help your parents phrase their requests in a way that makes sense to physicians in their group or area.

Perhaps most importantly, their doctor can **point out inconsistencies** in your parents' requests. Sometimes, refusing one kind of treatment makes it illogical to expect to receive another.

This need for clear communication applies to family members, too. Even though your parents' living will tried to anticipate every situation, the stream of actual events may not fit their assumptions. So, it's important that family members know what they want.

You may be able to clarify or extend your parents' wishes, if you can recall the context of specific conversations.

Another benefit of discussion with family members is the avoidance of unpleasant scenes and confrontations when your parents are incapacitated. While family members may have little legal authority to make decisions for incapacitated patients, they often feel they have **moral authority**. They may be confused by statements not previously shared with them, and may even try to contest your parents' wishes legally if they feel the choices are not in their best interest.

Joint Accounts

Having read all of this detail about powers of attorney and living wills, you might conclude that an easier way to transfer authority over your parents' affairs would be to simply **add your name** as a co-owner of their financial accounts. And you can do this.

However, many of the same problems arise when you add parties to bank accounts or titles to cars, houses and other property. And simply adding your name to a bank account or property title opens up your parents' property to your debts...and creditors.

Most states allow alternatives to joint accounts in the form of **transfer-on-death** or **pay-on-death designations**. In these circumstances, you have no present interest in your parents' funds and cannot access them while they're alive. Upon your parents' death, ownership of the property passes automatically to you—but you have no authority to conduct business for your parents while they're alive

One problem is that the widely used phrase **joint account** can have many meanings. With respect to bank accounts in the names of two people, there are actually four different statuses:

1) statutory joint tenancies with right of survivorship;

2) common law joint tenancies with right of survivorship;

3) tenancies in common with no right of survivorship; and

4) convenience accounts in which the surviving joint tenant has no ownership interest.

Confusion about these different meanings of joint accounts is made worse by common bank practices, which don't distinguish these differences.

Bank accounts are frequently used as a **convenience device** for and older person to enable another person access to funds for a particular purpose or due to the older person's infirmity or ill health. Convincing proof that an account was a convenience device will sometimes **defeat your claim to the account** as your parents' survivor.

Things that suggest a convenience device include:

* your deceased parent was the sole depositor;

* the funds were used solely for you parent's benefit during his or her lifetime;

* your parent exercised complete control over the account and was the sole person making deposits and withdrawals;

* your parent was elderly and infirm when the account was created;

* you had a confidential relationship with decedent; and

* the survivorship interest in the account is not consistent with other wills or estate plans made by your parent.

This legal minutia is designed to prevent abuse of older people. And a common form of financial abuse is for a caregiver (often not a family member) to befriend one of your parents…and then offer to sign on to your parent's accounts in order to "make things easier." Once that signing is done, the caregiver takes the money.

The problem of financial abuse of seniors has become so prevalent that most states have implemented laws making it a felony. Some laws provide for enhanced penalties when the victim is over a certain age, usually 65. Considering all of this, **a joint account is usually not the best mechanism** for transferring financial authority.

Psychological Effects

Transferring authority isn't all about mechanics. Planning well in advance of a major illness or mental incapacity can avoid psychological and emotional problems.

Some psychologists argue that the effect of family politics on an older parent can be similar to the anxiety children feel when their parents divorce. Your parents might also get angry—though their anger is that their children are fighting.

Family battles over authority and control often begin when one family member petitions the court to have a **parent declared incompetent**. That can take away the parent's ability to enter into contracts—including living wills and powers of attorney—make out a will or sign legal papers. If those agreements are quashed, control of the parent's money is usually placed in the hands of a trustee or guardian.

This process subjects the parent to scrutiny from a panel of doctors to determine competency, meetings with lawyers and guardians and court hearings. It's not a pleasant experience.

If declared incompetent, your parents may have to depend on the guardian to pay their bills and give them pocket money, something that can be especially difficult for a parent who has had a successful business career.

Aside from psychic scars, the battles between children and siblings over a parent's money also can drain the very accounts that are there to provide some financial stability for the elder parent.

Mental capacity is one of the thorniest issues facing families with older parents. And it comes to a fine point for most families when documents like powers of attorney and living wills need to be executed. Judging capacity is often complicated by the fact that your parents' sight and hearing may have deteriorated—which can make a person *seem* impaired, even if he or she isn't.

> Assessing capacity is even more difficult when judges and lawyers have to make judgments about a person for whom they have no benchmarks or experience. One solution is to contact your parent's physician to get a professional opinion, though in most cases your parent must consent to this.

It's even more complicated when **family politics and emotions** cloud people's perspectives.

When things turn ugly within a family, the interests of siblings, children, spouses...ex-spouses...and others can be difficult to bring together. This complexity has become even more common in an era when family members are scattered around the country or the world.

If you are the child who has stepped up to care for your parents, you are certainly aware of their desires and their mental capacity. Your siblings, uncles, aunts and in-laws may not be. Plans that you have made with your parents might seem right to you—but look like undue influence or manipulation to the rest of them.

> Family members who haven't been as close to your parents as you have will often feel free to make quick assumptions about hard decisions. Emotional charges that a power of attorney means you're "packing mom off to a nursing home" can begin a grinding erosion of carefully-made plans.

For all of these reasons, it's critically important that your parents carefully draft the mechanisms for transferring authority. And it's im-

portant that you have a professional review the documents. As much as anything, what you're paying for when you hire a lawyer to look over a power of attorney or living will (and the same thought applies to regular wills) is an outsider's perspective on the tone and content of the agreements.

Conclusion

In this chapter, we've discussed the mechanics and strategies for transferring medical and financial authority from your parents to you...or another person watching over them. Most of the toughest decisions that you have to make in helping your parents will probably involve these issues.

There isn't any easy way for your parents to admit they need you to step in and manage their affairs—and it's usually even harder for you to tell them that it's time. The kindest thing you can do for your parents is to make sure **they only have to go through these transfers once**. And you can do that by making sure the transfers you put in place are well-drafted and will withstand any challenges that other family members...or anyone else...might make.

Over the next few pages, I include two samples of power of attorney agreements and two samples of living wills. These are samples only, intended to provide you with a general knowledge of how the documents are structured and written. The specific laws of your state may require different language or form.

Do not use these sample documents for any transfer without the advice and review of an attorney or eldercare specialist in your area.

SAMPLE GENERAL POWER OF ATTORNEY

I, [YOUR PARENT'S FULL LEGAL NAME], residing at [YOUR PARENT'S FULL ADDRESS], hereby appoint [AGENT'S NAME] of [AGENT'S FULL ADDRESS], as my Attorney-in-Fact ("Agent").

If my Agent is unable to serve for any reason, I designate [ALTERNATE'S NAME], of [ALTERNATE'S FULL ADDRESS], as my successor Agent.

I hereby revoke any and all general powers of attorney that previously have been signed by me. However, the preceding sentence shall not have the effect of revoking any powers of attorney that are directly related to my health care that previously have been signed by me.

My Agent shall have full power and authority to act on my behalf. This power and authority shall authorize my Agent to manage and conduct all of my affairs and to exercise my legal rights and powers, including all rights and powers that I may acquire in the future. My Agent's powers shall include, but not be limited to, the power to:

1. Open, maintain or close bank accounts (including, but not limited to, checking accounts, savings accounts, and certificates of deposit), brokerage accounts, and other similar accounts with financial institutions.

 a. Conduct any business with any banking or financial institution with respect to any of my accounts, including, but not limited to, making deposits and withdrawals, obtaining bank statements, passbooks, drafts, money orders, warrants, and certificates or vouchers payable to me by any person, firm, corporation or political entity.

 b. Perform any act necessary to deposit, negotiate, sell or transfer any note, security, or draft of the United States of America, including U.S. Treasury Securities.

 c. Have access to any safe deposit box that I might own, including its contents.

2. Sell, exchange, buy, invest, or reinvest any assets or property owned by me. Such assets or property may include income producing or non-income producing assets and property.

3. Purchase and/or maintain insurance, including life insurance upon my life or the life of any other appropriate person.

4. Take any and all legal steps necessary to collect any amount or debt owed to me, or to settle any claim, whether made against me or asserted on my behalf against any other person or entity.

5. Enter into binding contracts on my behalf.

6. Exercise all stock rights on my behalf as my proxy, including all rights with respect to stocks, bonds, debentures, or other investments.

SAMPLE GENERAL POWER OF ATTORNEY (cont'd)

7. Maintain and/or operate any business that I may own.

8. Employ professional and business assistance as may be appropriate, including attorneys, accountants, and real estate agents.

9. Sell, convey, lease, mortgage, manage, insure, improve, repair, or perform any other act with respect to any of my property (now owned or later acquired) including, but not limited to, real estate and real estate rights (including the right to remove tenants and to recover possession). This includes the right to sell or encumber any homestead that I now own or may own in the future.

10. Prepare, sign, and file documents with any governmental body or agency, including, but not limited to, authorization to:

a. Prepare, sign and file income and other tax returns with federal, state, local, and other governmental bodies.

b. Obtain information or documents from any government or its agencies, and negotiate, compromise, or settle any matter with such government or agency (including tax matters).

c. Prepare applications, provide information, and perform any other act reasonably requested by any government or its agencies in connection with governmental benefits (including military and social security benefits).

11. Make gifts from my assets to members of my family and to such other persons or charitable organizations with whom I have an established pattern of giving. However, my Agent may not make gifts of my property to the Agent. I appoint [SUBSTITUTE AGENT'S NAME] of [SUBSTITUTE AGENT'S FULL ADDRESS], as my substitute Agent for the sole purpose of making gifts of my property to my Agent, as appropriate.

12. Transfer any of my assets to the trustee of any revocable trust created by me, if such trust is in existence at the time of such transfer.

13. Disclaim any interest which might otherwise be transferred or distributed to me from any other person, estate, trust, or other entity, as may be appropriate.

This Power of Attorney shall be construed broadly as a General Power of Attorney. The listing of specific powers is not intended to limit the general powers granted in this Power of Attorney in any manner.

Any power or authority granted to my Agent under this document shall be limited to the extent necessary to prevent this Power of Attorney from causing: (i) my income to be taxable to my Agent, (ii) my assets to be subject to a general power of appointment by my Agent, and (iii) my Agent to have any incidents of ownership with respect to any life insurance policies that I may own on the life of my Agent.

SAMPLE GENERAL POWER OF ATTORNEY (cont'd)

My Agent shall not be liable for any loss that results from a judgment error that was made in good faith. However, my Agent shall be liable for willful misconduct or the failure to act in good faith while acting under the authority of this Power of Attorney.

I authorize my Agent to indemnify and hold harmless any third party who accepts and acts under this document.

My Agent shall be entitled to reasonable compensation for any services provided as my Agent. My Agent shall be entitled to reimbursement of all reasonable expenses incurred in connection with this Power of Attorney.

My Agent shall provide an accounting for all funds handled and all acts performed as my Agent, if I so request or if such a request is made by any authorized personal representative or fiduciary acting on my behalf.

This Power of Attorney shall become effective immediately, and shall not be affected by my disability or lack of mental competence, except as may be provided otherwise by an applicable state statute. This is a Durable Power of Attorney. This Power of Attorney shall continue effective until my death. This Power of Attorney may be revoked by me at any time by providing written notice to my Agent.

[DATE]
[YOUR PARENT'S SIGNATURE]
[YOUR PARENT'S FULL LEGAL NAME]
[WITNESS' SIGNATURE]
[WITNESS' FULL LEGAL NAME]
[WITNESS' SIGNATURE]
[WITNESS' FULL LEGAL NAME]
[NOTARY'S STATEMENT AND STAMP]

SAMPLE HEALTH CARE POWER OF ATTORNEY

I, [YOUR PARENT'S FULL NAME], am of sound mind, and I voluntarily make this designation.

I designate [AGENT'S FULL NAME], my [DESCRIPTION OF RELATION-SHIP TO YOUR PARENT] living at [AGENT'S FULL ADDRESS], as my patient advocate to make care, custody and medical treatment decisions for me in the event I become unable to participate in medical treatment decisions. If my first choice cannot serve, I designate [SUCCESSOR'S NAME], living at [SUCCESSOR'S ADDRESS], to serve as patient advocate.

The determination of when I am unable to participate in medical treatment decisions shall be made by my attending physician and another physician or licensed psychologist.

In making decisions for me, my patient advocate shall follow my wishes of which he or she is aware, whether expressed orally, in a living will, or in this designation.

My patient advocate has authority to consent to or refuse treatment on my behalf, to arrange medical services for me, including admission to a hospital or nursing care facility, and to pay for such services with my funds. My patient advocate shall have access to any of my medical records to which I have a right.

I expressly authorize my patient advocate to make decisions to withhold or withdraw treatment which would allow me to die and I acknowledge such decisions could or would allow my death.

My specific wishes concerning health care are the following: (if none, write "none")

I may change my mind at any time by communicating in any manner that this designation does not reflect my wishes.

It is my intent that my family, the medical facility, and any doctors, nurses and other medical personnel involved in my care shall have no civil or criminal liability for honoring my wishes as expressed in this designation or for implementing the decisions of my patient advocate.

Photostatic copies of this document, after it is signed and witnessed, shall have the same legal force as the original document.

I sign this document after careful consideration. I understand its meaning and I accept its consequences.

[DATE]
[YOUR PARENT'S SIGNATURE]
[YOUR PARENT'S FULL ADDRESS]
STATEMENT OF WITNESSES

SAMPLE HEATH CARE POWER OF ATTORNEY (cont'd)

We sign below as witnesses. This declaration was signed in our presence. The declarant appears to be of sound mind, and to be making this designation voluntarily, without duress, fraud or undue influence.

[WITNESS' SIGNATURE]

[WITNESS' FULL LEGAL NAME]

[WITNESS' FULL ADDRESS]

[WITNESS' SIGNATURE]

ACCEPTANCE BY PATIENT ADVOCATE

(A) This designation shall not become effective unless the patient is unable to participate in treatment decisions.

(B) A patient advocate shall not exercise powers concerning the patient's care, custody and medical treatment that the patient, if the patient were able to participate in the decision, could not have exercised in his or her own behalf.

(C) This designation cannot be used to make a medical treatment decision to withhold or withdraw treatment from a patient who is pregnant that would result in the pregnant patient's death.

(D) A patient advocate may make a decision to withhold or withdraw treatment which would allow a patient to die only if the patient has expressed in a clear and convincing manner that the patient advocate is authorized to make such a decision, and that the patient acknowledges that such a decision could or would allow the patient's death.

(E) A patient advocate shall not receive compensation for the performance of his or her authority, rights, and responsibilities, but a patient advocate may be reimbursed for actual and necessary expenses incurred in the performance of his or her authority, rights, and responsibilities.

(F) A patient advocate shall act in accordance with the standards of care applicable to fiduciaries when acting for the patient and shall act consistent with the patient's best interests. The known desires of the patient expressed or evidenced while the patient is able to participate in medical treatment decisions are presumed to be in the patient's best interests.

(G) A patient may revoke his or her designation at any time or in any manner sufficient to communicate an intent to revoke.

(H) A patient advocate may revoke his or her acceptance to the designation at any time and in any manner sufficient to communicate an intent to revoke.

SAMPLE HEALTH CARE POWER OF ATTORNEY (cont'd)

(I) A patient admitted to a health facility or agency has the rights enumerated in Section 20201 of the Public Health Code, Act No. 368 of the Public Acts of 1978, being section 333.20201 of the Michigan Compiled Laws.

I understand the above conditions and I accept the designation as patient advocate for [YOUR PARENT'S FULL NAME].

[DATE]

[AGENT'S SIGNATURE]

SAMPLE LIVING WILL

TO MY FAMILY, DOCTORS, LAWYERS AND ALL THOSE CONCERNED WITH MY CARE

I, [YOUR PARENT'S NAME] being of sound mind, make this statement as a directive to be followed if I become unable to participate in decisions regarding my medical care.

If I should be in an incurable or irreversible medical or physical condition with no reasonable expectation of recovery, I direct my attending physician to withhold or withdraw treatment that merely prolongs my dying. I further direct that treatment be limited to measures to keep me comfortable and to relieve pain.

These directions express my legal right to refuse treatment. Therefore I expect my family, doctors and everyone concerned with my care to regard themselves as legally and morally bound to act in accord with my wishes, and in so doing to be free of any legal liability for having followed my directions.

I especially do not want:

[LIST EXCLUDED TREATMENTS OR THERAPIES]

Other instructions and comments:

[OTHER PREFERENCES OR INSTRUCTIONS]

Proxy Designation Clause: Should I become unable to communicate my instructions as stated above, I designate the following person to act in my behalf:

[PROXY'S FULL NAME]

[PROXY'S FULL ADDRESS]

If the person I have named above is unable to act on my behalf, I authorize the following person to do so:

[ALTERNATE'S FULL NAME]

[ALTERNATES'S FULL ADDRESS]

This Living Will Declaration expresses my personal treatment preferences. The fact that I may have also executed a document in the form recommended by state law should not be construed to limit or contradict this Living Will Declaration, which is an expression of my common-law and constitutional rights.

[DATE]

[YOU PARENT'S SIGNATURE]

[WITNESS' SIGNATURE]

[WITNESS' FULL LEGAL NAME]

[WITNESS' FULL ADDRESS]

[WITNESS' SIGNATURE]

[WITNESS' FULL LEGAL NAME]

[WITNESS' FULL ADDRESS]

SAMPLE HEALTH CARE DECLARATION

I, [YOUR PARENT'S FULL NAME], being of sound mind, desire that, as specified below, my life not be prolonged by extraordinary means or by artificial nutrition or hydration if my condition is determined to be terminal and incurable or if I am diagnosed as being in a persistent vegetative state. I am aware and understand that this writing authorizes a physician to withhold or discontinue extraordinary means or artificial nutrition or hydration, in accordance with my specifications set forth below:

(Initial any of the following, as desired):

_____ If my condition is determined to be terminal and incurable, I authorize the following:

_____ My physician may withhold or discontinue extraordinary means only.

_____ In addition to withholding or discontinuing extraordinary means if such means are necessary, my physician may withhold or discontinue either artificial nutrition or hydration, or both.

_____ If my physician determines that I am in a persistent vegetative state, I authorize the following:

_____ My physician may withhold or discontinue extraordinary means only.

_____ In addition to withholding or discontinuing extraordinary means if such means are necessary, my physician may withhold or discontinue either artificial nutrition or hydration, or both.

[DATE]
[YOUR PARENT'S SIGNATURE]

I hereby state that the declarant, [YOU PARENT'S NAME], being of sound mind signed the above declaration in my presence and that I am not related to the declarant by blood or marriage and that I do not know or have a reasonable expectation that I would be entitled to any portion of the estate of the declarant under any existing will or codicil of the declarant or as an heir under the Intestate Succession Act if the declarant died on this date without a will. I also state that I am not the declarant's attending physician or an employee of the declarant's attending physician, or an employee of a health facility in which the declarant is a patient or an employee of a nursing home or any group-care home where the declarant resides. I further state that I do not now have any claim against the declarant.

[WITNESS' SIGNATURE]
[WITNESS' SIGNATURE]
[NOTARY OR COURT CLERK'S STATEMENT AND STAMP]

12 Charity, Giving...and Other Good Things

We had to put my mother-in-law in a nursing home last year. And, when we did, we found out that her finances were a mess. My wife's parents owned a lot of real estate and invested in the stock market for decades; because they were never in trouble, we never asked about their situation. After my wife's dad died, her mother started giving a lot of money away to charities and political groups. Her house was full of direct-mail solicitations from hundreds of causes. Literally, hundreds. She was writing checks to all of them. As a result, she's just about broke. And, even with the deductions, she owes tens of thousands to the IRS. Now the rest of the family is angry at my wife—the oldest child—for not doing something sooner.

One place that any parents, even wealthy ones, may need help is estate planning. There's an entire industry dedicated to selling them this kind of information—but much of that industry is promoting certain kinds of investments, insurance policies or tax strategies. And these suggestions are usually for products that **generate commissions for the suggesters**.

There's another phenomenon that happens more often than you might think. Some older people have **confused notions about financial priorities**: They may feel more obligation to the charities and nonprofit groups that actively solicit them than children or family mem-

bers who try to stay low key about money. These people believe that they *have* to give money to the World Wildlife Fund, People for the American Way or the Republican Congressional Election Committee…and that their kids can inherit what's left after that.

Many charities and non-profits understand this—and design their fund-raising campaigns to make contributions seem like existing commitments. That's their business. As a concerned child of older parents, *your business* is to make sure your parents don't get taken in by **manipulative fund-raising** tactics. And that, if they want to give their money away, they do it in the most effective manner.

This chapter will consider the ways to do so.

Giving your parents advice about charitable donations can be a thorny issue. They may not want your advice. Your goal shouldn't be to tell them how much they should give away…or to whom. It's to make sure they do it in the best, most money-wise way. If they want to give money to some group whose politics you can't stand, that's their prerogative. You should focus on making sure they don't hurt themselves in doing it.

Gifts and Taxes

Giving is a good tax-management strategy. And there are two ways that it works:

- gifts to nonprofit organizations (qualified under section 501(c)3 of the U.S. Tax Code) are **tax deductible**, like money put in defined contribution retirement funds;

- cash gifts to anyone—including family members—can **reduce** the size of your parents' taxable estate.

We'll talk about charitable giving later. First, let's consider how ordinary gifts work. When someone gives someone else money or property, the giver is subject to federal gift tax if the gift is more than $11,000 in one year. But **gifts under $11,000 a year are tax-free**.

Even if tax applies to gifts, it may be eliminated by the unified credit. The **unified credit is an allowance** that applies to both the gift tax and the estate tax. It's also the main tool that government uses to **evaluate and tax estates** or inheritances, establishing the applicable exclusion amount. But the unified credit is a onetime thing; any part of the allowance used against gift tax in a given year reduces the amount that can be used against gift or estate taxes later.

> For 2003, the unified credit is $345,800 and the applicable exclusion amount is $1 million. Starting in 2004, there are separate unified credit and applicable exclusion amounts for gifts and taxable estates. The taxable estate unified credit and applicable exclusion amount will grow to $1,455,800 and $3,500,000, respectively, in 2009.

At its top level, the federal estate tax is 50 percent of an estate's value, so the tax bite can really hurt. It's a good thing to know the value of your parents' estate long before the taxman comes to collect. It can be hard to broach this topic, but keep in mind that your own inheritance can be at stake.

For now, most families avoid the estate tax either by having estates worth less than $1 million or by being smart enough to use gifts and trusts in a way that lowers their estate value beneath that number. In these cases, they don't have to pay estate taxes.

It's Better to Give

The term "gifting" has the irritating ring of bureaucratic doublespeak. The term comes up frequently in financial planning—and with good reason. It's a useful tool.

Gifting refers to working around the federal gift tax, which applies to the transfer—for no compensation—of any property. Your parents can make a gift to you if they give you property (including money)— or the use of or income from property—without expecting to receive

something of at least equal value in return. If they sell family members something at less than its full value or if they make an interest-free or reduced interest loan, they may be gifting.

A separate annual exclusion applies to each person to whom your parents make a gift. So, they can give up to $11,000 each year to each of any number of people—and none of the gifts will be taxable.

If your parents are married (to each other), **each of them can give up to $11,000** to the same person each year without making a taxable gift. And, since they can give each other a limitless amount of money without paying tax, they have double gifting capacity.

In fact, they don't have to play gifting games between each other if they're married. If your mom or dad makes a gift to a third party, the gift can be automatically considered made half by your mom and half by your dad. This is known as **gift splitting**.

If a gift is split, a gift tax return must be filed to show that both spouses agreed to the gift; and a return must be filed even if half of the split gift is less than $11,000.

Generally, a gift tax return must be filed on IRS Form 709 if:

- more than $11,000 (the annual exclusion) is given during the year to someone other than a spouse;

- your parents are splitting a gift;

- a gift was given to someone other than a spouse and it can't be "possessed, enjoyed or received income from" until sometime in the future (this covers some trusts); or

- one parent gave the other an interest in property that will be ended by some future event.

If the only reason your parents must file a gift tax return is because they are splitting a gift, they may use IRS Form 709-A, which is a shorter and simpler version of Form 709.

It's best to keep gifts during any calendar year under the tax-free limit. If your parents go over this amount, they either have to pay some money to the Feds or use up some of their unified credit. That's why **gifting takes discipline** and an early start; it works best when money is moved gradually to family members over an extended period of time.

For example: In 2003, your dad gives you a cash gift of $8,000. He also pays the $11,000 college tuition of a friend's granddaughter Goneril, who's gone back to school after a bad divorce. He gives your 25-year-old daughter Regan $25,000; he also gives your 27-year-old daughter Cordelia $25,000.

Your dad has never given taxable gifts before, so he's doing a lot of paperwork for the first time. He probably applies the exceptions to the gift tax and the unified credit as follows:

- under the educational exclusion, the gift of tuition to Goneril is not taxable at all;

- under the annual exclusion, the entire $8,000 gift to you, the first $11,000 of his gift to Regan and the first $11,000 of his gift to Cordelia are not taxable;

- he's left with taxable gifts of $28,000 ($14,000 over the annual limit on his gift to Regan plus $14,000 over the annual limit to Cordelia); at the standard gift tax of 20 percent, he owes the Feds $5,600;

- after all those gifts, he doesn't want to pay the IRS another $5,600, so he subtracts the $5,600 from his unified credit for 2003. The amount of unified credit that he can use against the gift or estate taxes in later years is reduced by $5,600

- you dad would have to file a Form 709.

Now, if your dad *and mom* were making these gifts, the gifts could be split—reducing the amount they'd have to subtract from their unified credit.

Calculating Estate Tax

A taxable estate is determined by calculating the gross value of a dead person's estate minus various allowable deductions. Once this calculation is made, the IRS uses this number to assess estate taxes.

A gross estate includes the total value of all owned assets or property in which your parents had an interest at the time of one of their deaths.[1] The estate also includes:

- life insurance proceeds payable to the estate or, if the dead parent owned the policy, to his or her heirs;

- the value of certain annuities payable to the estate or its heirs; and

- the value of certain kinds of property transferred out of the estate within three years before the parent died.

The allowable deductions used in calculating the taxable estate include:

- funeral expenses paid out of the estate;

- debts the parent owed at the time of his or her death; and

- the marital deduction (generally, the value of the property that passes from the estate to a surviving spouse).

For more information on deductions that you might be able to make from a family estate, check with IRS form 706—the detailed list of allowed deductions.

Once you've calculated the taxable estate value, you can apply the **unused portion** of your parents' unified credit against taxes due.

For example, Jon gave his daughter Angelina $100,000 in 2002. This was Jon's first taxable gift; he filed a gift tax return, subtracting

[1] There's not enough room in this book to analyze the details of estate planning. For a more complete treatment of the subject, see Silver Lake Publishing's *Family Money* (2002). Some parts of this chapter are based on material in that book.

the $11,000 annual exclusion and figuring the gift tax on his taxable gift of $89,000. The gift tax turned out to be $17,800. Jon didn't want to pay this tax, so he used $17,800 of the unified credit to eliminate the tax on the gift.

Jon made no other taxable gifts and died in 2003. The available unified credit that could be used against his estate tax was $328,000. This was the unified credit for 2003 ($345,800) less the unified credit used against the tax on the gift to Angelina ($17,800).

An estate tax return must be filed if the gross estate, plus any adjusted taxable gifts and specific gift tax exemption, is more than the filing requirement for the year of death.

The adjusted taxable gifts is the total of the taxable gifts your parents made after 1976 that are not included in their gross estate.

Prior to President George W. Bush's estate tax law changes—which took effect in 2002—all transfers of money or property (outright, or by will or trust) were subject to a single, federal unified gift and estate tax system. President Bush's changes have set the estate tax (though not the gift tax) for repeal in 2010. Then, in 2011, the estate tax will revert to the rate that was in effect before 2002.

Insurance, Annuities, Etc.

The proceeds from a dead person's life insurance policy paid by reason of his or her death generally are excluded from income. The exclusion applies to any beneficiary—whether a family member or other individual, a corporation or a partnership.

Life insurance proceeds paid to your parents because of the death of the insured policyholder are not taxable unless the policy is turned over to them for a price.

Your parents can **exclude from income** accelerated death benefits they receive on the life of an insured individual if certain requirements are met. Accelerated death benefits are amounts received under a life insurance contract before the death of the insured. These benefits also include amounts received on the sale or assignment of the contract to a viatical settlement provider.

If your parents receive life insurance **proceeds in installments** (as sometimes happens to beneficiaries of annuities), they can exclude details of each installment from their income.

If each installment they receive under the insurance contract is a specific amount based on a guaranteed rate of interest, but the number of installments they will receive is uncertain, the part of each installment that they can exclude from income is the amount held by the insurance company divided by the number of installments necessary to use up the principal and guaranteed interest in the contract.

If, as the beneficiary of an insurance policy, your mom is entitled to receive the proceeds in installments for the rest of her life without a refund or period-certain guarantee, she'll figure the excluded part of each installment by dividing the amount held by the insurance company by her life expectancy.

Example: As beneficiary, your mom chooses to receive the $50,000 proceeds from a life insurance contract under a life-income-with-cash-refund option. She is guaranteed $2,700 a year for the rest of her life (which is estimated by use of mortality tables to be approximately 25 years). The actuarial value of the guarantee is $9,000. The amount held by the insurance company, reduced by the value of the guarantee, is $41,000 ($50,000 - $9,000) and the excludable part of each installment representing a return of principal is $1,640 ($41,000 divided by 25). The remaining $1,060 ($2,700 - $1,640) is interest income to your mom. If she should die before receiving the entire $50,000, the refund payable to the refund beneficiary is not taxable.

Trusts for Family or Charities

If your parents have enough money and are serious about giving it to family or to charities, they should think about setting up trusts that will do this. They don't need to be billionaires to use trusts; most can be set up with only a few thousand dollars.

> The use of a trust says more about your parents' seriousness about giving than the extent of their wealth. Giving a few hundred dollars each to many charities is not as tax effective as setting up several thousand dollars to earn money over a long period for a few groups.

A trust is a legal contract by which one party—the trustee—is given legal ownership of some property to be managed or invested for the benefit of someone else. **Trusts are private contracts** or agreements, but are recognized by the laws and courts as independent legal entities—like people or corporations.

The property in the trust is known as the **trust principal** or corpus. The person for whom it's being managed or invested is the beneficiary (there can be more than one beneficiary to a trust). Finally, the person making the trust is called the grantor (or settlor or trustor in different locations).

> Generally, one person can play up to two of the three key roles in a trust. The grantor can also be the trustee; the grantor can also be the beneficiary. In most cases, though, one person can't be all three.

Like any contract, a trust can be structured too rigidly and with unreasonable conditions—or it may be written too loosely. Both extremes can encourage unwise decisions among the people they're intended to benefit.

Most married people leave their property to their spouses when they die. But, for larger estates, it may be better to leave property in a **credit shelter trust** for the surviving (also called *second* in some contracts) spouse's benefit.

This trust shelters the first spouse's assets—and credit—up to $1 million. The income from it still goes to the surviving spouse for life; even the principal can be tapped for purposes of health, education and support. But the assets aren't subject to estate tax when the surviving spouse dies. Without this type of trust, the tax hammer would fall on the children with the death of the second spouse.

Single people have fewer options, but can also reduce estate taxes by setting up **charitable trusts** (in which a charity owns the principal but the beneficiaries collect interest as long as they live) or making annual gifts.

> In many cases, a trust can remain empty (or *unfunded* in trust jargon) for quite a while after its creation. In some states, however, nominal funding (e.g., $100 in a bank account) is required. This is a good idea anyway. It shows that the trust is more than a piece of paper.

Although an empty trust can exist, in order to function, a trust must have assets formally transferred to the trustee, with this title used in the documents of ownership. Financial institutions will require authorization, in the form of the trust document, before they will accept instructions from a trustee.

Trusts can be **living** (established during the grantor's lifetime) or **testamentary** (established in a will). Separately, trusts can either be revocable or irrevocable. Living trusts are usually revocable, which means the grantor can change structure or terms. If a trust is irrevocable, the grantor can never change or terminate it—or withdraw assets, even in an emergency. An irrevocable trust is an independent entity under the law.

Testamentary trusts remain more common than living trusts because most people are hesitant about transferring major assets while they're still alive.

Lifetime property transfers into living trusts inevitably involve frank discussions about death...and lots of paper work. And many people are uncomfortable talking about death, let alone executing a contract about it. But relying on testamentary trusts to transfer assets only delays the work until somebody else (usually a lawyer or accountant) has to do it.

The main problem with trusts is that they are sometimes **badly drawn**. If they leave important people or facts out—or if they include language that contradicts itself—trouble will follow. The existence and structure of trusts also may complicate family relationships.

Living Trusts

Generally, a living trust is used as an alternative to a will; it gets its name because you set it up when you're alive, transfer all or most of your assets into it, then administer it yourself as trustee.

Living trusts cost more at the front end to set up than wills, but the extra cost is often worth paying. At your parents' death, assets in the living trust are distributed according to their provisions, without supervision of a court. A properly designed living trust makes the hand-off of assets clean and private.

> **Living trusts do not cut estate taxes. During your parents' lives, they have to pay taxes on investment profits made by the trust and, after they die, their estate still owes estate taxes. So they should still use gifts and other tactics to reduce the size of their estate.**

A simple living trust is **revocable**. Your parents (the *grantors*) transfer assets to the trust; but the trust document allows them com-

plete control over everything, including the right to terminate the trust, during their lives.

If there is only one grantor, the simple living trust becomes irrevocable at his or her death. If the grantor has been serving as his or her own trustee, it is imperative to have an alternate named to handle post-death affairs and property distribution.

> In the case of a married couple with children, on the death of the first spouse, the trust usually remains revocable. The survivor stays in control as sole trustee. But—again—it is critical to have an alternate trustee already in place when the second spouse dies.

When your parents are gone, you'll have two basic options for the disposition of trust assets: a division into separate trust shares for each child; or continuation as a single fund for the benefit of all the children until specified ages, at which time total or partial distribution occurs. The single pot approach is usually best, since it allows more flexibility in dealing with emergencies or special needs.

In the broad financial context, there are three main advantages to using a living trust:

- **Avoiding probate**. It can save you significant time and money on the administrative and attorneys' fees related to this legal process. (We talk about probate more...a lot more...in the next chapter.)

- **Privacy**. Probate is a public process; wishes in living trusts are kept private.

- **Flexible management**. You can turn over the management of your trust during your lifetime to your successor trustee. In most cases, you can scrap the whole trust and start a new one. Just make sure that the grantor retains the right to terminate the trust, regardless of who's managing it.

Marital and Bypass Trust

This is the tax planning cornerstone for many combined marital estates (all property owned by the husband, the wife and jointly) worth over $1 million in 2002. In these trusts, your parents serve as their own trustees. Most people specify the broad outline of their intentions at the time the trust is prepared but leave themselves great discretion as to all kinds of details.

> While both spouses are alive, there can be a single *initial trust*, that is revocable and completely in their control. It is similar to, and serves all the purposes of, a simple living trust. The initial trust ends at the first spouse's death, by splitting into two new trusts ("A" and "B").

The A trust is also called the "**marital deduction trust**." Property in this trust is absolutely and completely under the control of the surviving spouse, who can even revoke the trust at any time.

The B trust (some planners joke that B refers to the "below-the-ground" spouse) is irrevocable, and makes use of the dead spouse's estate tax shelter. The B trust is designed for the ultimate benefit of heirs; it's designed to conform to the federal estate tax "shelter limit."

The B trust is also called the "**bypass trust**," because property in it bypasses taxation.

The tax goal of the B trust is to **get this money out of your parents' combined estate**, so that it escapes estate taxation after the surviving spouse's death.

With proper planning, both spouses add a disclaimer clause in their wills giving the surviving spouse the right to disclaim as much of her inheritance from the other as she wants. Anything she disclaims goes into the tax shelter trust, which pays her income and—at her death—goes to the kids. The trust, also set up in a will, is just a shell unless the surviving spouse disclaims money to fund it.

> **If your mom inherits $1.5 million from your dad and the estate tax exclusion is $1 million, she can disclaim $500,000 to the trust. Her estate won't be taxed; her heirs inherit $1 million from her and $500,000 from the credit shelter trust—both amounts untaxed because neither is above the $1 million limit.**

Trusts for Minors

Gifts to trusts established for minors qualify—by law—in whole or part for the annual gift tax exclusion. These trusts are irrevocable, yet permit some control over the timing of wealth transfer to the next generation.

In the so-called **Section 2503(c) Trust** (the section refers to U.S. tax code), annual income may be accumulated and not paid out—but the trust must provide that, if necessary, both income and principal can be used for the minor's benefit. When the minor turns 21, he must be given the right to receive all 2503(c) trust assets in an outright distribution. He can, however, elect to allow the trust to continue.

In the related **2503(b) Trust**, annual income cannot be accumulated; it must be paid to the beneficiary each year. However, in this case, the principal need not be made available for distribution upon the beneficiary's 21st birthday. Unlike the 2503(c) Trust, the 2503(b) Trust principal is not required to ever be distributed to the income beneficiary; it can go to somebody else.

Since the beneficiary has no immediate (if any) right to the trust principal, the beneficiary's only present interest in the 2503(b) Trust is an income interest, the right to receive annual income payments from trust investments. So, the amount of each gift that qualifies is the present value of the series of income payments that the gift will produce over the years. A financial calculation is necessary.

Both types of 2503 Trust can receive annual gifts, including gifts used by the trustee to pay life insurance premiums. If the insured (or

spouse) is the grantor, trust income should not be used to pay premiums—or the grantor may be considered the owner of the policy for estate tax purposes.

This is an often overlooked point; so, consider using trust principal or yearly gifts to pay premiums.

Charitable Remainder Trusts

Charitable remainder trusts (CRTs) are best if your parents have a lot of money tied up in investments that have appreciated over the years, such as **stock, bonds, a home or a business**.

If those assets aren't providing them with dividends, interest or other income, your parents may need to sell the asset and buy something else that will provide them with income. But, when they sell something they've owned for a long time, they're probably going to owe a lot of taxes.

A charitable remainder trust allows them to avoid the tax bite and do some altruistic good. When your parents use a CRT, they move assets into the trust and name a qualified, tax-exempt charity (or several) as beneficiary. They usually remain trustees.

Once they place the assets in the CRT, the trust can sell the assets **without paying taxes** and invest the proceeds in something that **provides current income** for your parents. They are entitled to that income for as long as they live; when they die, the principal goes to charities they named when they set up the trust.

A close variation, called a **charitable remainder unitrust** (CRUT), allows your parents to receive **a fixed percentage** of the trust's value each year, rather than a set dollar amount.

Many people prefer the CRUT because it can provide some inflation protection: As the trust (presumably) grows in value each year, so, too, will the dollar amount of your parents' annual withdrawal allowance.

> **With either a CRT or CRUT, the remainder interest that will eventually go to charity has a value today, established with a financial calculation, using an "assumed" future interest rate.**

IRS publishes the interest rate each month to be used in this calculation of the value—in today's dollars—of the charity's right to receive the remainder of trust assets at the specified future date. That is the amount your parents are giving away. It is, therefore, the value of the current income tax deduction.

A big additional benefit is that the donated property, and all future price appreciation, is removed from your parents taxable estate.

GRATs

The **grantor retained annuity trust** is an irrevocable trust, good for shifting some of the value of an asset out of the estate. The grantor places assets in trust for the ultimate benefit of the children (i.e., they have a remainder interest), but retains the right to an annual payout for a period of years.

By accepting some gift tax liability at the time the GRAT was set up, your parents reduce their estate tax liability later and the heirs end up with more. If your parents die within the term of the trust, all property is included in the estate, and there are no tax consequences—just as if nothing had been done.

The key to the GRAT technique (and the CRUT) is the **relative values** given the two interests involved: The gift of the remainder interest in the trust principal, and the value of what your parents have retained—the right to collect a certain cash payout from the trust each year for X years.

There is a financial calculation that depends on the current interest rate published by the IRS, the number of years during which your parents will take the trust payout and the amount of the payout.

The greater the annual payout and the number of years of payments, the **greater the value your parents have retained** for themselves—and the smaller the value the IRS gives to what is left over.

QPRTs

The **qualified personal residence trust** is an irrevocable trust, similar in concept to a GRAT, but with a confusing name. It's a good method of shifting the value of the family home out of an estate, for the purpose of lowering the ultimate estate tax.

In this scenario, the house is placed into a trust for the benefit of the children. The value of this remainder interest is a taxable gift.

As with a GRAT, your parents accept some gift tax now to save more on estate tax later. What they get isn't income, but the right to live in the house for a term of years. If they outlive that term, the value of the house—plus any appreciation since it was transferred to the trust—passes to the children with no additional federal estate tax.

As with a GRAT, if your parents do not survive the term of the trust, it has no tax effect.

The QPRT does, however, have **two significant drawbacks**: First, the children will have received the house by lifetime gift, not inheritance, so there is no step-up in the tax basis of the property. For homes purchased decades ago at a fraction of today's price, this means that tax (at the 20 percent capital gains rate) must be paid on the increase in value—**if the property is ever sold** by the children.

Second: A relatively recent tax regulation—applicable to QPRTs created after May 1996—has eliminated the common technique of permitting your parents the right to **buy back the residence** at the end of the trust term.

Conclusion

If your parents have planned well and made good money during their working lives, they may have quite a bit of money when they're older and they may need your help in managing this money.

Often, when they get to their retirement age, people think about giving their money to charities or causes they support. The worst way for them to do this is by writing lots of checks to lots of groups. The best way is to set up some form of charitable remainder trust that allows them to use the income earned by their money now and leave substantial money to the groups they support when they are gone.

You can help your parents by advising them to look for **tax-advantaged ways to give their money** away. Of course, the mechanical details of trust accounts can fill many books; your parents should work with a lawyer or accountant when they're setting these things up. If they don't have one already, the charities that they intend to support can often make good suggestions.

If you're helping parents in this situation, keep in mind that trusts can work like annuities—they can generate income for your parents now (in fact, many trusts use annuities to do this). The extra value of a trust is that it **reduces or eliminates the taxes** that can eat up your parents money...either while they're still living or after they're gone.

Remember and remind your parents that trusts can cause problems if badly drawn or excessively complex. A trust agreement doesn't need to be more than 10 pages long...and can usually be shorter than that. And it doesn't need to use any more technical language than what we've discussed in this chapter.

13 Scams, Probate...and Other Bad Things

My dad died six months ago. And everything that's happened since then has been a nightmare. He was a successful real estate broker and investor for 40 years. He sent three kids to college and helped each of us buy our first house. My mom died 10 years ago; dad married Roberta three years later. We were all happy for him. But, now that he's gone, everything's coming apart. It turns out he lost a lot of money in a couple of shady investments...and he died without a will. Roberta says she's keeping everything that's left because dad lied to her about the investments. My brothers say she talked him into them and they're going to sue her.

One of most important reasons to help your parents with their affairs as they get older is to **protect them**. As people get older, even the smartest and most successful can get drawn into **bad decisions**. In some cases, this is because they're not as sharp as they used to be; but, in many other cases, the bad calls have to do with emotional issues like fear of dying or loneliness that leads to misplaced trust.

As with charitable giving, you have to **tread carefully** when helping your parents with their plans for leaving behind their money and assets. The emotional issues they bring to the topic may lead them to wrong conclusions—classically, that you're trying to "pack them off to die" or you're "not waiting 'til the body's cold."

And your parents aren't the only ones who can be difficult critics when it comes to end of life planning. If you have siblings…or if your parents have been married several times…family politics can make your financial advice a point of dispute. Other family members might grumble or openly allege that your advice was self-serving in some manner—that you used your influence with an ailing parent to give yourself a bigger share of the estate.

So, as with giving, the best role you can play is to **ask your parents what they want** to do…and then focus on helping them do so **in the most effective way**. This is the approach that the best financial planners take; and, if one has already helped your parents well, your job is much easier.

If no one's helped your parents, the job falls to you.

This book isn't intended to be a treatise on estate planning or money management. Instead, we'll focus on the most common problems that trip up older people when it comes to managing their money and making their final arrangements.

And these most common problems fall into two rough categories: getting **scammed** and getting **bogged down in probate**. We'll consider the details of each, in turn.

Avoiding Scams

Once you've established that your parents have enough money, income and insurance to cover their basic needs through their last years, you should ask them **what they expect from the money** they have. If you don't—and if they don't have specific goals—they may be vulnerable to being swindled.

In the previous chapter, I pointed out how aggressive some non-profit organizations can be when it comes to fundraising…and I was talking about *legitimate* outfits there. Crooks are even more cunning when it comes to playing on older people's confusion about money mechanics and financial obligations.

You've probably heard about telemarketers who prey on retirees cooped up in their homes, relying on appliances like television, radio or a computer for their connection to the outside world. These crooks exist...and they do like to pick on older people. However, the schemes they promote usually follow the same, basic outlines. And that means you and your parents can do well by watching out for **a few common danger signs**.

Internet Auction Frauds

The Internet is a great resource for older people. It allows them to stay in touch with family or friends...and keep up-to-date on news or with subjects of interest. But the Internet is also a new form of media used by some savvy swindlers.

The most common form of Internet scam is the **online auction fraud**. Most auction frauds are simple variations on the classic **"bust out" scheme**. In these schemes, a swindler opens a business or offers goods for sale online. He then accepts payments for the goods (and, sometimes, credit for supplies) but never makes any products or pays any bills. He stays in contact with customers and creditors as long as possible—without honoring any commitments. Finally, he disappears, **leaving customers and creditors empty-handed**.

Internet auctions are a good environment for swindlers because they are administered—but not really controlled—by large, well-known companies. Your parents have probably heard of eBay and Amazon; and they may be aware that both have auction services. But they may not realize that actual business being done on these sites is between **unregulated (and loosely identified) individuals**.

> **Swindlers are often drawn to circumstances that allow people to be confused about identity.**

Most auction sites offer some form of **seller ratings**. These are programs that invite buyers to rate the seller and the deal on various scales, all designed to give other buyers some idea of what they can expect from the individual sellers.

However, to protect themselves from getting scammed, your parents should take a few extra steps. These include:

- **Look beyond rating scores**. Read through the detailed comments that back up ratings—look for clues in even mild complaints. Comments like "frustration" and "delay" even in positive feedback can be signs for problems.

- **Look at the seller's history**. Has the seller ever sold the kind of product your parents are buying? Ideally, he or she has sold at least a few similar products. The more expensive the product, the more important this becomes.

- **Know how you got to a site**. One of the trickiest aspects of the Internet is the cloudy connection that exists among Web sites. Your parents may not even be aware which site they're on when they see something they want to buy.

- **Avoid off-site auctions.** Some swindlers will pressure you to move off of a recognized auction site and do business privately. This way, they can avoid a high level of scrutiny.

Another smart protection may seem to run against the spirit of online commerce: **Keep a paper trail.** More specifically, encourage your parents to:

- print a hard copy of the Web site's main page;

- print a hard copy of the product detail page;

- print hard copies of all e-mails between them and the seller; and

- print hard copies of all exchanges with the Web site's Internet service provider (ISP).

Again, the biggest risk is that your parents pay for something and the seller never delivers. Most larger online auction sites offer some kind of **protection against nondelivery** of goods sold on their sites. In these cases, your parents usually have to absorb a **deductible** equal to 10 percent of the purchase price of the non-delivered goods.

Also, if they paid by credit card, your parents may have some success going to the card company. Most offer some form of "customer protection"—which will usually mean **refunding part of all of the charges** on your parents' card.

> Credit card companies may require considerable documentation—including various sworn statements. And their response time can be quite slow.

There are other things that you can do if you think **your parents have been scammed** online:

- Confirm that a fraud has been committed. Some problems turn out to be basic disputes between buyers and sellers.

- As much as possible, stay in contact with the seller. Your parents should state clearly that they will make a formal complaint if they don't get satisfaction.

- Keep a paper trail of all communication. Especially in an age of e-mail, it may be tempting to avoid paper—but nothing supports a claimed fraud better than hard copy.

- Take advantage of complaint channels. Most online auction sites invite buyer feedback; bad reports about specific sellers can pressure them to improve...or stop selling.

Ponzi Schemes

The dot.com bubble of the 1990s struck many people as a big, economy-wide swindle. In truth, the investment mania **gave cover to**

real crooks. (Again, crooks like confusion.) There was an increase in the number of financial scams reported all around the United States—and *that* boom lasted after the dot.com bubble had burst.

The most common investment swindle of the 1990s and 2000s was the **Ponzi scheme**—another old-fashioned fraud.

A Ponzi scheme isn't complicated, mechanically. The perpetrator collects money from investors, promising huge returns in a matter of months or weeks. Then, he has to do one of two things:

1) return a portion of the money as profit while convincing investors to keep their principle (which is dwindling fast) invested; or

2) recruit new investors, whose money is used to produce the promised windfall to the earlier ones.

Finding the **second level of investors** is the hard part of the scheme. Once those investors are recruited, the scheme often drives its own growth—so, **word-of-mouth publicity** is essential to a scheme's success. When word of early profits spreads, new investors pour in, allowing the swindler to pay off the earlier investors.

The schemes may yield returns for those who start them or join early on. As long as there are enough people to support the next level, the previous one is safe. In financial circles, this is known as the "greater fool" theory. As long as you find someone willing to take your place in the scheme—a greater fool—the fact that you were a fool to invest doesn't matter. (This may remind some readers of the "dot.com bubble" in technology investments that happened during the late 1990s.)

Investment swindles rely on trust. Of the key factors that allow Ponzi schemes to flourish, **misplaced trust** is most important. It's the point on which burned investors—once they learn they've lost money—most often blame themselves. Invariably, the person will offer some version of "I can't believe I trusted that crook...."

> Telephones, television, computers and the Internet have shattered the traditional sense of social proportion and created an encouraging environment for swindlers. People don't trust their neighbors but believe they have a personal relationship with Oprah Winfrey or Hillary Clinton.

Swindlers thrive on the inability of some investors to tell **the difference between a friend and an acquaintance**. This is particularly true in business circles, where the networking mentality often confuses business cards in a Rolodex with time-tested relationships.

Many smart swindlers have the same characteristics and tricks of the basic telephone scammer, including:

- they're courteous;

- they sound concerned about your parents' well-being;

- they listen to your parents' complaints;

- they flatter;

- they try to be a surrogate son or long-lost friend;

- they offer some financial advice; and

- they promise that they can get a better return on your parents' money.

Then they *take* your parents' money.

Personal charisma is a swindler's best tool. But your parents can turn that tool against him. Warn them that there are recurring signs that a swindler is hoping to bank on his charisma. These include:

- the swindler **talks about *you*** a lot—but in general and psychological terms ("you're being decisive," "you're taking control of your life," "you're investing in yourself");

- if your parents ask financial questions about the investment, the swindler responds in **clichés** and philosophical or psychological **abstractions**;

- the swindler describes himself as an **"idea man"** or "visionary"—anyone to whom your parents give money needs to pay attention to details;

- the swindler talks a lot about **emotional matters**, such as fear, joy, happiness and love;

- the swindler **talks about talking**, saying that he doesn't understand what you mean…or asks if you understand what he's saying; and

- the swindler **answers questions with questions** ("What are you saying?" "How can I make you happy?" or "Are you saying you want your money back?").

Charismatic swindlers will often try to turn facts on their heads. In some cases, crooks at the center of crumbling schemes—and under investigation by the SEC or the FBI—are able to convince investors that the Feds are the villains.

Swindles are an unavoidable part of a capitalistic economy (and probably every other kind of economy, too). But the basic features of their schemes remain relatively simple.

- They place themselves in the context of legitimate operations—whether country club, church or auction Web site.

- They promise big, guaranteed profits…with no risk.

- They use the jargon of technology or psychology…and hope that you don't ask too many questions about details.

- They talk about what you can do with all of the money you make, rather than the mechanics of their deals.

- They count on their personal charm or charisma to divert detailed questions or comments that you have.

Your parents can avoid these traps by taking **a few basic precautions** when they're thinking of investing or lending money:

- make sure of someone's identity before giving them money...and don't let connections blur who's who;

- whenever possible, transfer money through disinterested third-parties and—if possible—escrow accounts;

- no matter how high-tech a business might be, keep a paper trail of documents related to any investment;

- don't be afraid to admit not understanding the details of an investment...and trust enough to hesitate and ask more questions; and

- be wary of any seller or borrower who doesn't answer questions simply and directly.

Scams can fool even the smartest or most intuitive person. They're designed to do that. So, tell your parents to keep that in mind when they hear about a sweetheart deal or surefire bet. There is no reward without risk; and **the higher the reward, the greater the risk**.

Avoiding Probate

Probate is the legal process that oversees the distribution of your parents' possessions after they have died. It is the way to assure that their wills are valid, that their debts are repaid and that their assets go to the right recipients. Probate is usually a long and tedious process. And, just like anything that is long and tedious—and requires attorneys—**probate can be very expensive**.

Expect to pay between 6 and 10 percent of your parents' estate in probate costs, attorneys' fees and executor's fees. If their estate is worth a modest $200,000, probate can cost as much as $20,000.

Probate is initiated in the county of the dead person's legal residence. Usually, the first step is taken by the executor or other interested person who's in possession of the will. This person files (with or without the help of a lawyer) a Petition for Probate of Will and Appointment of Executor—or a similar standard form.

If there is no will, somebody must come forward and ask the court to be appointed as administrator, instead of an executor. Most often, this is the surviving spouse or an adult child, although it might also be another interested party.

There is a common misconception that a will can be drafted in a manner to avoid the probate process completely. This is not possible. Specific assets can avoid probate…but some form of the process must take place for every estate. There are usually streamlined—and in some places highly expedited—procedures set up by the local court system to handle the settlement of small estates, or even larger ones, if uncomplicated.

The probate procedure involves three basic steps:

- collection, inventory and appraisal of all assets that are subject to probate;

- payment of taxes and to creditors; and

- formal transfer of estate property.

The surviving spouse and/or children are generally allowed some inheritance under state law, whether or not there is a will. Generally, that comes off the top first. After that, the order of payment of claims against the estate is usually:

1) costs/expenses of administration;

2) funeral expenses;

3) debts and taxes; and

4) all other claims.

What remains of the estate after these payments are made is available for distribution to heirs and beneficiaries.

If Your Parents Die Without a Will

Some people—even some with considerable assets—remain cynical about what happens with their money and possessions after they die. They avoid making wills because they fear death...or don't want to "waste" time thinking about things that happen after they're gone.

This may be the best choice for a specific person, but it makes trouble for the people he or she leaves behind.

If your parents die intestate (without a will), the court will choose the person responsible for wrapping up your affairs. This person is called an **administrator**, and might not be the person your parents would have wanted. Often, a neutral lawyer is appointed and must be paid with estate funds.

A neutral lawyer being paid with estate funds may not be in any hurry to get things resolved.

A key point to remember: Probate is designed to prevent fraud or abuse. It's not designed for efficiency or protection of wealth.

A quick way to consider probate is to look at what happens under different family circumstances. Here are the ground rules if the person who dies without a will is:

- **Married with children**. The law in most states awards only a third to a half of the dead person's property to the surviving spouse and the remainder to the children, regardless of their age.

- **Married with no children**. Most states give only a third to a half of the estate to the survivor. The remainder gener-

ally goes to the dead person's parent(s), if they're alive. If both parents are dead, many states split the remainder among the dead person's brothers and sisters.

- **Single with children**. State laws uniformly provide that the entire estate goes to the children.

- **Single with no children**. Most state laws favor the dead person's parent(s) in the distribution of property. If both parents are deceased, many states divide the property among the brothers and sisters.

There are some good reasons for these statutory distributions. If there is a will, the surviving spouse can usually renounce it and instead opt to take the share of the estate provided by state law. This is a legal device historically intended for the protection of the survivor.

> If a husband holds the title to the property himself and writes a will directing it to his children by a previous marriage, the second wife can file a petition in probate court to take her share of the estate.

In most cases, probate proceedings diminish family wealth. Even the simplest will can prevent...or at least minimize...the damage.

> A will is a decision-making device, forcing the maker to see that it becomes a precise legal tool that no one can argue with, dispute or change easily.

There are two ways in which your parents can write a will: with an attorney or by themselves. If they write the will themselves, there are several ways to proceed: they can use a will kit or software that includes standard forms...or, they can scrawl their thoughts on a scrap of paper (in legal terms, this is called a "holographic will").

> Courts sometimes recognize poorly scrawled wills, while tossing out carefully crafted lawyer's work. But, the scrap of paper approach is easier for angry people to challenge, so it's not a good idea if your parents are leaving people anything substantial.

So, the best way to make sure that things end up where your parents want them is to make a will. Beyond that, it's hard to generalize. But, some of the necessary items in an effective will include:

- your parents' full names and principal residence, stated clearly;

- the date;

- a declaration that the document is a will;

- the names of their executor and substitute executor;

- the names of guardians and successor guardians for children or disabled people in their care;

- a list of their assets and a list of major debts or liabilities;

- a list of established trusts, including names of trustees and successor trustees;

- a list of life insurance policies;

- instructions for which funds should be used...or assets sold...to pay estate taxes and other costs;

- a list of gifts made from the estate, the complete name of each recipient and some description of his or her connection to or relationship with your parents;

- where they want to have their funerals, burials, cremations, etc.—or whether they don't want these ceremonies at all;

- their signatures, made in the presence of at least two witnesses with their names attached to the document.

Reciprocal Wills

Most married couples (and, for that matter, unmarried ones) do well to set up reciprocal wills. The concept is simple: Each partner writes a separate will that is a mirror image of the other's. Depending on where you live, the wills may be part of a single legal document, may reference each other or may restrict changes made to one but not the other. Among other things, this device provides the simplest form of parity and assurance that basic financial plans can be achieved.

> For married couples, reciprocal wills also simplify some tax issues. If the combined estates of both spouses total under $1 million, the wills may be all the tax planning they need.

Most simple wills prepared for parents have a clause to deal with a **common disaster** situation. Each will says some variation of: "All of my property to my spouse, if he/she survives me by at least 30 days. Otherwise, all to the children." There's nothing special about using 30 days, but the period should be less than six months. If it is longer, some state laws limit the tax-free status of the property transfer to the surviving spouse.

If either or both the wife and husband have **children from a previous marriage**, the reciprocal wills are usually not true mirror images. Each will has a parallel section that articulates the differences. This usually works—legally—but an estate lawyer must review it before it is signed.

Differences—even minor ones—can make a big difference when one spouse dies first (or is presumed to die first, in the case of a common disaster). What happens if a husband and wife with reciprocal wills die together in a car wreck? The executor of the husband's will sees that the wife did not survive for 30 days after her husband's death. She inherits nothing. The husband's estate is divided among his children. They pay inheritance tax, but the logic of the transfer is clear.

On the other hand, assume the common disaster clause says something like: "If we die together, and the order of death cannot be determined, my wife is presumed to have survived me." This might sound ludicrous...but in some situations it's a good idea. Property must be left to the surviving spouse, in order to take the unlimited marital deduction for calculating federal estate taxes. If the spouses' estates total over $1 million, this can mean a big tax break.

Now, go back to the aftermath of the car wreck. The husband's executor distributes property as if the wife were still alive. Never mind that she lived only a minute longer; she gets everything. The husband's money is lumped in with the wife's property. Her will doesn't mention the husband's children from a previous marriage (neither did his). All of her assets, including her husband's, go to her kids, according to her will. His kids from the previous marriage get nothing.

> Most states have adopted the Uniform Simultaneous Death Act to avoid these problems. The law dictates the order of death when parents die together. It is used only when the spouses' wills say nothing about who survived whom—or if there are no wills at all.

Community Property

The term *community property* often comes up in discussions about estate planning (and divorce). It is a form of property ownership—solely between husband and wife—recognized in Arizona, California, Idaho, Louisiana, Nevada, New Mexico, Texas, Washington and Wisconsin. (The other states are common law states, using a different set of laws regarding marital property ownership.)

Specific community property laws differ greatly among these states, but the defining feature is this: Irrespective of the names on title documents, ownership of (almost) all property—including income from wages and self-employment—acquired during marriage by either

spouse is **automatically split**, so that each spouse owns a separate, undivided half interest.

> In terms of community property, an undivided interest is one in which each spouse has half ownership of the whole pie, rather than full ownership of only half of the pie.

Property **acquired by a spouse separately** and brought into the marriage remains separate. Property acquired by gift or inheritance or in exchange for separate property or money, also remains separate. The income, if any, the separate property produces is treated differently. In California, for example, separate property income remains separate property; in Texas, however, income produced by the separate property of one spouse becomes community property.

Each spouse is free to dispose of his or her half of community property in a will. It does not automatically pass to the survivor, as it would if owned jointly, with right of survivorship. Of course, the deceased spouse's federal taxable estate contains his or her half of the couple's community property.

> Community property issues, like so many estate planning issues, usually come up if your parents have been married more than once. In these cases, you should be careful about any advice you give your parent (and stepparent)—especially if it affects resources that might be inherited by your stepparent's children.

Of Sound Mind

Under the law of most states, the person making a will must be of sound mind. He must understand, for example, that he has three children and four grandchildren, who would naturally be those to whom a person would leave his estate. (But that does not mean he must do

so.) Additionally, he must be aware that, by signing the w., making a final disposition of his property.

> The will maker is not required to be smart or wise or reason-able or fair. He must only know what he is doing and, if he does, the law will respect whatever disposition he cares to make, subject to lawful claims that must be paid first, and the rights, if any, of the surviving spouse.

Most wills recite that the maker is of sound mind. The law tries hard to reject claims that the maker was mentally-impaired or under undue influence or duress. If a will is thrown out, the estate is handled as if there wasn't one to begin with.

Holographic and Attested Wills

Some states do not permit **handwritten, or "holographic," wills**. Other states have strict regulations about their use. In most cases, for a handwritten will to be legal, at least **three competent witnesses** must testify that they believe the will was written entirely in the hand-writing of the person whose will it purports to be and that the signa-ture was written in the handwriting of that person.

At least one witness must testify that the will was found after the person's death among his valuable papers, in a safe-deposit box or other "safe place" or that the person had left it with someone for safekeeping.

An **attested will**, on the other hand, is written and signed by the person making the will, or someone else in his presence, and attested by at least two competent witnesses. This kind of will stands on firmer ground. It isn't necessary for the will to be written in the presence of the witnesses. But the person making it must signify to the witnesses that this is his will and sign it in their presence or acknowledge to them that the signature is his if he has already signed it.

... dies, the witnesses must appear before a court
...fy that the witness signatures on the will are theirs.
... do not require either holographic or attested wills

...**d will** is hardest to question or contest. This kind of
willitten substantially in the words specified by state law, signed by the person making the will in the presence of a notary public and two witnesses under oath, signed by the witnesses and signed and sealed by the notary.

What a Will Doesn't Control

Property that passes under the terms of your parents' will is called **probate property**, referring to the probate process that executes the terms of their will. There are a number of assets that pass by the operation of law or contract that are not controlled by their will.

Proceeds from any **life insurance** policy go directly to the beneficiary named on the policy, without passing through your parents' will. The person who receives the proceeds does not have to pay taxes on them. But, if your parents own and control the life insurance policy (having the ability to borrow on the policy or change the beneficiary is considered control), the proceeds of the policy are part of their estate and may be subject to various federal and local taxes.

Proceeds from **retirement plans, such as IRAs, 401(k) plans**, pension and profit-sharing plans, etc., also pass directly to named beneficiaries. However, like insurance proceeds, these assets are subject to estate tax and federal income tax. There's also an additional 15 percent tax if your parents have a large amount of money (in 2002, the amount was $1 million) in the plan.

Assets owned by your parents and someone else, such as houses, bank accounts and brokerage accounts, can be held in **joint tenancy with right of survivorship (JTWROS)** accounts. This means that if one owner dies, the other has legal rights to the assets. If

a spouse is the surviving person, usually half of the value of the asset is taxed in the dead person's estate. If it's someone else, such as a child, the IRS will look to who actually paid for the assets to decide who will pay.

> For you, as a child, owning something in a JTWROS trust or account with your parents is not usually a successful way to avoid taxes. However, it can establish your claim to a piece of family property. And, more commonly, it may become necessary if there are questions about your parents' competency while they are living.

Other Reasons to Minimize Probate

Throughout the probate process, the **executor**—in some states, called a **personal representative**—plays a central role. He or she is responsible for seeing that the estate makes it through probate.

> Sometimes the executor is also a beneficiary. In these cases, he cannot give himself preferential treatment. The best way to assure family peace is to make a will that states clearly how assets should be handled.

One of the executor's most important duties is to take an inventory of estate assets. An executor must also act to **preserve and protect the assets**, according to the prudent person rule. Obeying this rule is part of a **fiduciary duty** imposed by law on executors (and trustees) to act cautiously, as though dealing with their own affairs.

That said, the burden of getting things right rests with the person who's died. An executor will only be liable for problems if he or she acts **criminally** or is **grossly negligent**. This is rare. The executor is not liable for a poor return on estate investments—this is *not* so rare—as long as those chosen are prudent.

An executor is entitled to reasonable compensation, often limited to a certain percentage (e.g., 5 percent) of the property in the probate estate. Extra compensation, related to handling some special matter, may be allowed by the court.

> **The key point in choosing an executor is fairness. The executor of even a modest estate can be the lightning rod for all kinds of family disputes.**

Conclusion

An unfortunate—and inevitable—part of aging is that strengths that served your parents well for most of their lives begin to diminish. Poor judgment about investments and money management can lead them to lose their hard-earned resources. Fear and confusion about death can make them ignore the important aspects of planning for after they are gone.

Perhaps the best support you can give your parents is advice that helps them avoid these perils. Just as they looked after you when you were a child (even if they did so imperfectly), you now return the obligation by looking after them.

In this chapter, we've taken a brief look at the two biggest dangers that lurk wherever older people gather: scams and probate. (And many family members swear that probate is a scam.) You need to be a lawyer or a fraud investigator to look out for your parents with regard to these risks.

You just need to be reasonably well-informed and pay attention to what...and how...your parents are doing.

Baby Boomers and
the Hard Conversation

You're facing the dilemma of taking care of your parents...at the same time you're taking care of the responsibilities of their own retirement and providing for your kids—their health, education and emotional well-being. Welcome to the multigenerational family.

I've tried to use the term "sandwich generation" as little as possible in this book because it doesn't do justice to the complex reality of most extended families. You're not in the middle of three generations; you're in the midst of four...or seven...or 10 people.

And, in most cases, your parents aren't really analogous to your children. Even if your parents are completely broke (and most aren't), they have access to **various financial and insurance resources**. If you help them navigate these programs, you may find that they're at least somewhat self-supporting.

Be thankful for that. Your parents are likely collecting as much as any generation will from the social welfare programs run by the U.S. federal government. Your generation...and your children's...is likely to have to age with fewer government benefits that are currently offered to older people.

In the 2000s, baby boomers are turning 50 at the rate of 10,000 per day. So, consider helping your parents through their old age a primer to living through your own.

Families have traditionally played this role—educating younger members through the experiences of older ones. The main distinction

that you and your parents are experiencing is that longer life expectancies have made a roller-coaster ride of family dynamics in America during the past several decades.

First, our society had an historically big surplus of wealth, which it channeled toward relatively few older people; now, it has to deal with an **actuarial reckoning** of less wealth and more older people living longer—and requiring benefits whose costs are increasing exponentially.

Adding to this stress is a major loss of retirement assets—some $7.7 trillion of paper wealth, to be exact—during the investment market crash that started in 2000.

Many people near retirement age don't have the time to make up these losses. They're working longer to care for themselves…and for their parents, children or other family members over the long run.

Welcome to the end of retirement as your parents knew it.

Understanding Your Parent's Circumstances

As I've said throughout this book, the key to everything in helping your parents is to **know their circumstances**. Whether it's finding out what real estate they own, any retirement funds they have, how their health is, or anything else, it's up to you to know. This may mean asking your parents some awkward, personal questions. Or, it may mean doing research with old employers, banks or local government agencies.

However you get the information…get it.

Once you understand your parents' position, you need to make a plan to maintain their retirement security. That plan includes making sure your parents have their retirement money properly allocated and diversified to insure that they have **minimized the risk of losing what they've got**. Nothing can be worse than having their retirement fully funded—and then suddenly losing it because they put their money in some high-risk investment.

The next important step is to have a well thought-out estate plan. Estate planning, through wills and trusts, will insure that your parents' resources don't get sucked up by taxes, legal fees or other transaction costs...but are passed on in a manner that your parents desire.

Get Your Parents Their Benefits

Knowledge is power. Awareness and understanding of the benefits available to your parents will help to assure your parents' financial security. Many seniors miss out on benefits available to them because either they...or their families...are shy about asking.

As one financial planner I know says, "It's always a good idea to assume you're poor, no matter how rich you are." For older people, this means considering all of the many benefits available—even if they have a fully funded retirement plan. Things can change quickly.

Some underutilized programs include:

- **Medicaid**. Medicaid pays for medical benefits and nursing home care for low-income individuals. Around 3 million senior citizens are eligible but have not applied for these Medicaid benefits.

- **Prescription Drug Assistance**. The majority of states administer programs to help seniors pay for prescription drugs. Many seniors are unaware of these state-run programs.

- **Medical Benefit Counseling**. Seniors can get free counseling on all of the medical benefits that they are entitled to, including Medicare, Medigap and Medicare HMOs.

- **Veterans Benefits**. The Veterans Administration provides medical care to military veterans regardless of income.

- **Social Security Supplemental Income**. Social Security provides additional benefits to low-income senior citizens

through its Supplemental Income program. The benefit provided is in the form of a monthly check; over a million seniors are eligible but have not applied for this money.

- **Food Stamps**. The Department of Agriculture administers the Food Stamp program that pays for groceries for low-income individuals. Over 3.7 million seniors are eligible for these programs but have not applied for it.

- **Subsidized Meals**. Most seniors, regardless of income, are eligible to receive meals either on a group basis or through home delivery.

- **Property Tax Relief**. Property taxes going up every year are a fact of life for many regions of the United States. Because this is a harsh burden for seniors, most states have programs that reduce property taxes for them.

- **Home Energy Services**. Many regions of the United States have programs that provide low-income seniors with help with their home's energy costs through subsidized energy costs and free home energy repairs and services that can lower energy bills.

- **Employment Services**. Most states administer programs that provide seniors with counseling on jobs, résumés and job placements.

I've discussed most of these programs in detail. The point of this review is remind you that you should explore **every program available to your parents**, regardless of how much money they have.

Look for Your Own Elder Care Resources

After years of trying, without a lot of success, to help workers who care for elderly relatives, some large companies are making another push with benefits programs to address this need.

In January 2001, Ford Motor Company began offering its 150,000 North American workers free house calls by geriatric-care managers to assess the health of elderly relatives and develop plans for their care. At about the same time, AT&T Corp. rolled out "one-stop shops" to coordinate employee benefits for older family members. And, Fannie Mae hired a full-time elder care specialist to help employees at its Washington, D.C., headquarters.

Caring for an elderly relative typically takes at least eight hours a week and spans **eight years**—and, as we've seen, the time commitment is expected to grow as the number of middle-aged workers increases and their parents live longer.

These new programs follow previous efforts to help workers who double as caregivers. In the late 1980s, companies started **"resource-and-referral" programs**, typically toll-free numbers that offered some counseling and information about elder care services. Few workers used them, even though arranging elderly care can be a hard and time-consuming task.

The problem: Few people plan ahead for eldercare and, when a crisis hits, they don't think of the workplace as a resource.

The Discussion

The last, and most important, point of this book is that you have to be assertive about talking with your parents.

You may not want to think about death. You may not like the childhood issues that your parents dredge up. You may not be a Florence Nightingale when it comes to nursing the sick. But you have to find the courage to **speak candidly with your mom and dad** about their money, their health and their preferences for what happens to them in the last days.

There's no list of government programs to help with this.

If you have major problems with talking to your parents about these things, the best advice I can give is to do it gradually. If you and

your parents have open and honest talks about simpler things, you can more easily move into a talk about these harder ones.

Obviously, the ease of this discussion depends on your relationship with your parents. If you haven't been close to them, consider helping them as a way to right whatever had been wrong in the past. No matter what terms you and your parents are on, the process of helping them can be an opportunity to improve things.

Planning—managing money, transferring legal authority, preparing an estate—is one thing. But having the right state of mind to plan and plan well is the ultimate challenge.

Index

20% Off Silver Lake Publishing books

Silver Lake features a full line of books on key topics for today's smart consumers and small businesses. Times are changing fast—find out how our books can help you stay ahead of the curve.

[] **Yes**. Send me **a free Silver Lake Publishing catalogue** and a 20% discount coupon toward any purchase from the catalogue.

Name:_____

Company:_____

Address:_____

City:_____ State:_____ Zip:_____

Phone:_____

Silver Lake Publishing • 2025 Hyperion Avenue • Los Angeles, CA 90027 • 1.323.663.3082

slpz1

Free Trial Subscription

Silver Lake Publishing introduces **True Finance**, a monthly newsletter dedicated to money and its management. **True Finance** offers more than dry lists of mutual funds or rehashed press releases. It focuses on the trends—technological, economic, political and even criminal—that influence security and growth. It includes columns from the authors of some of Silver Lake Publishing's bestselling books, including **The Under 40 Financial Planning Guide**, **Insuring the Bottom Line** and **You Can't Cheat an Honest Man**.

[] **Yes**. Please send me **a free trial subscription to True Finance**.

Name:_____

Address:_____

City:_____ State:_____ Zip:_____

Phone:_____

Silver Lake Publishing • 2025 Hyperion Avenue • Los Angeles, CA 90027 • 1.323.663.3082

slpz1

BUSINESS REPLY MAIL

FIRST-CLASS MAIL PERMIT NO. 73996 LOS ANGELES CA

POSTAGE WILL BE PAID BY ADDRESSEE

**SILVER LAKE PUBLISHING
2025 HYPERION AVE
LOS ANGELES CA 90027-9849**

**NO POSTAGE
NECESSARY
IF MAILED
IN THE
UNITED STATES**

BUSINESS REPLY MAIL

FIRST-CLASS MAIL PERMIT NO. 73996 LOS ANGELES CA

POSTAGE WILL BE PAID BY ADDRESSEE

**SILVER LAKE PUBLISHING
2025 HYPERION AVE
LOS ANGELES CA 90027-9849**